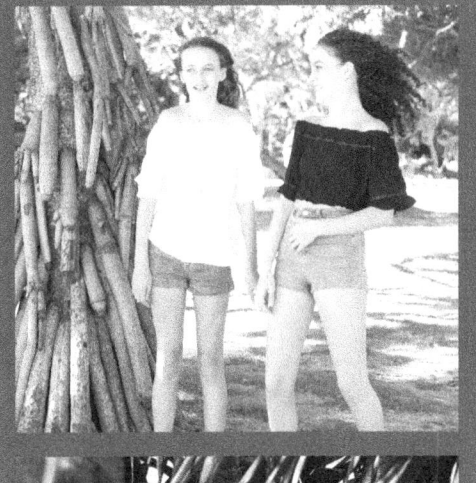
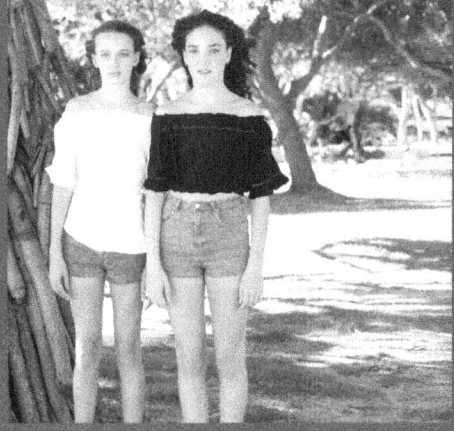
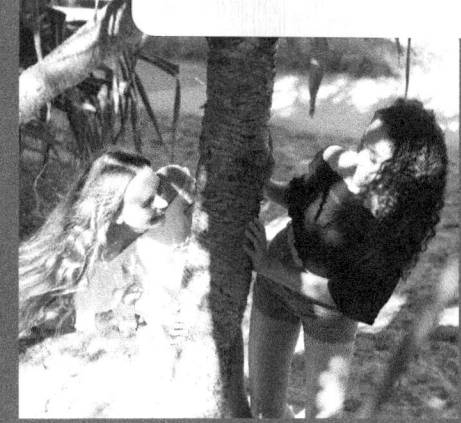

I Love Black and White Photographs

July and August 2016

Author, Photographer and Publisher

Ian McKenzie

ISBN-13: 978-1539359845
ISBN-10: 1539359840

Copyright 2016
Ian McKenzie

www.iansbooks.com

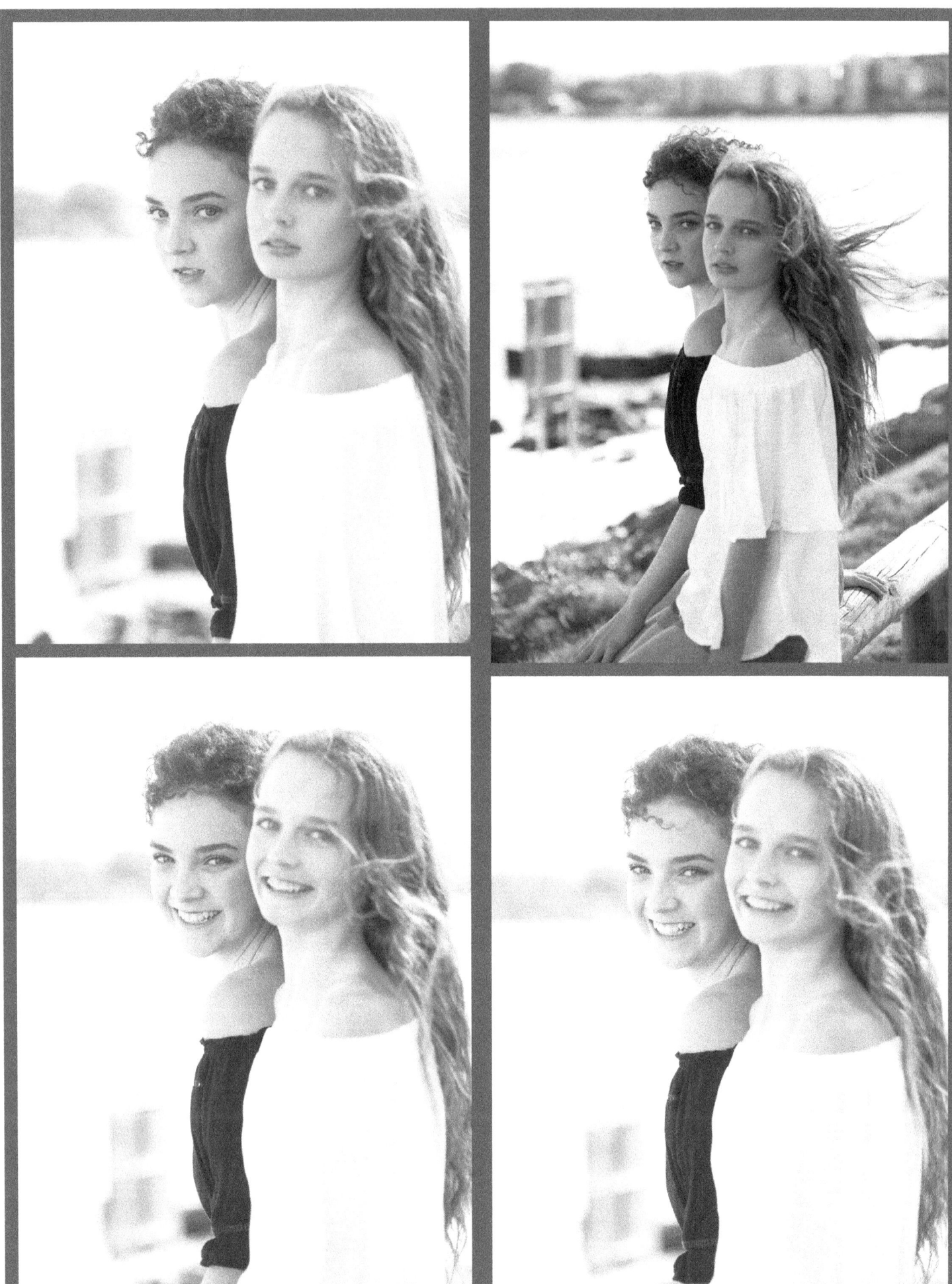

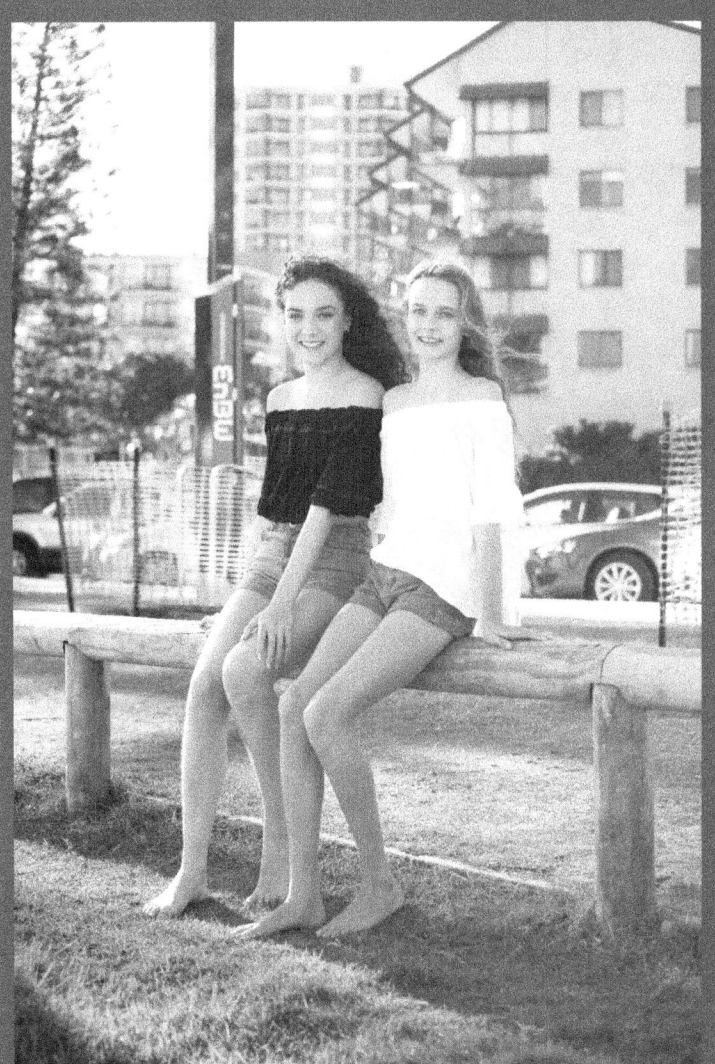
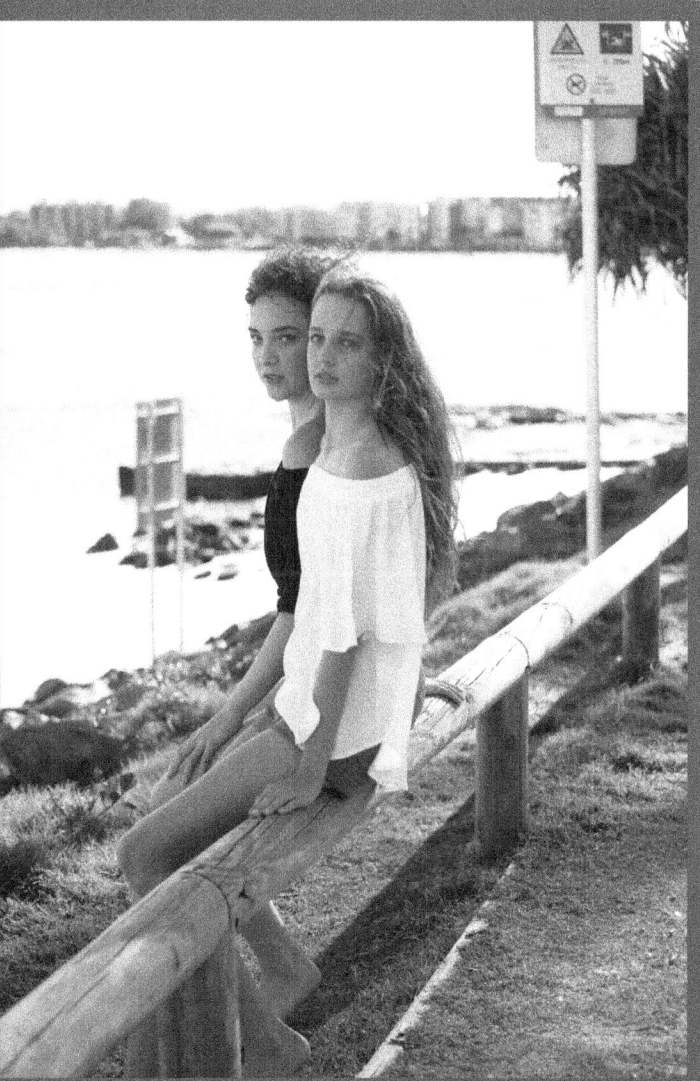

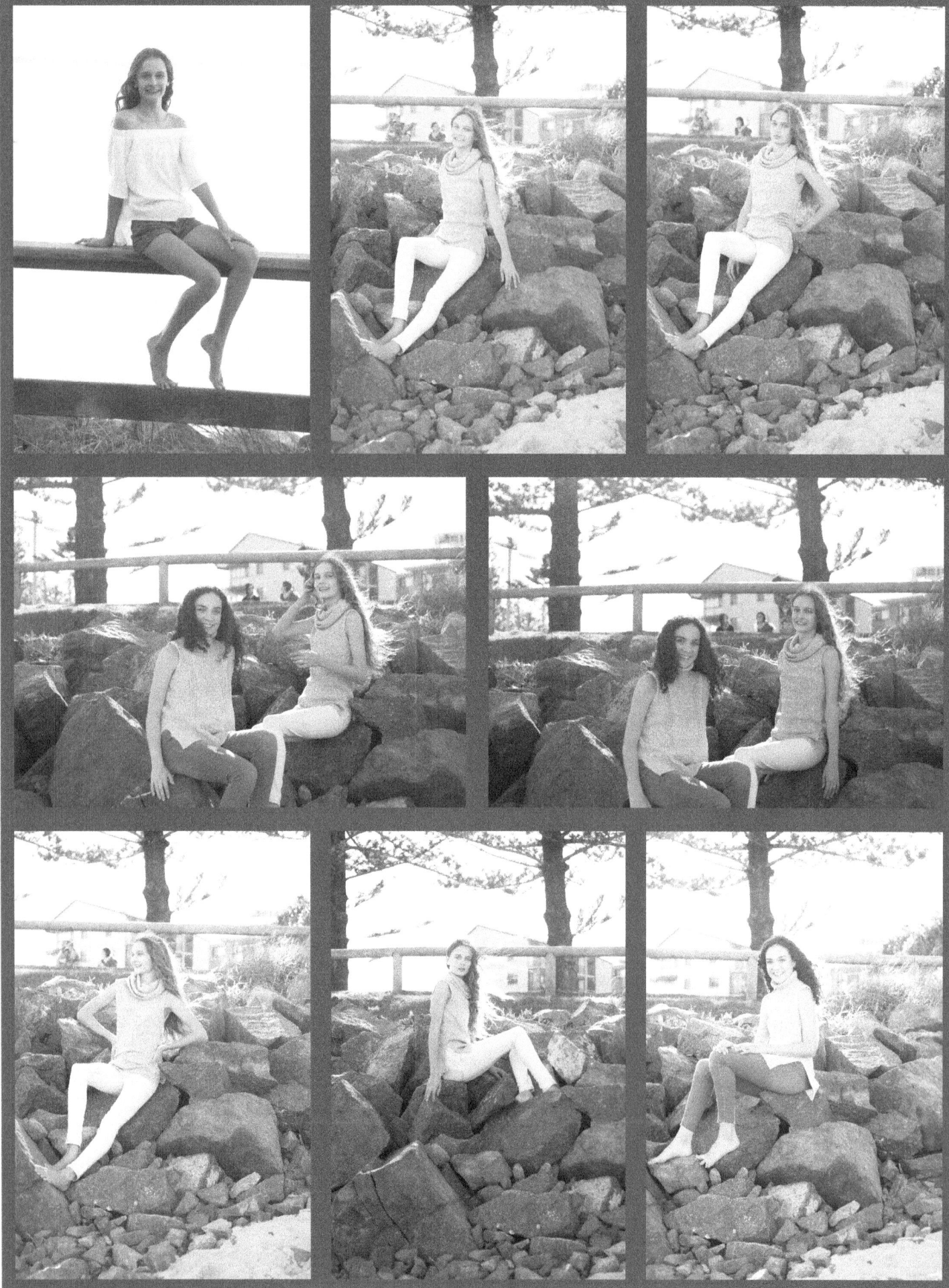

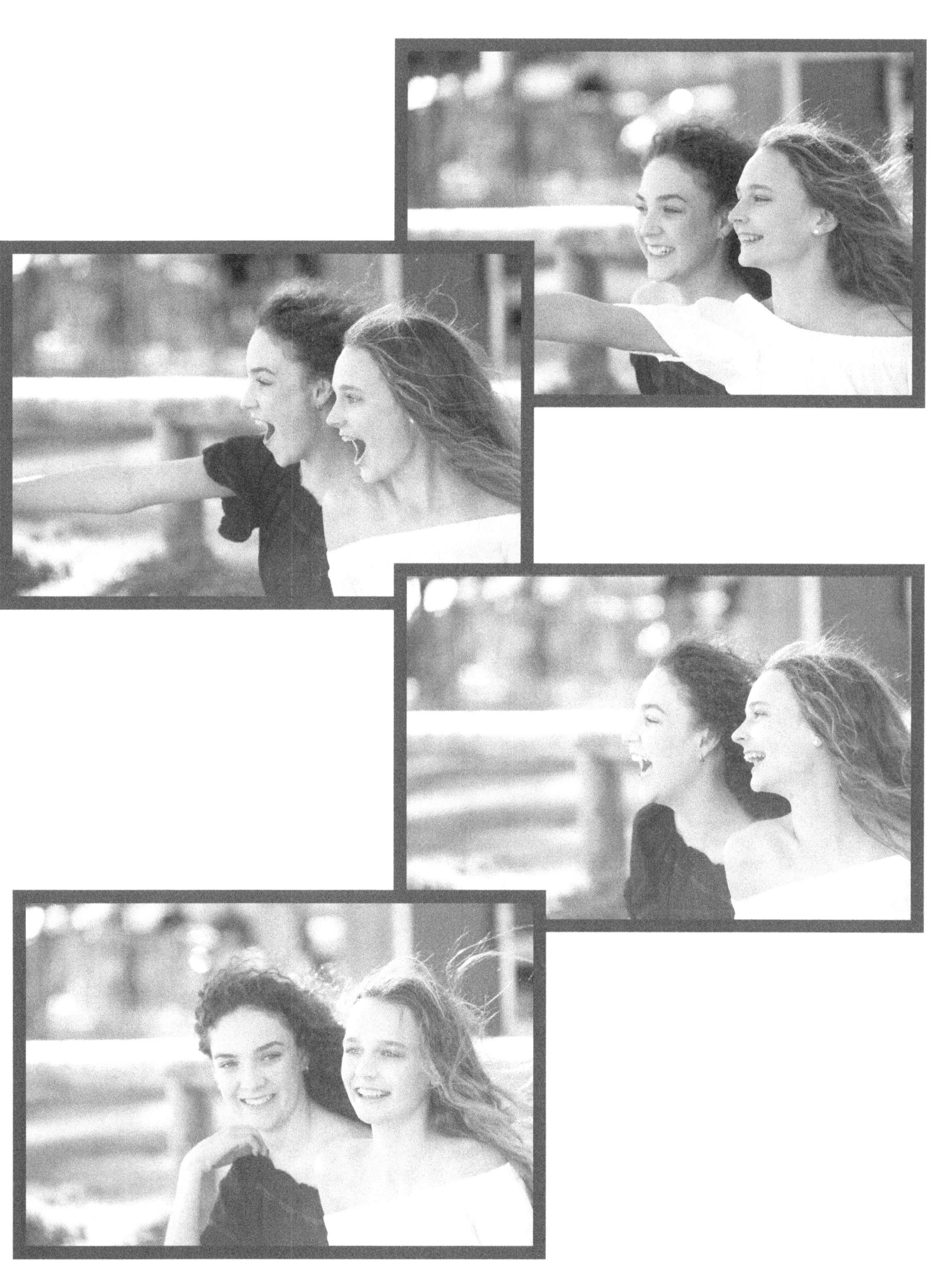

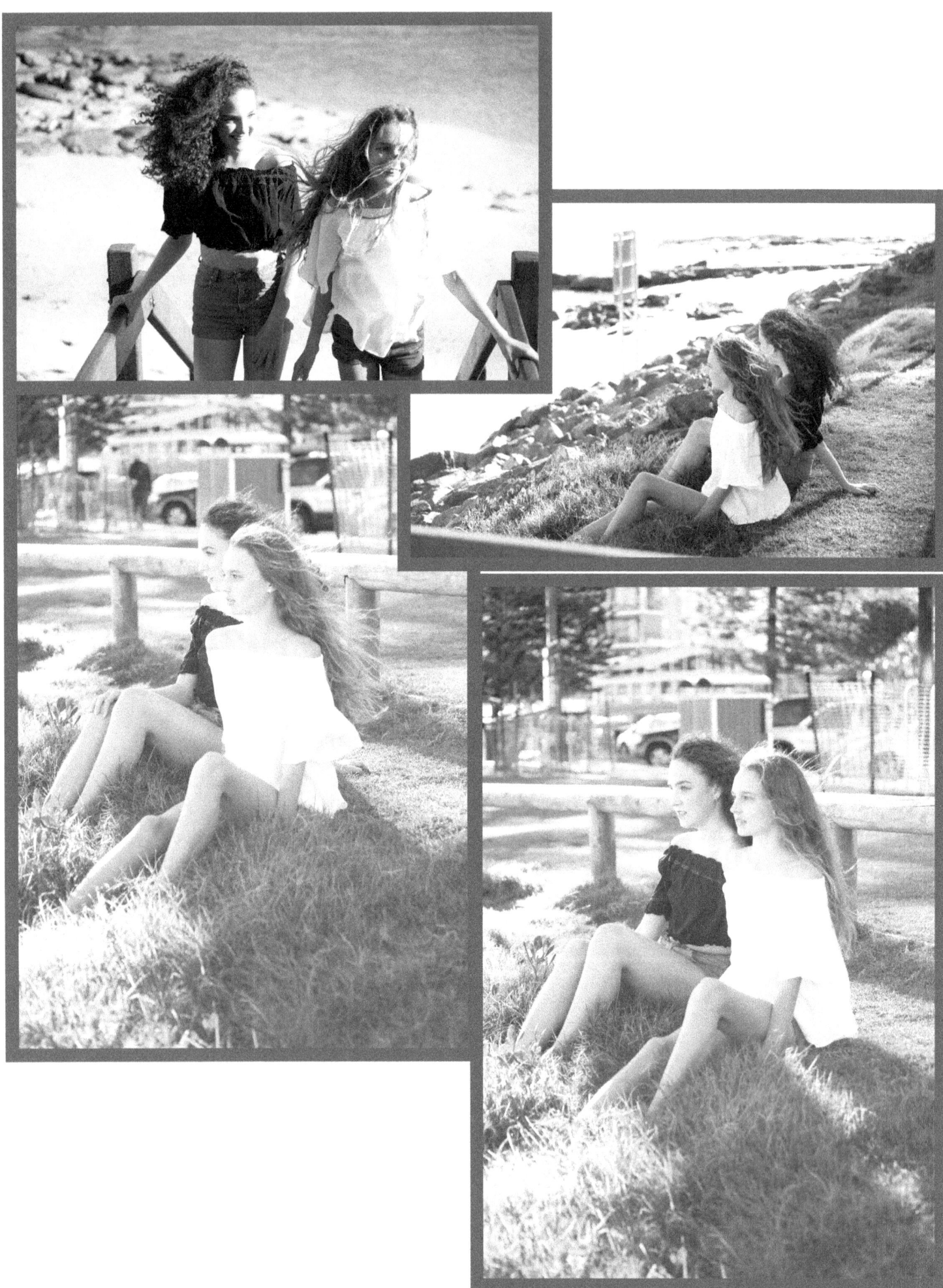

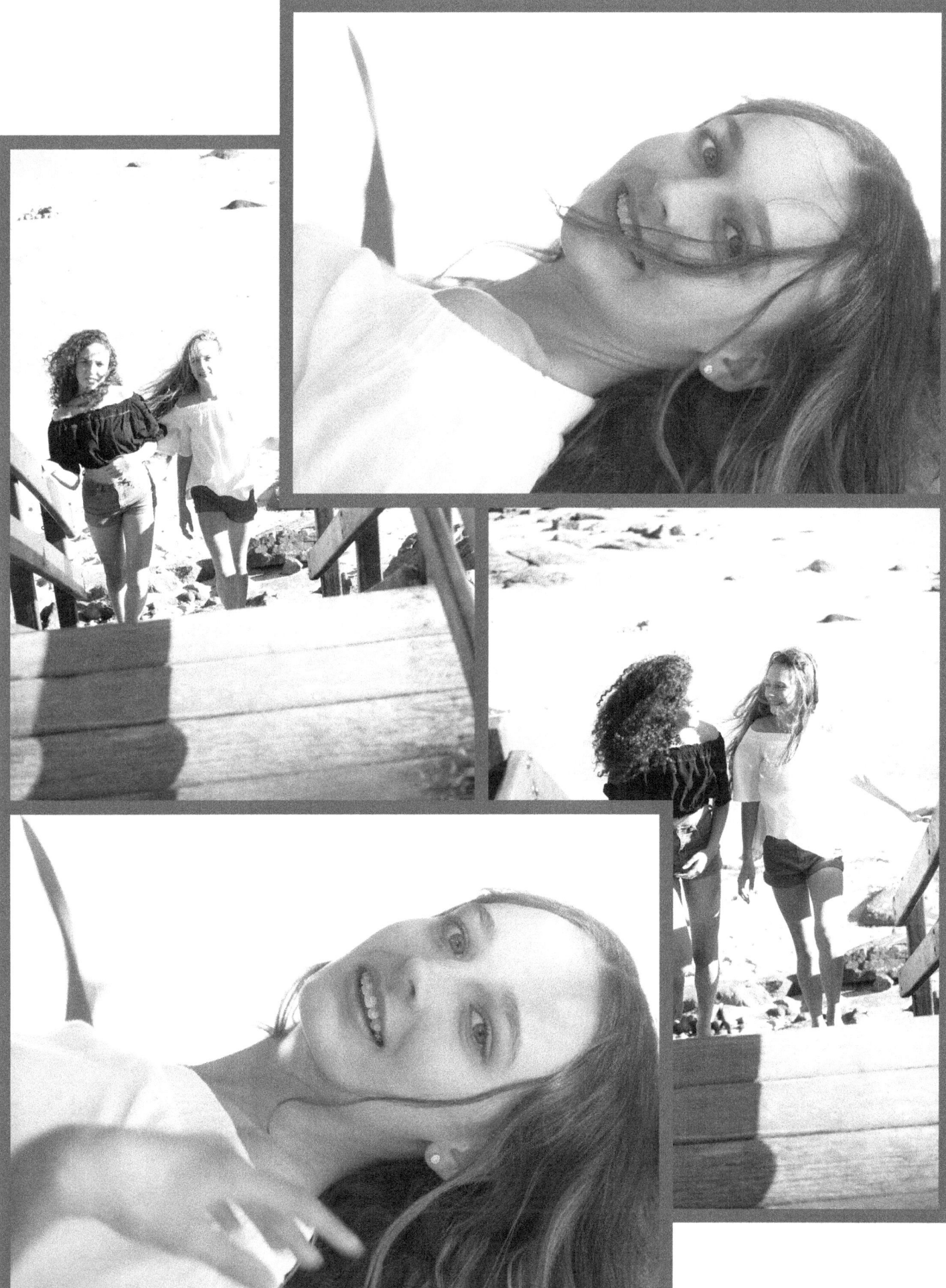

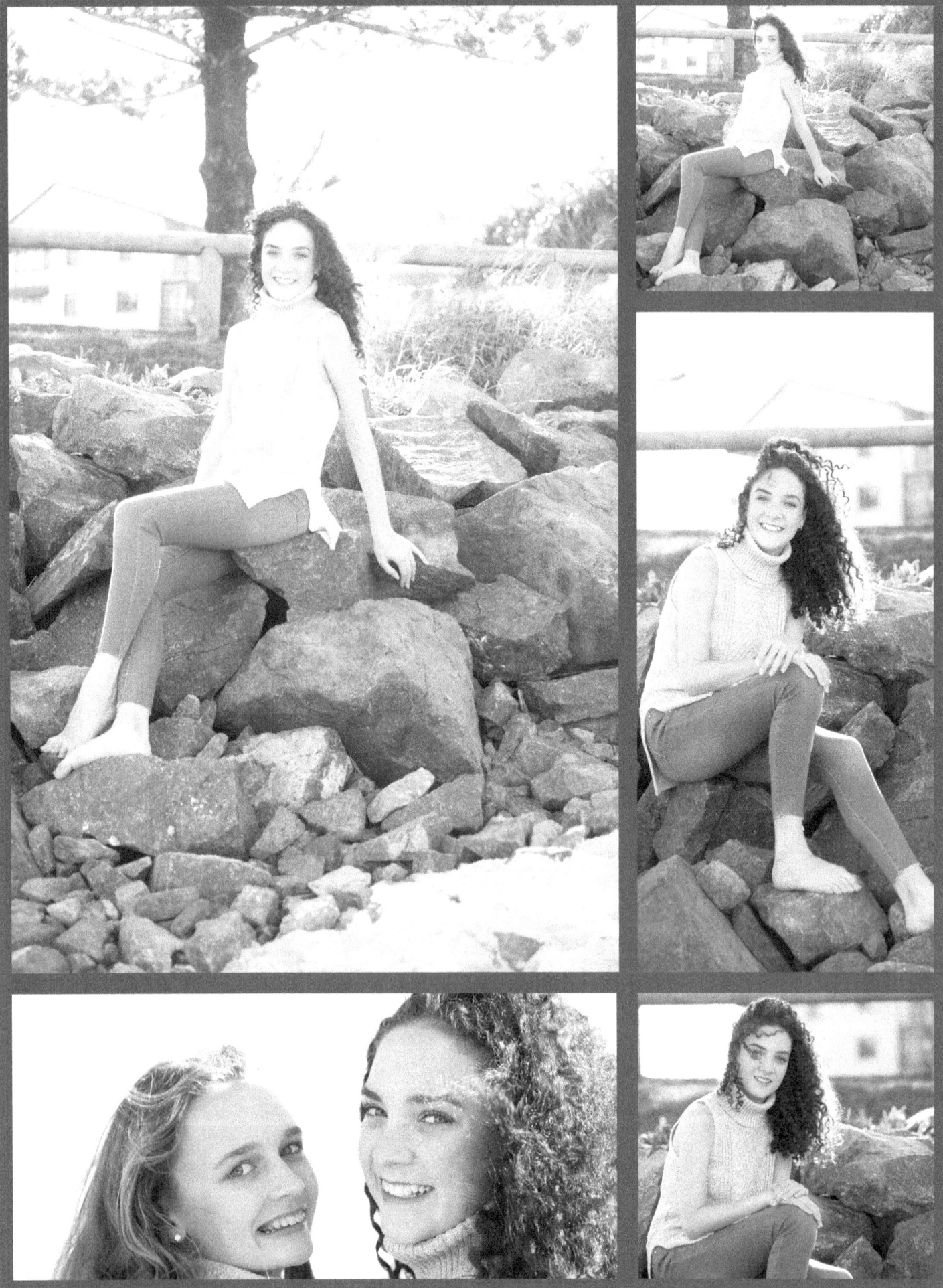

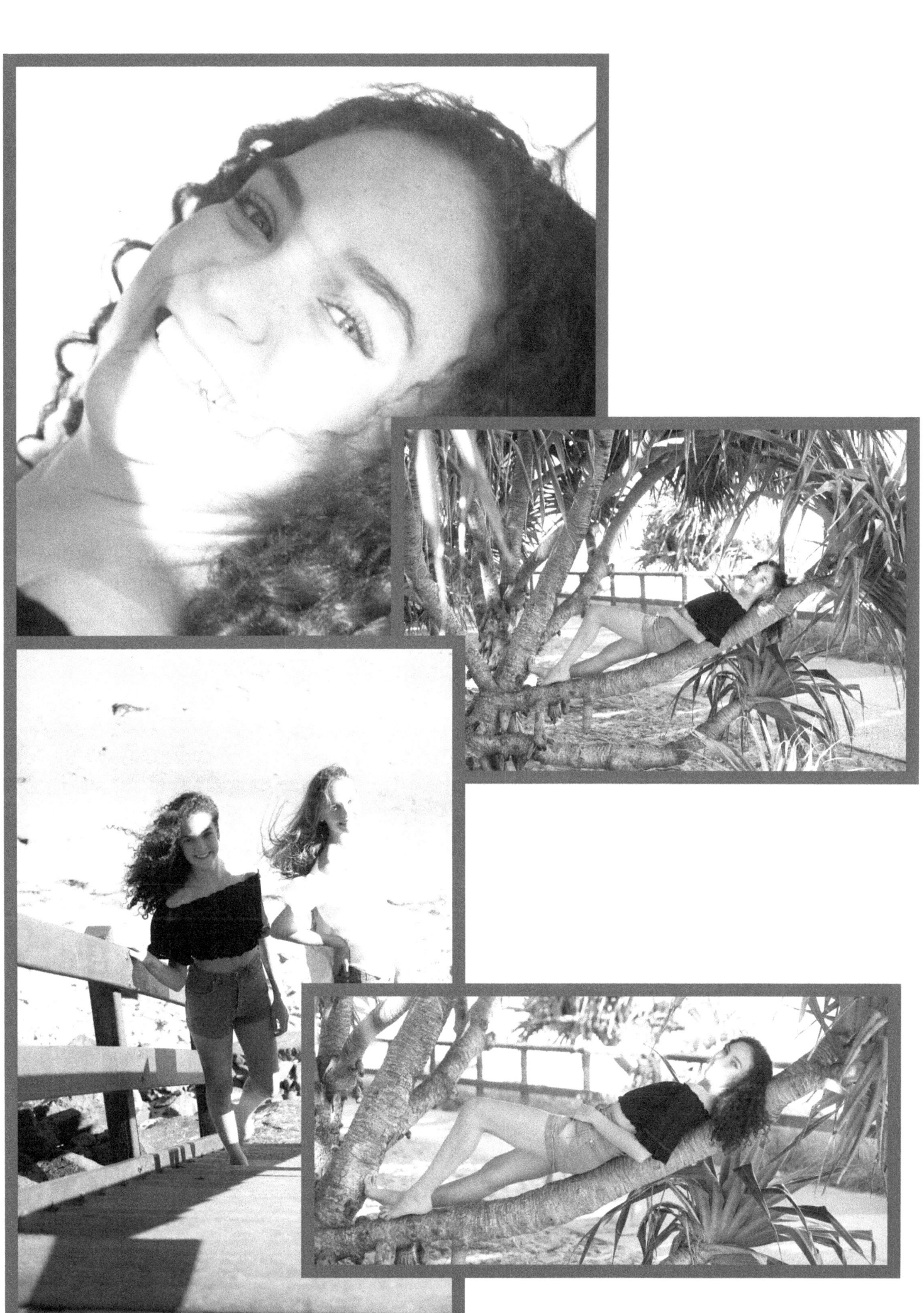

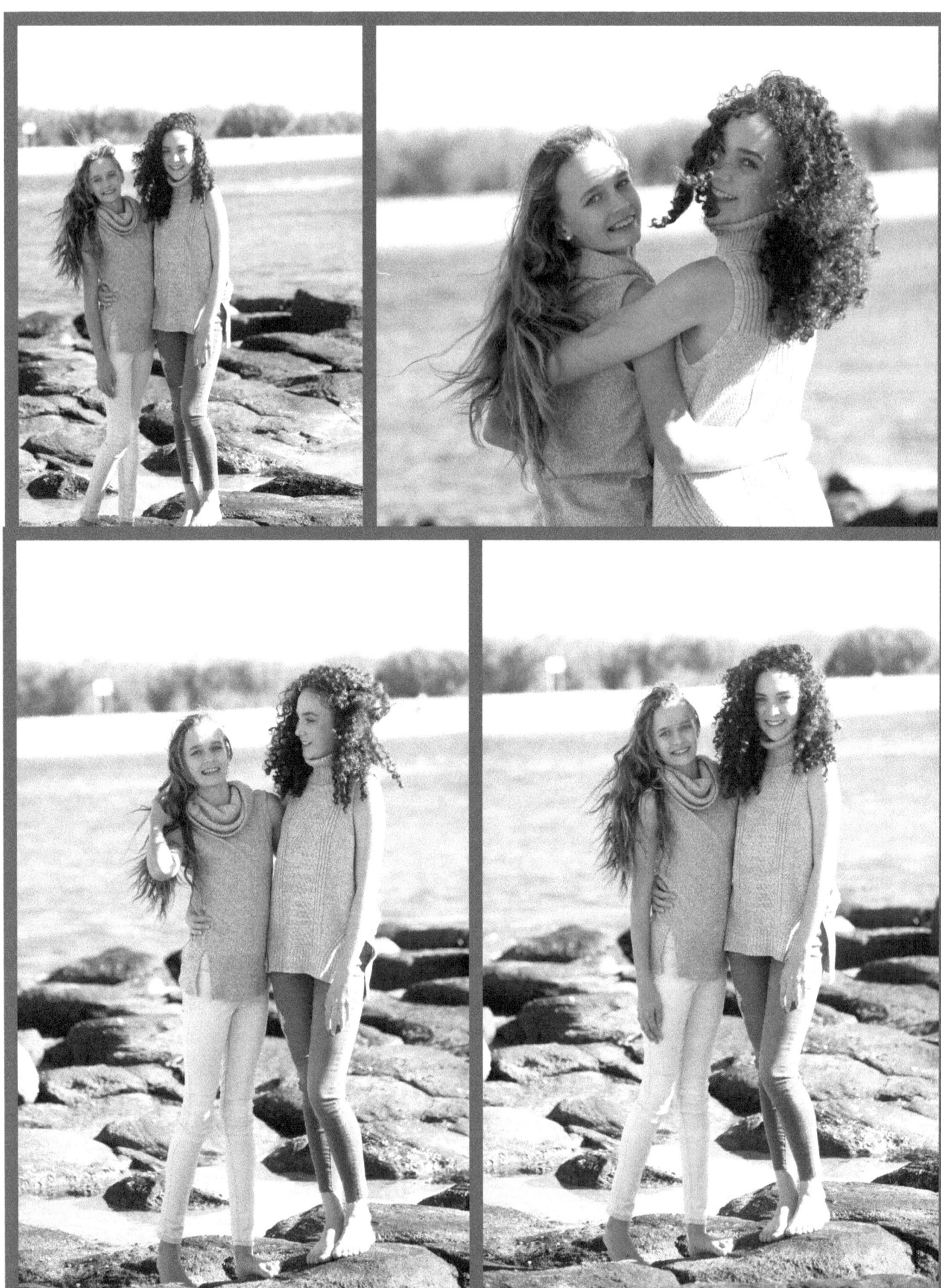

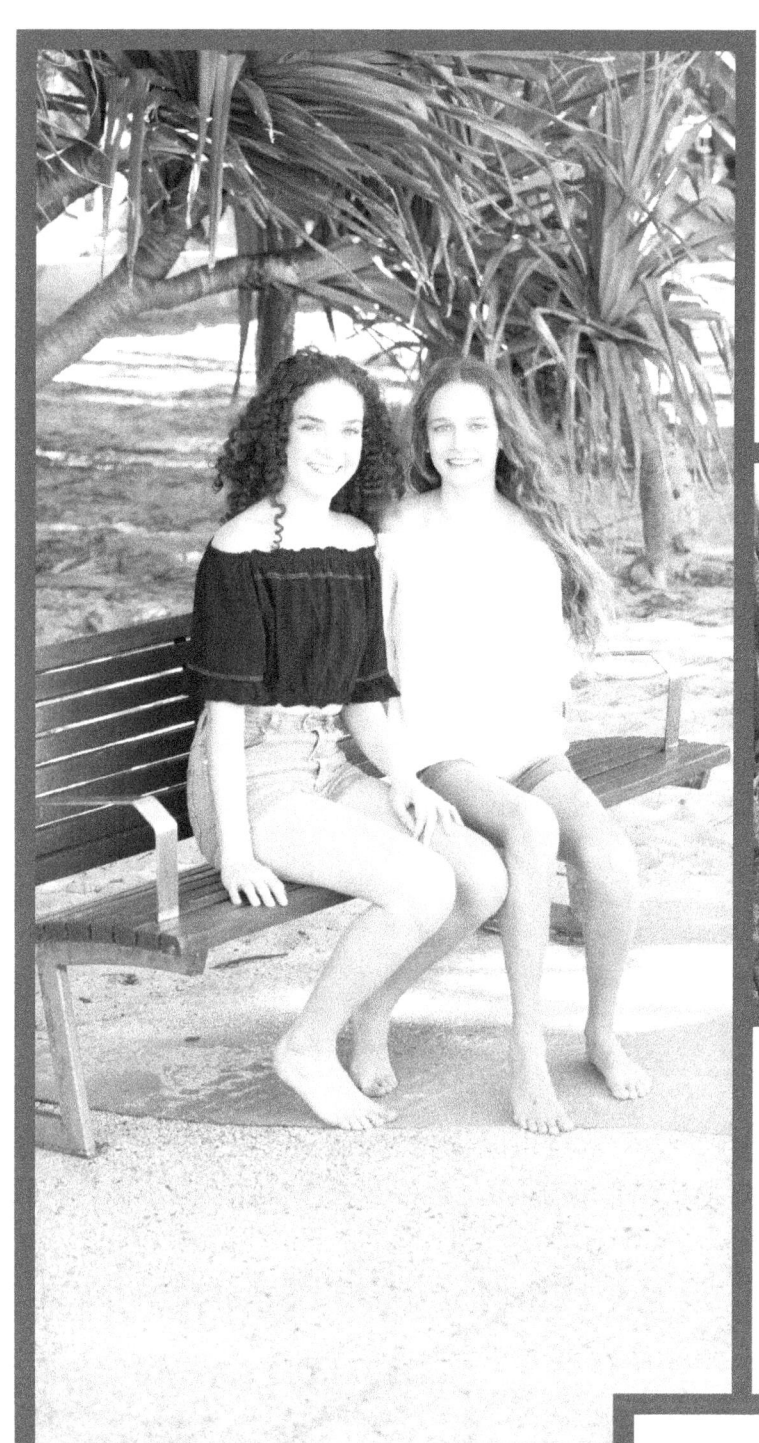
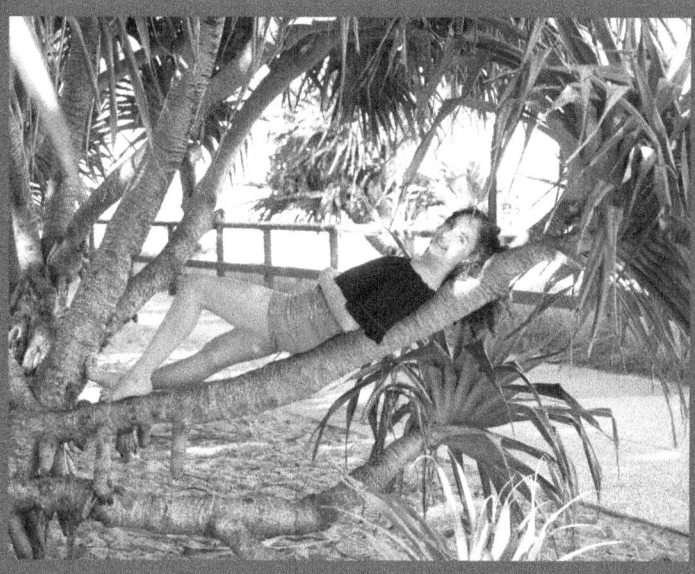
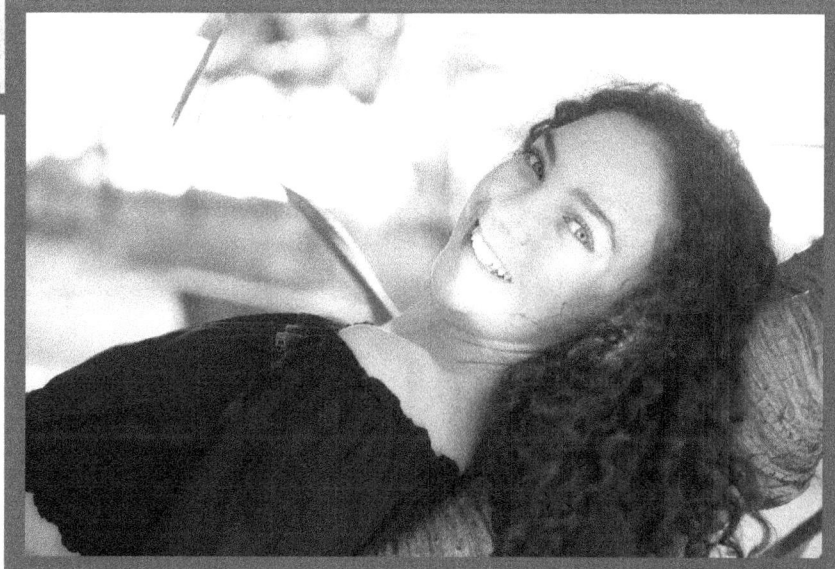

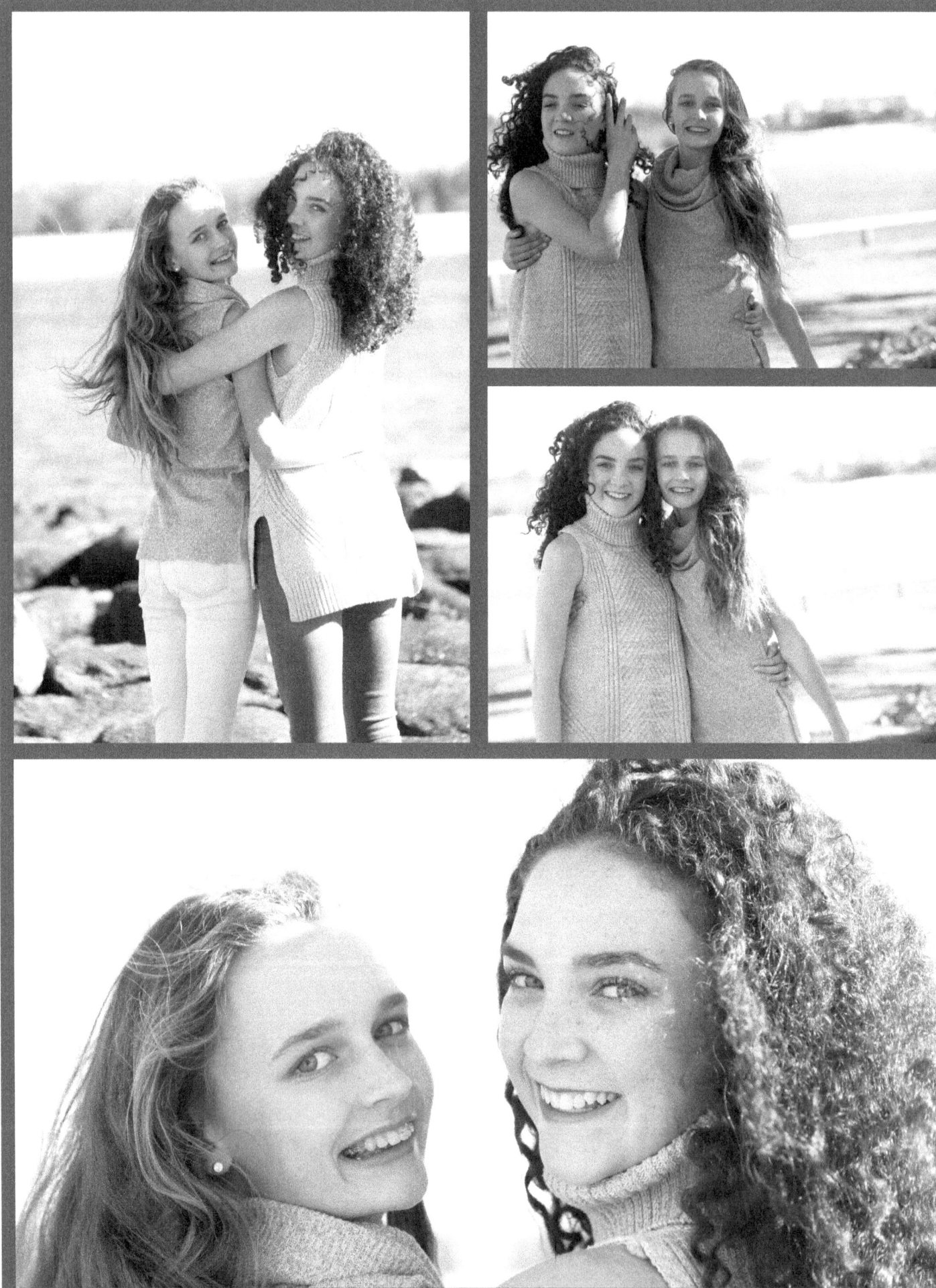

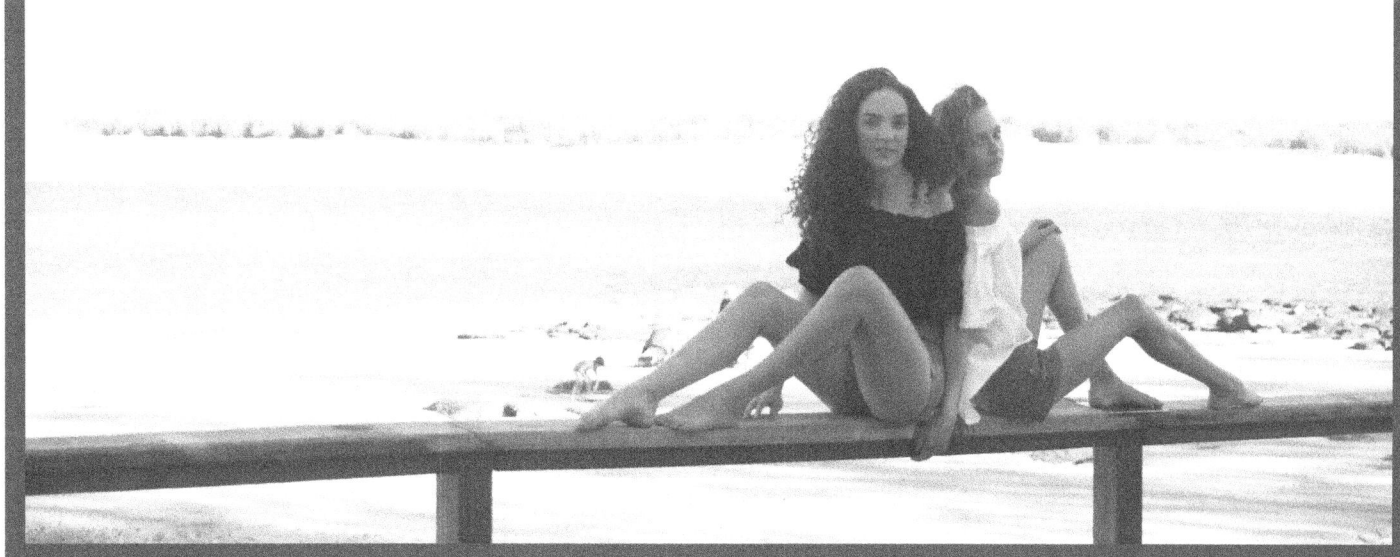

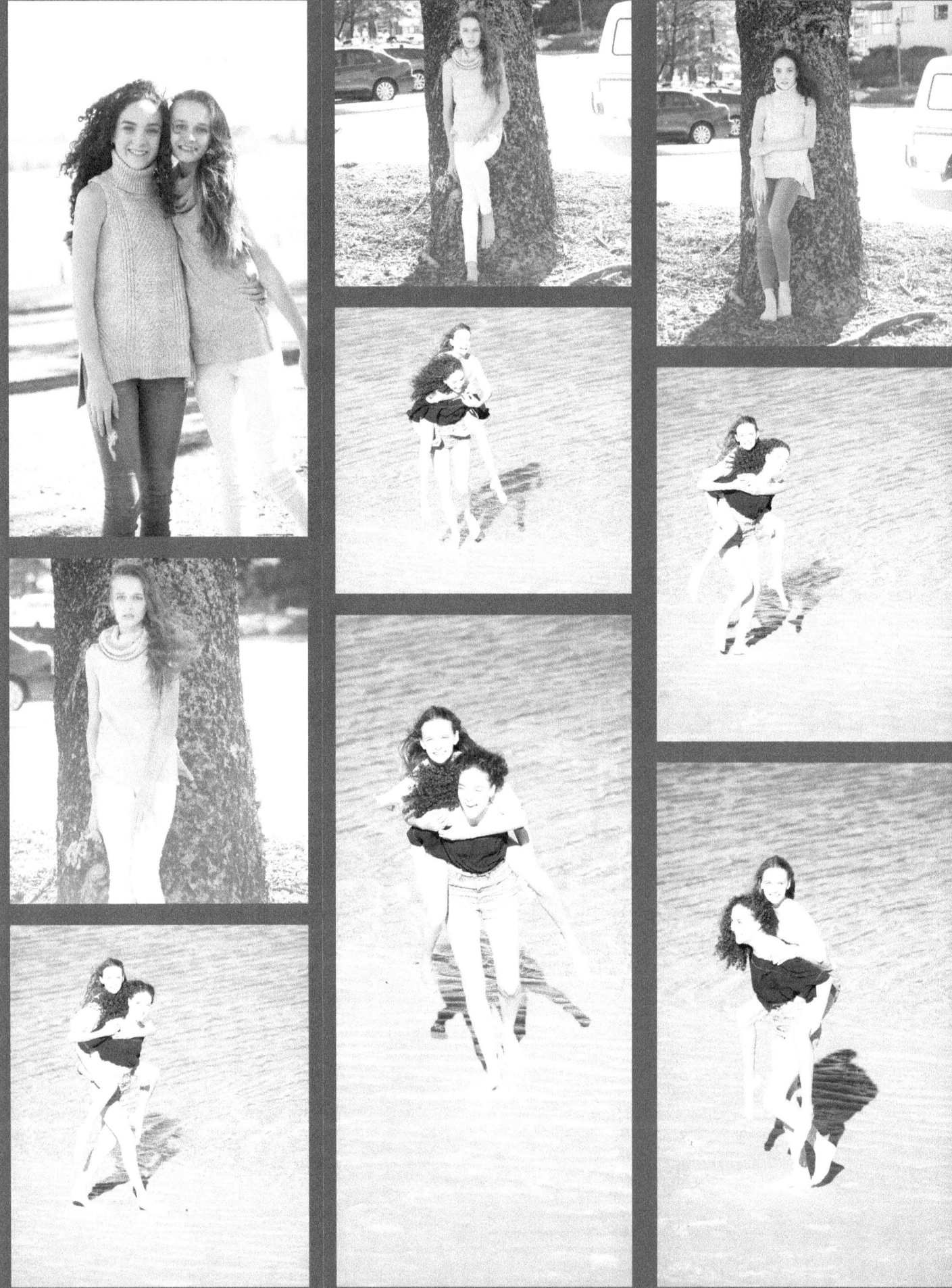

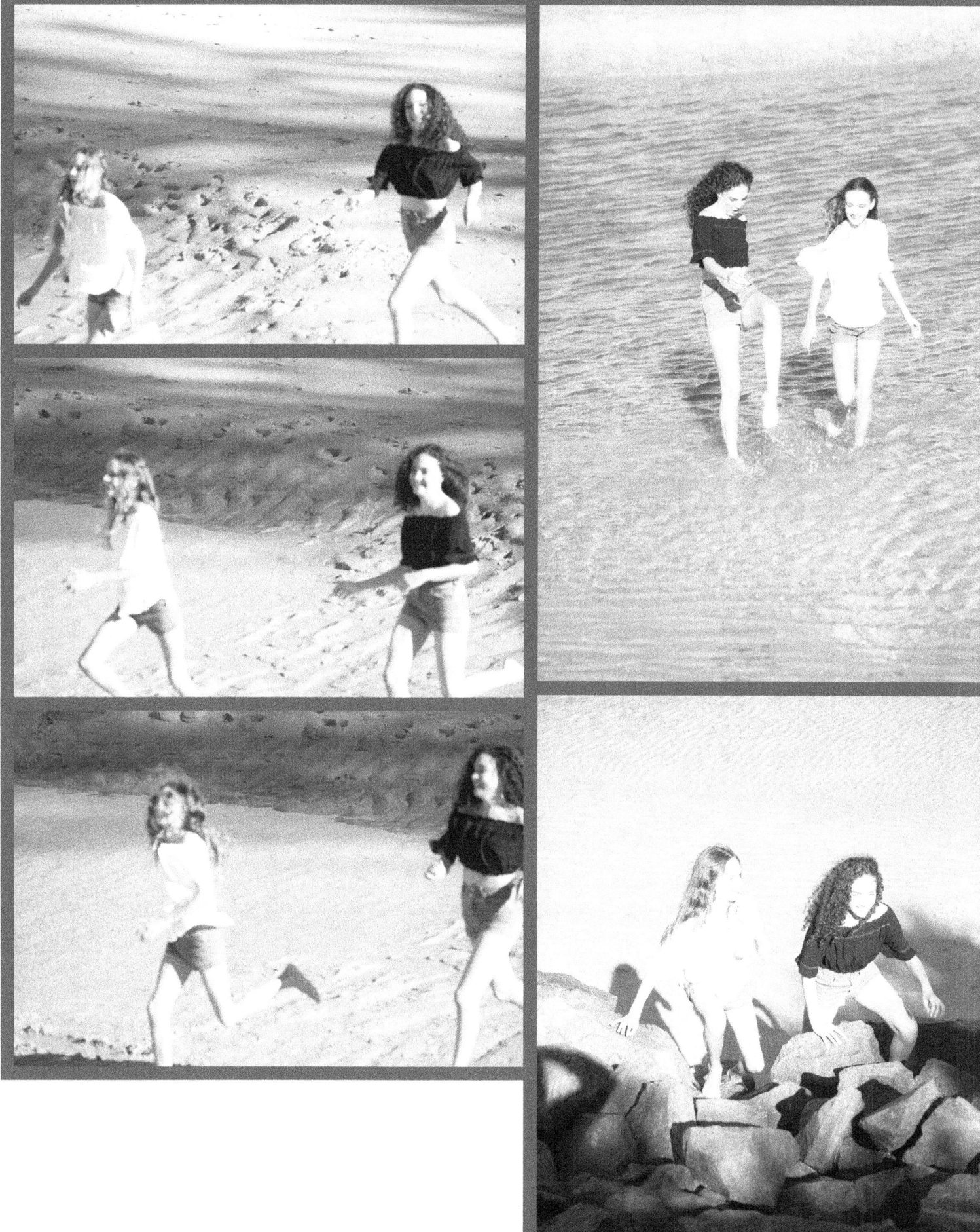

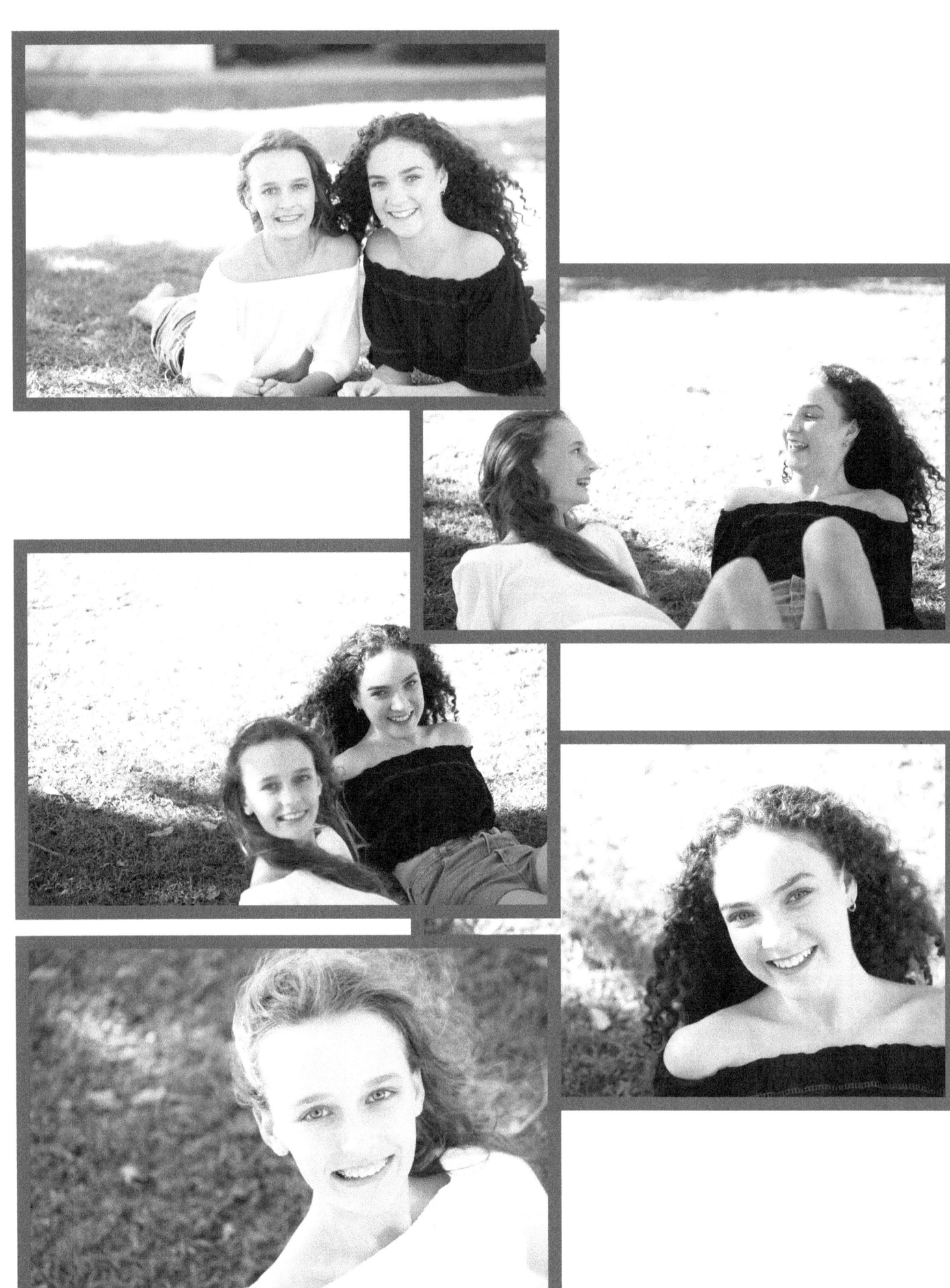

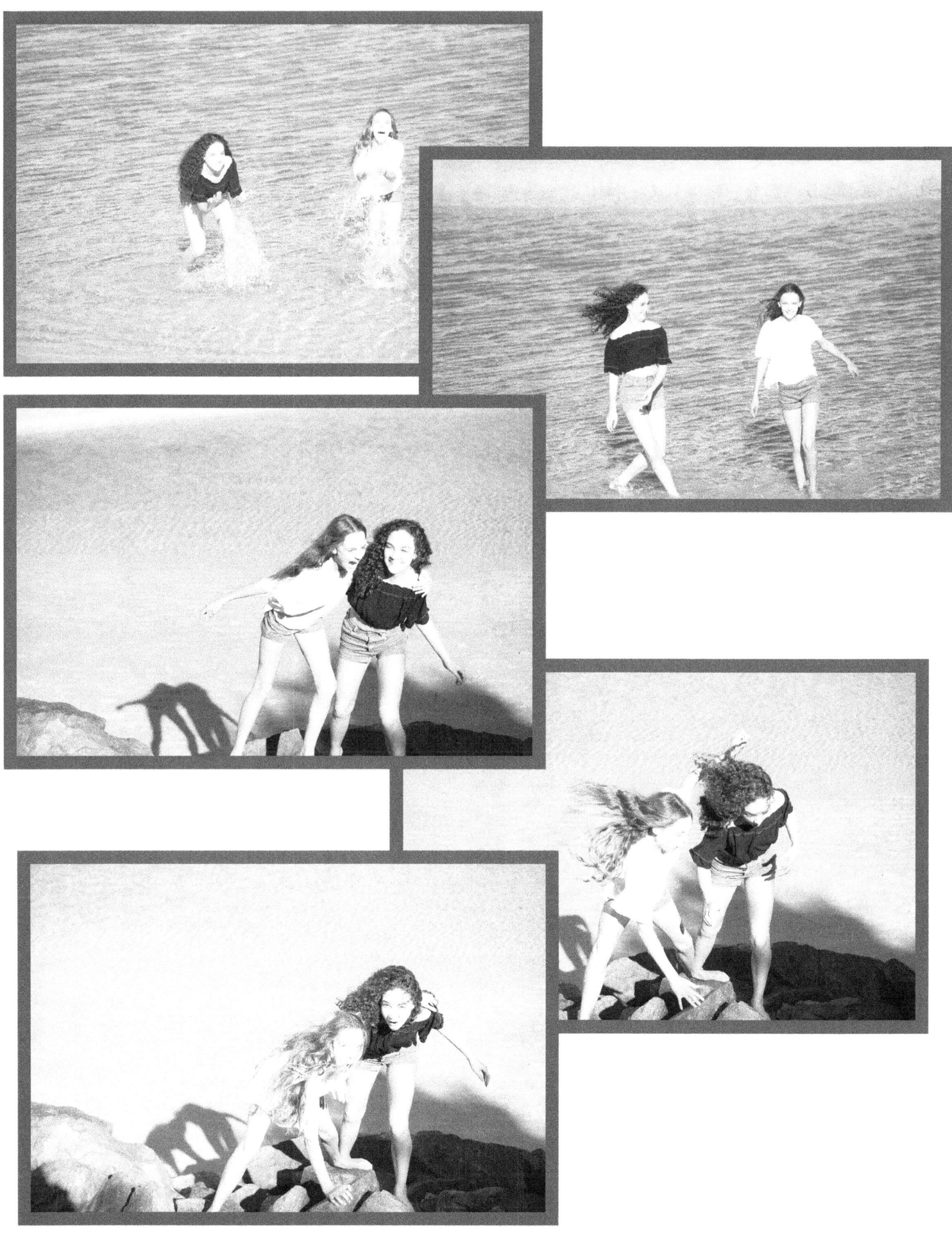

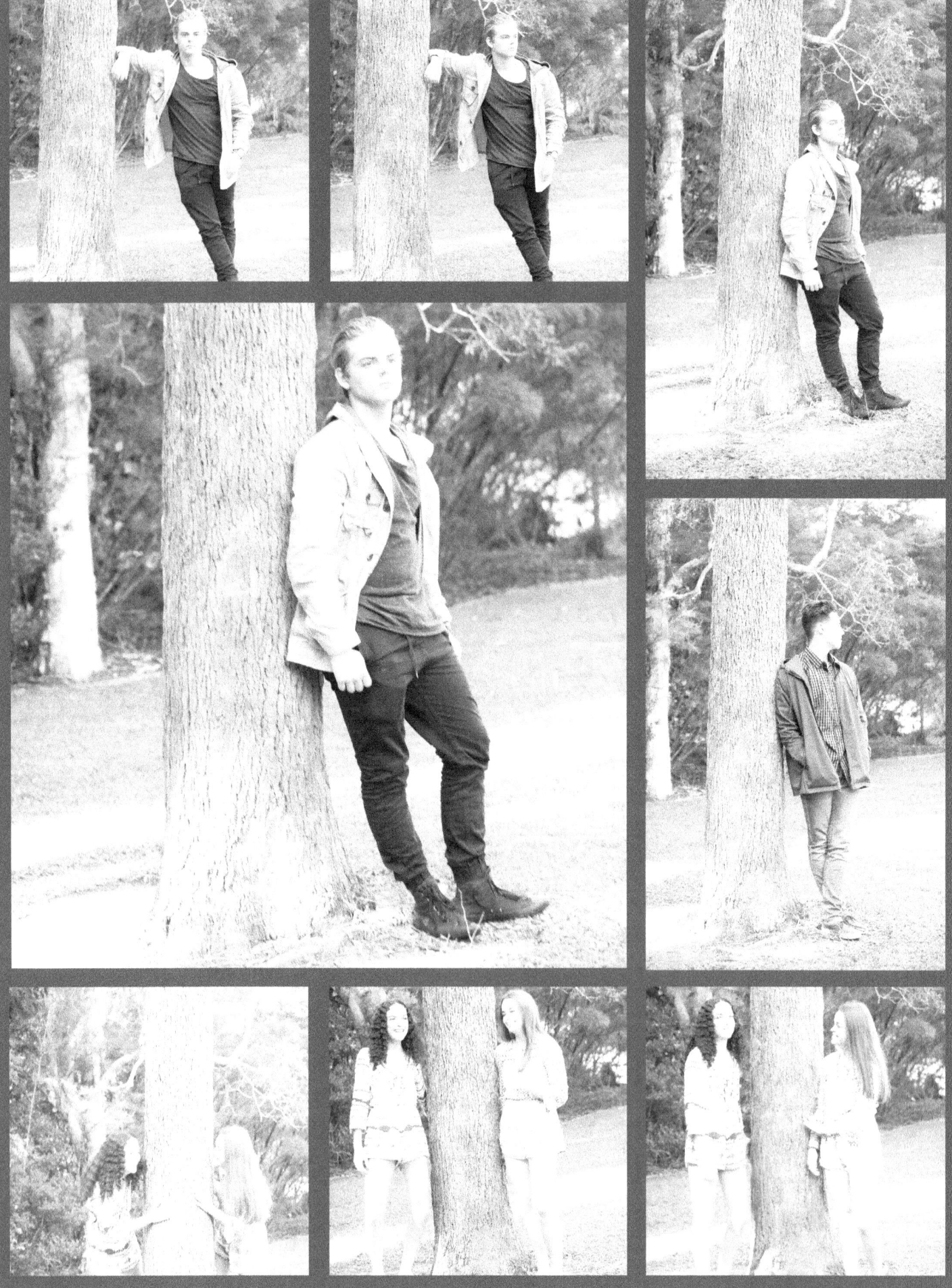

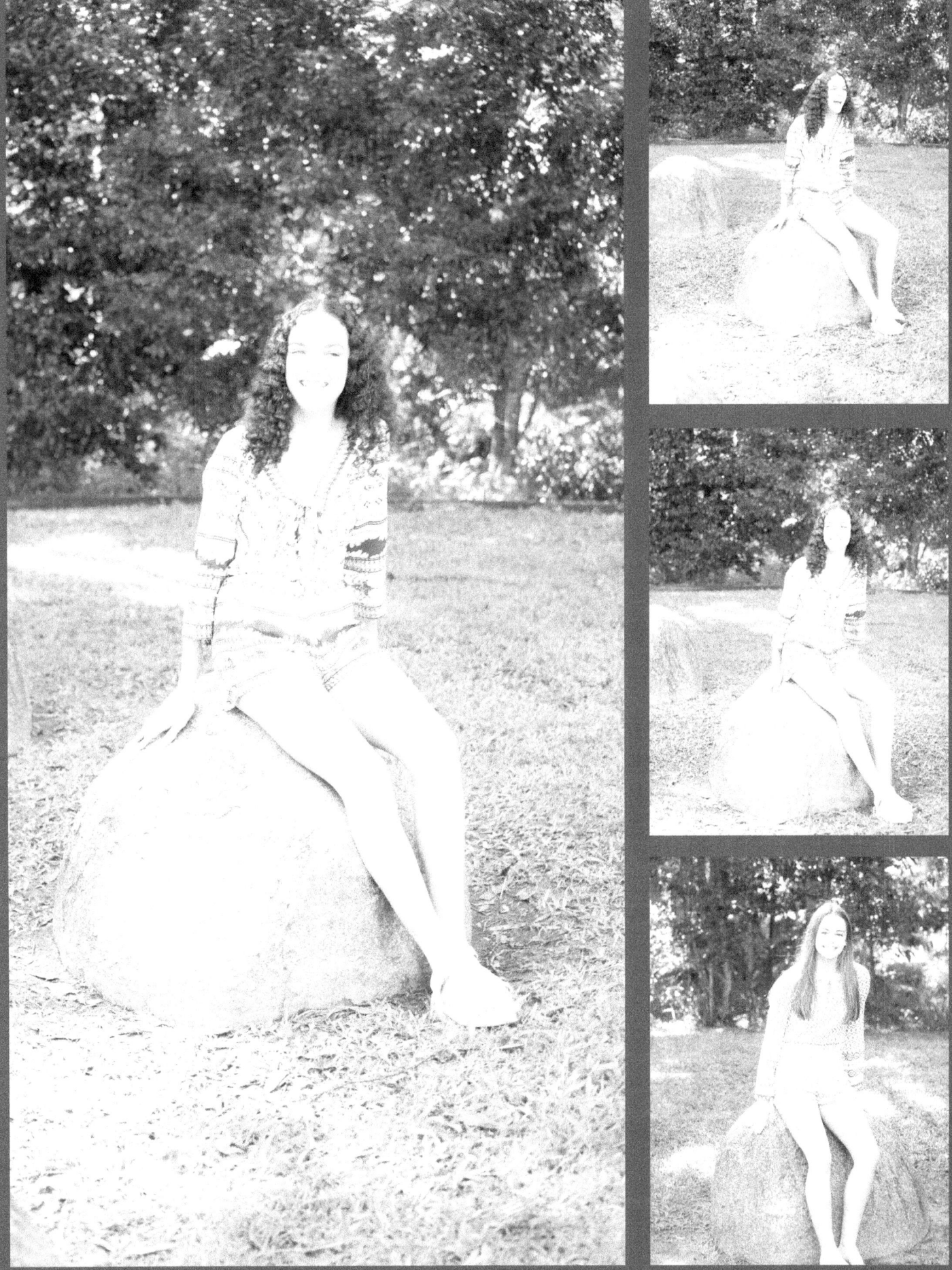

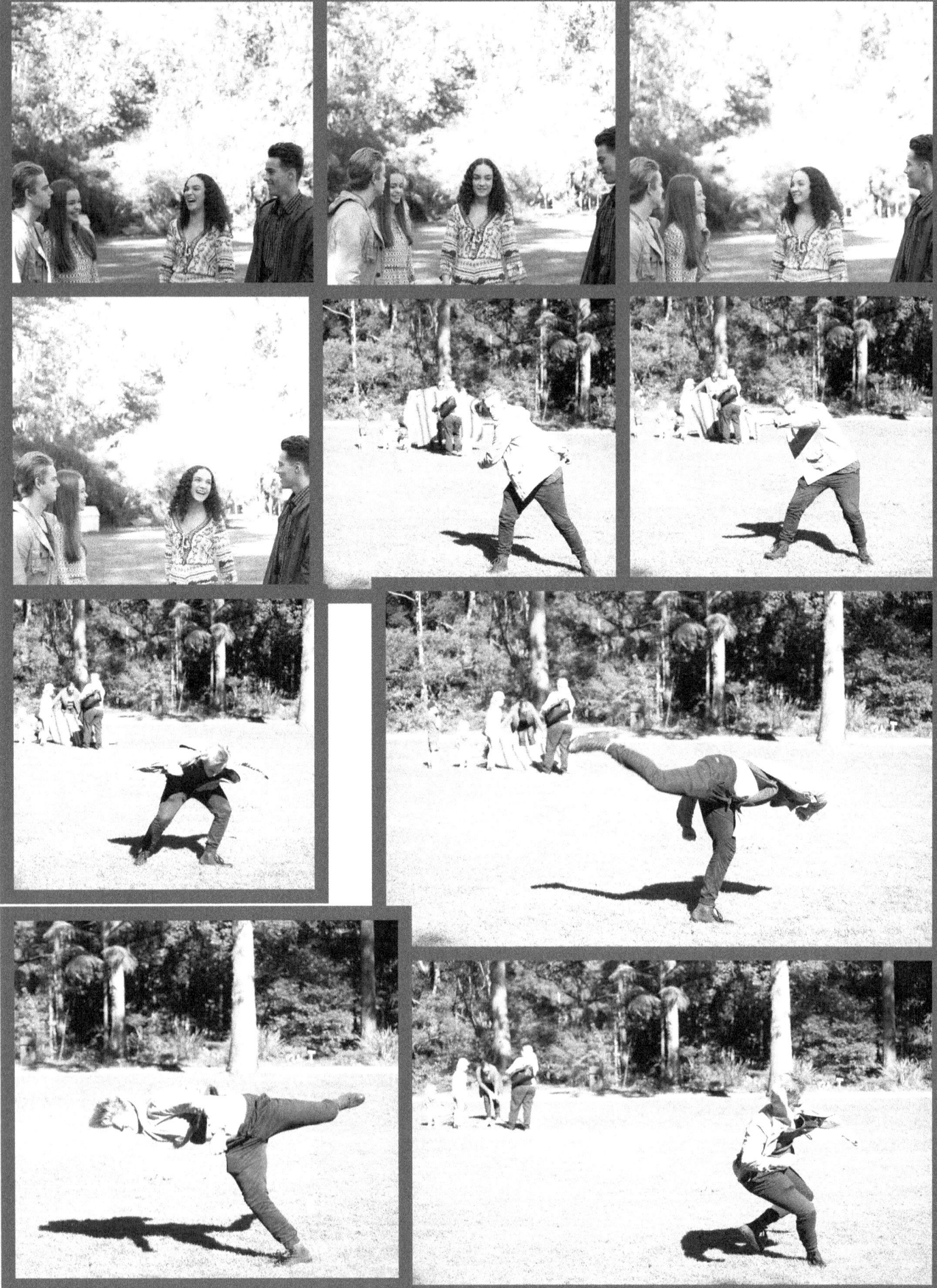

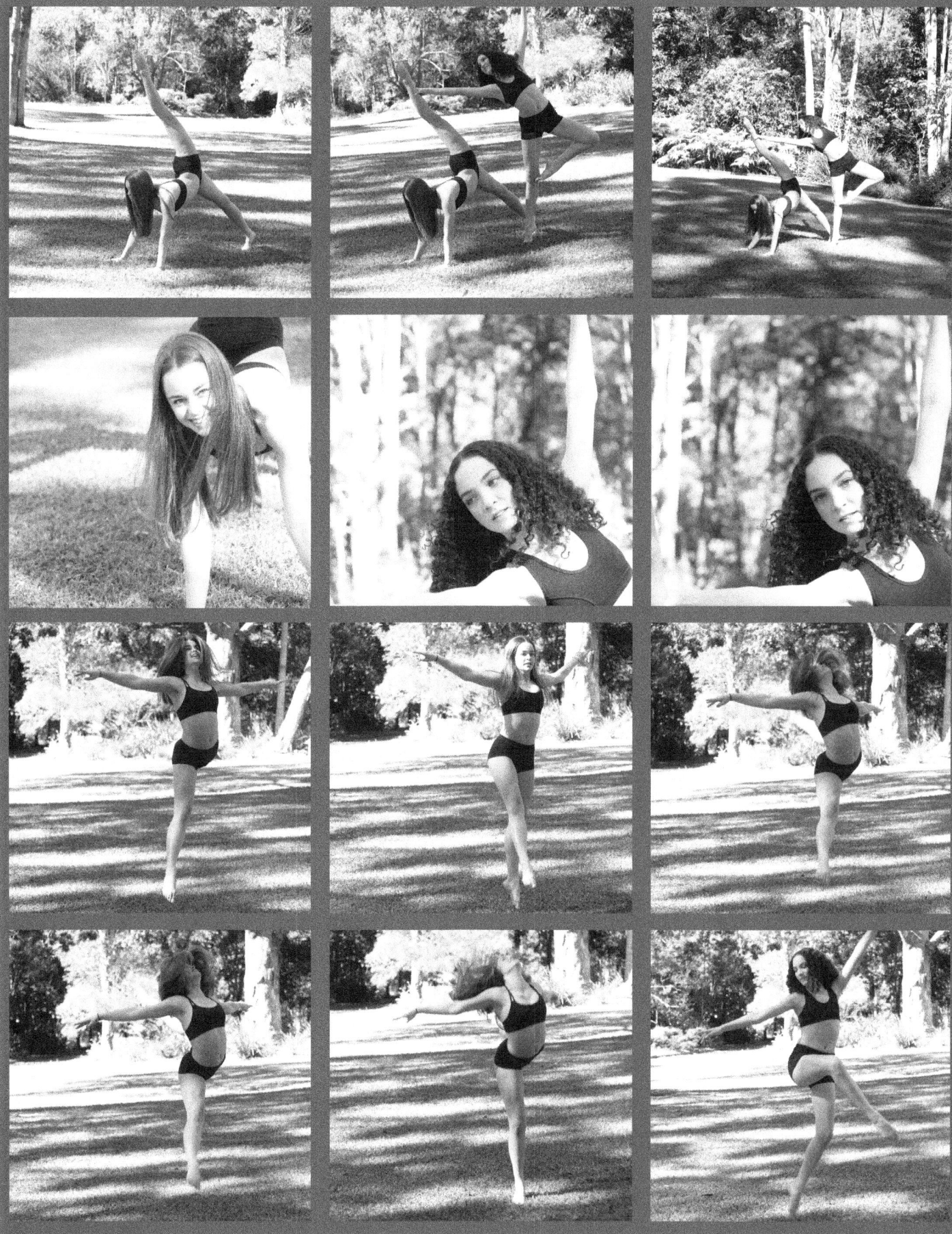

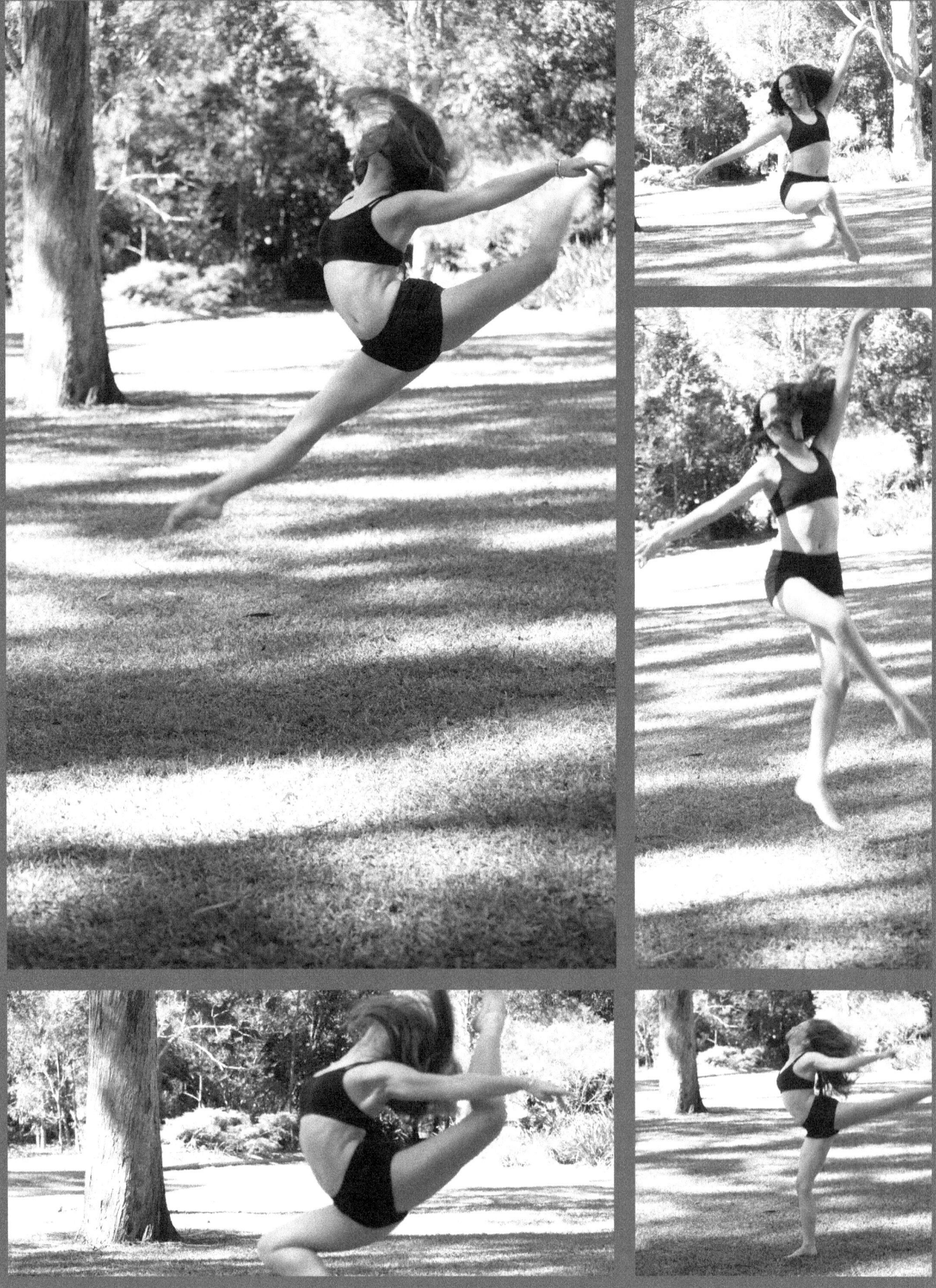

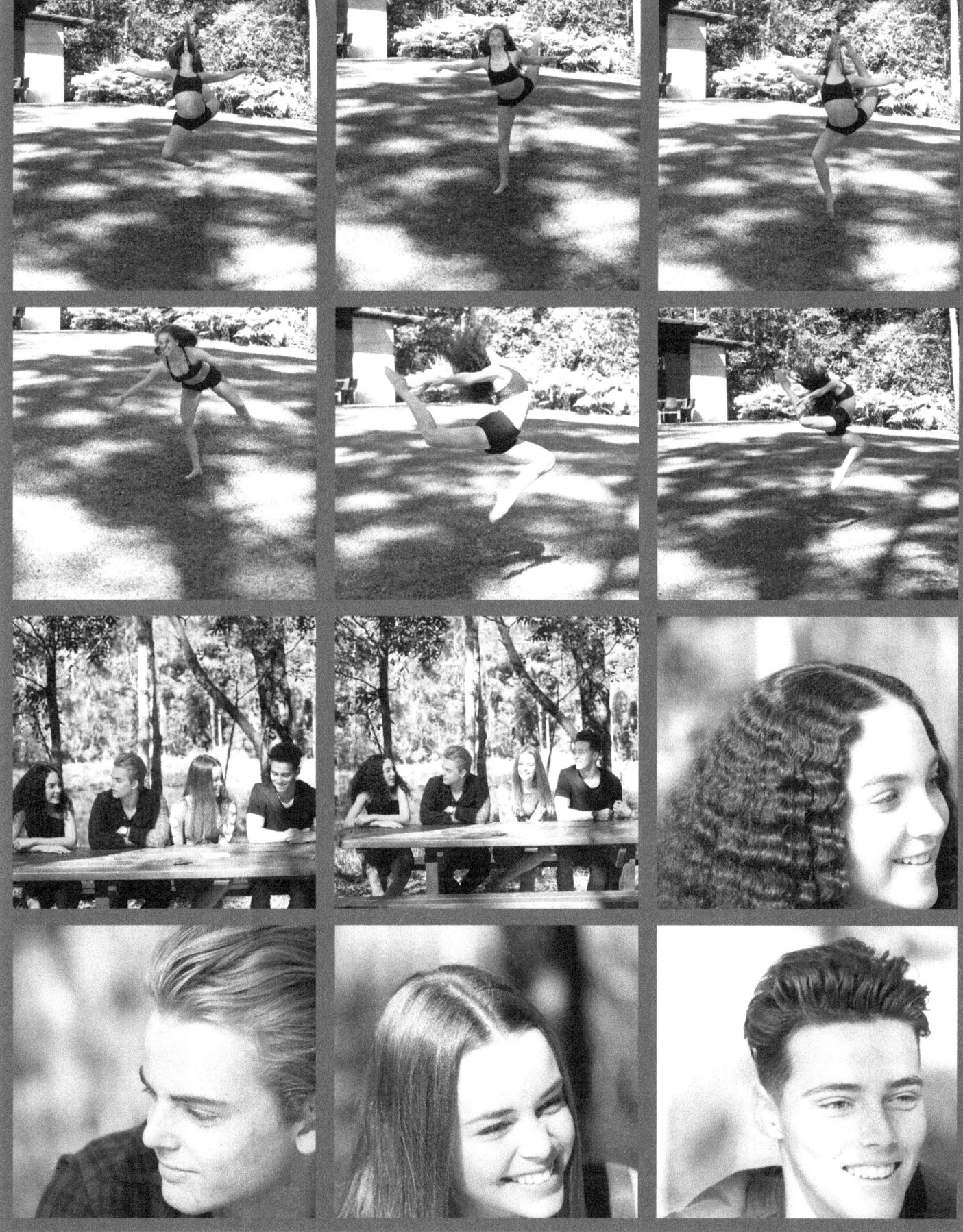

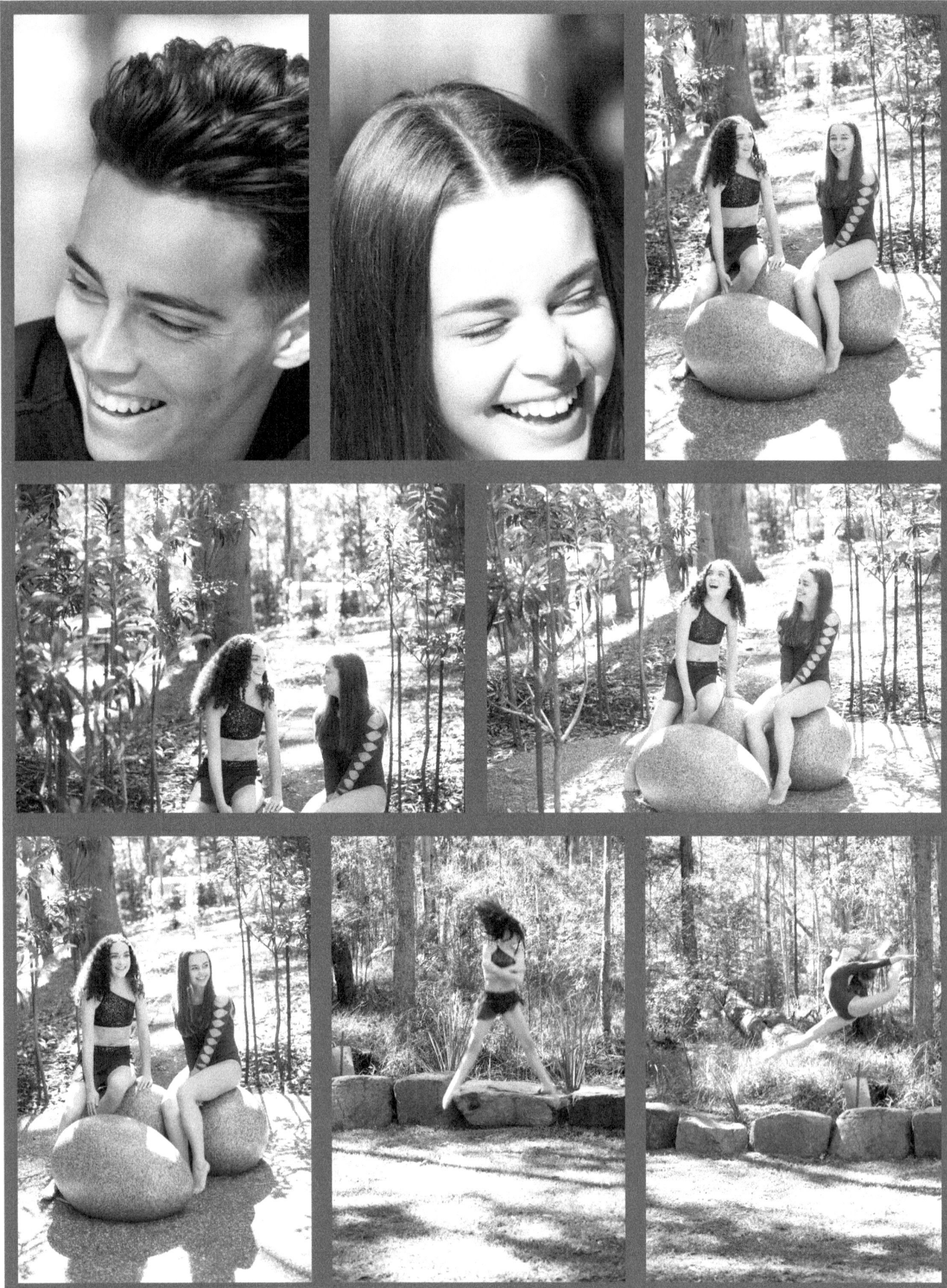

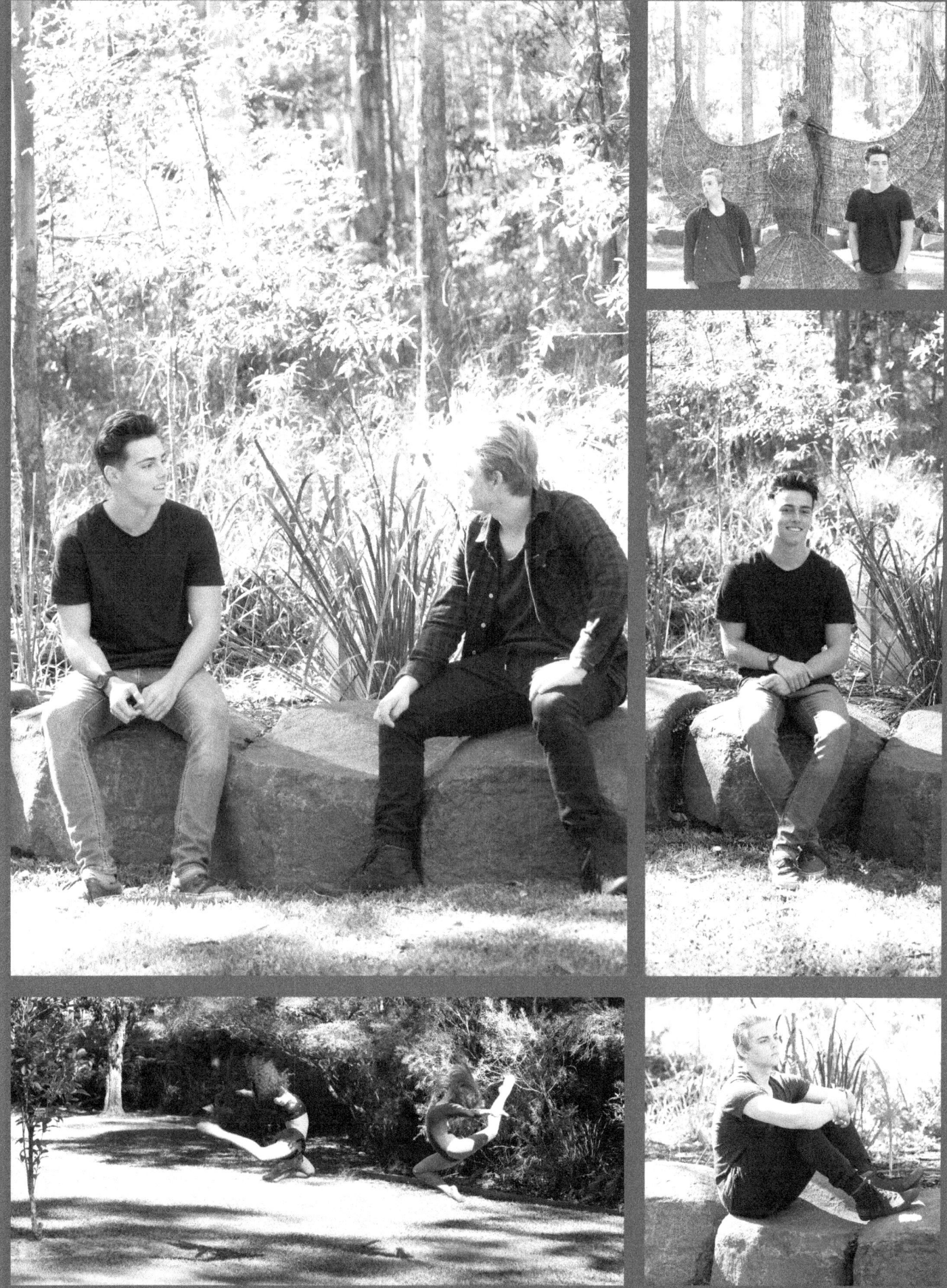

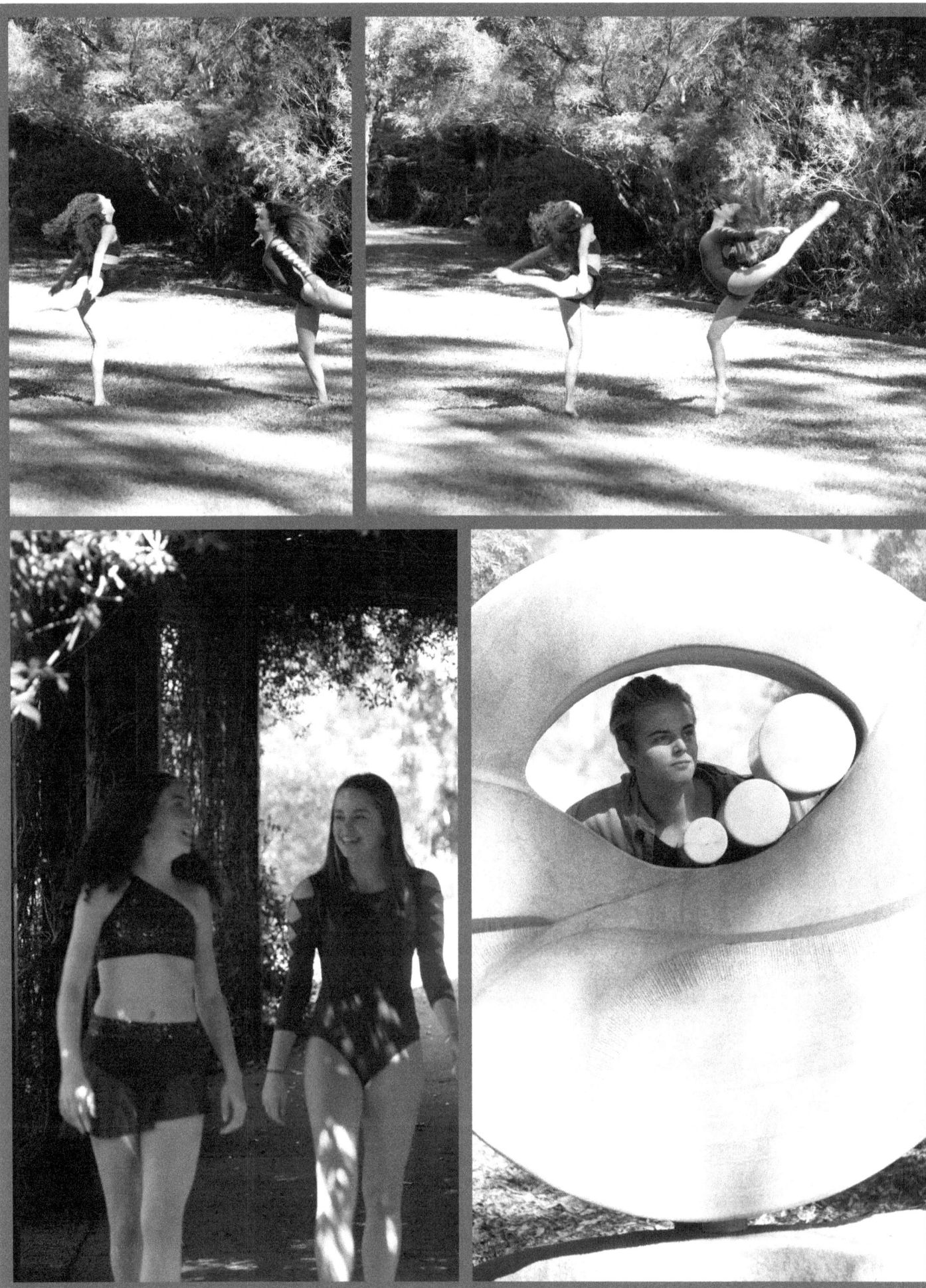

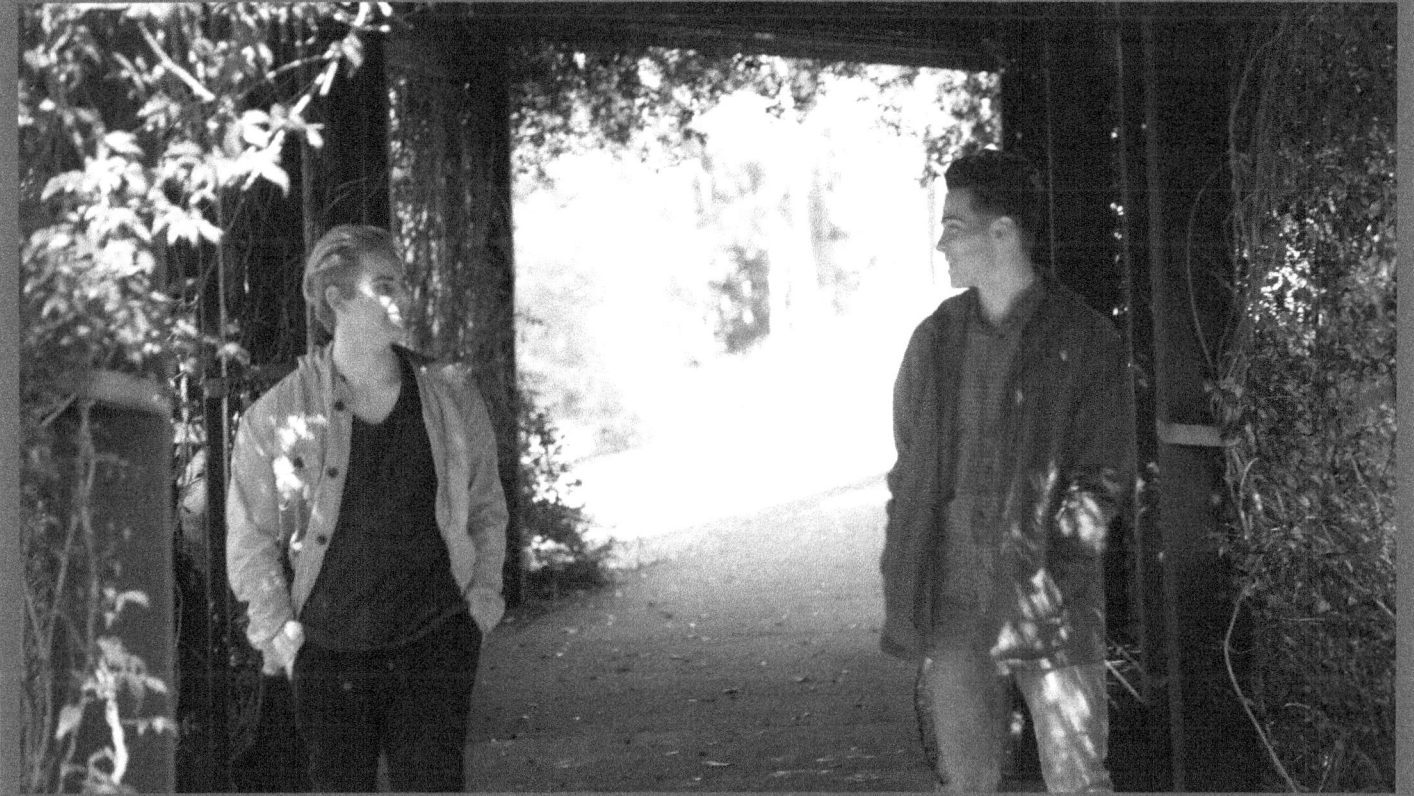

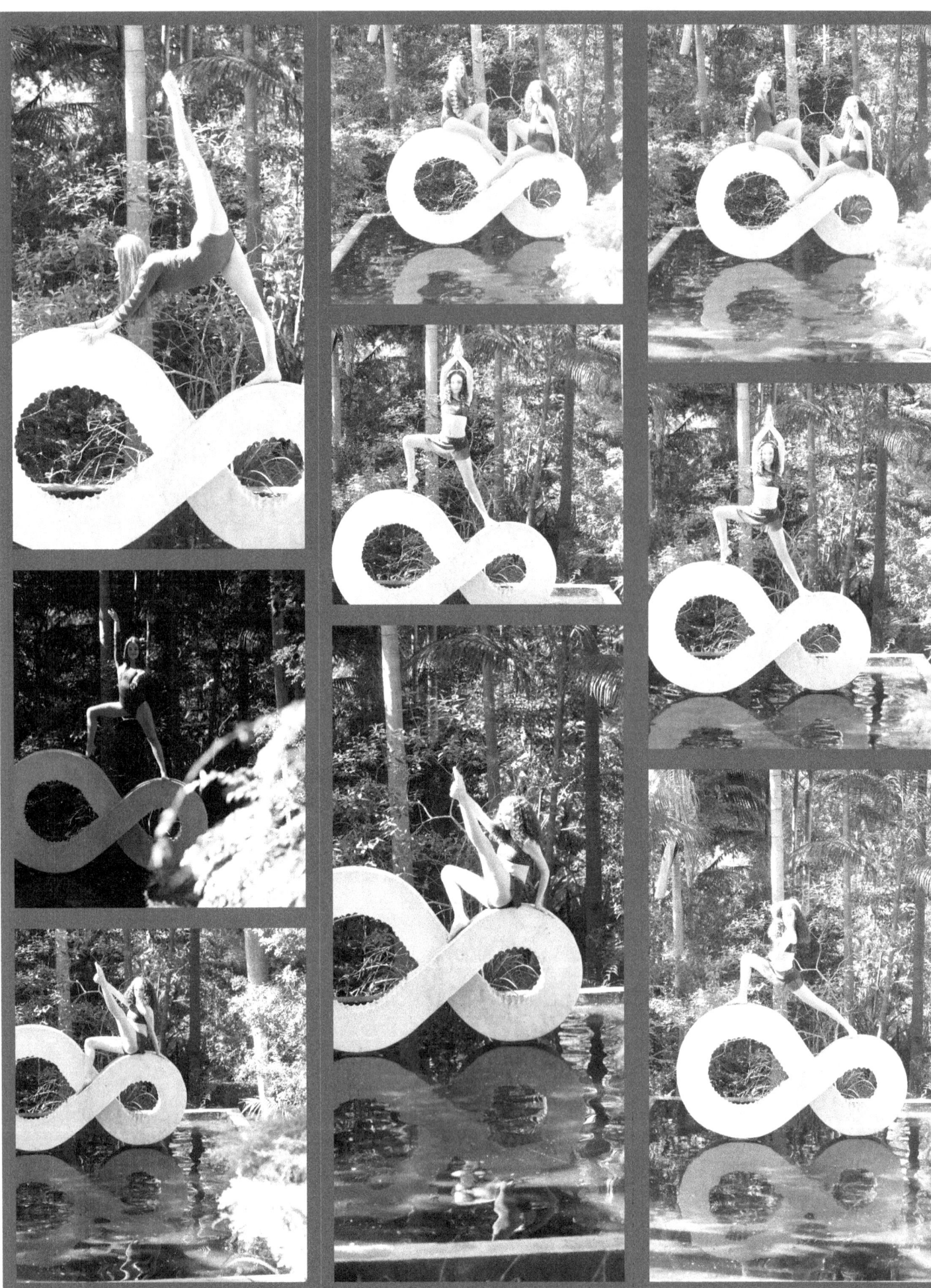

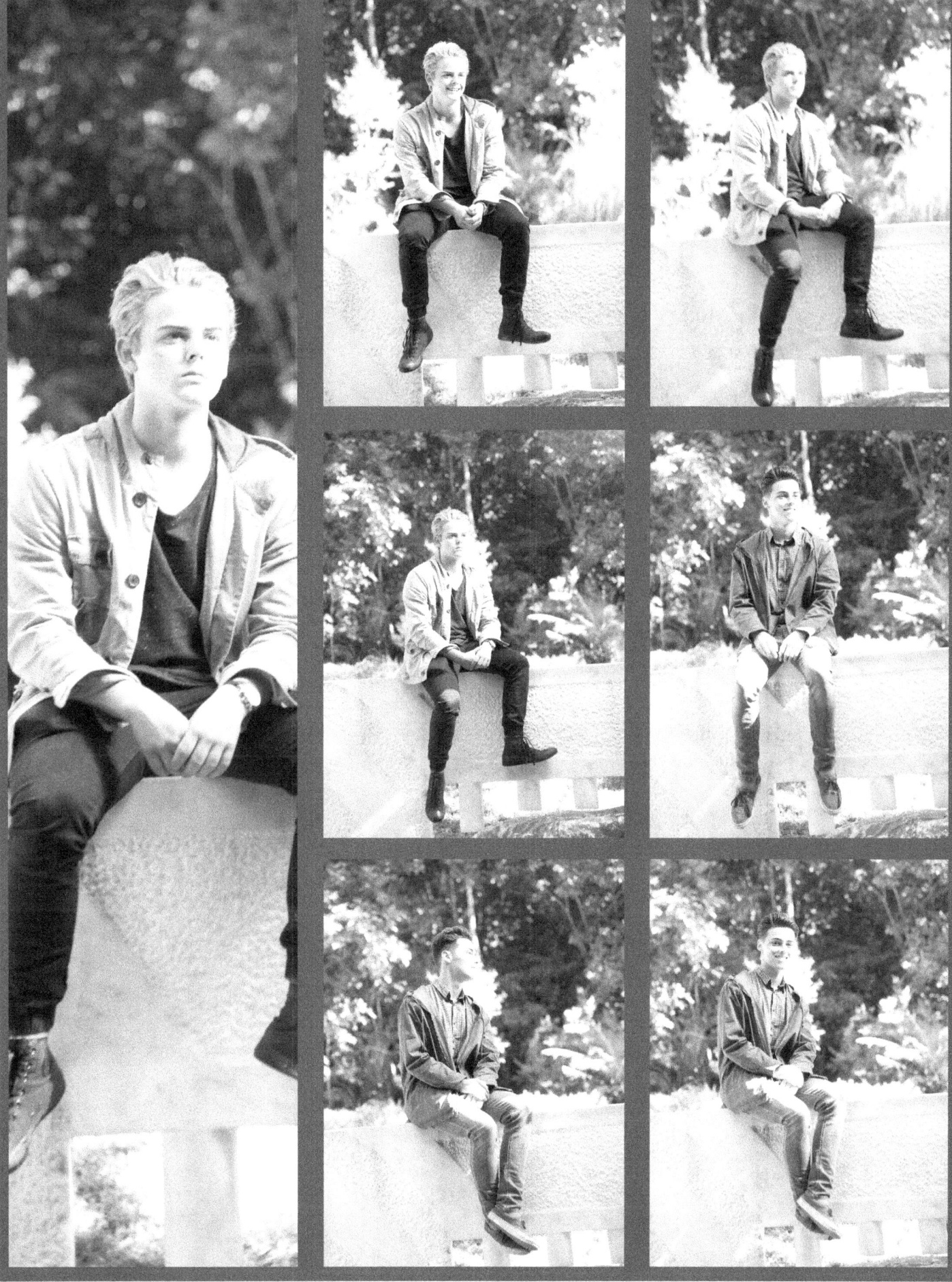

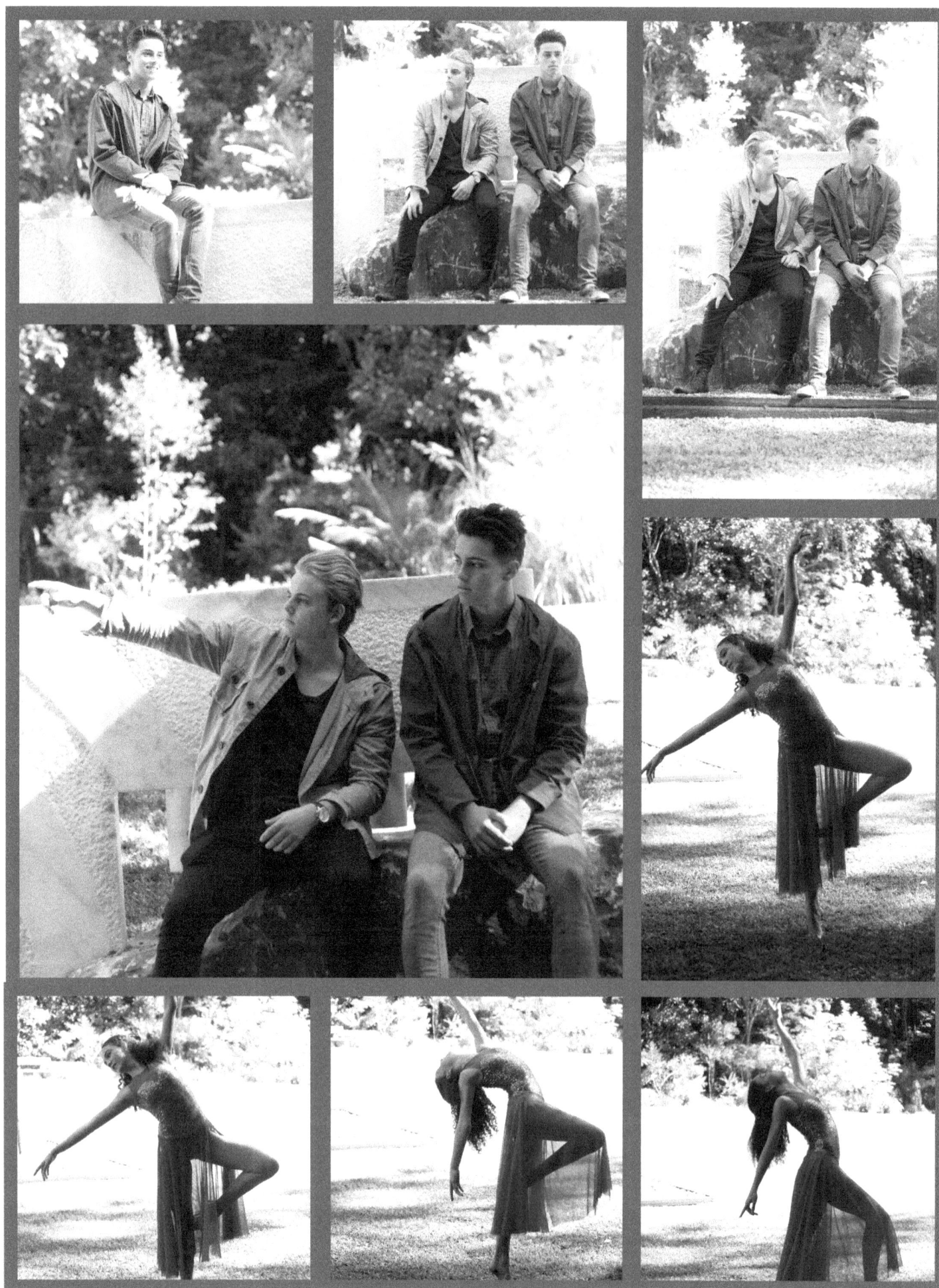

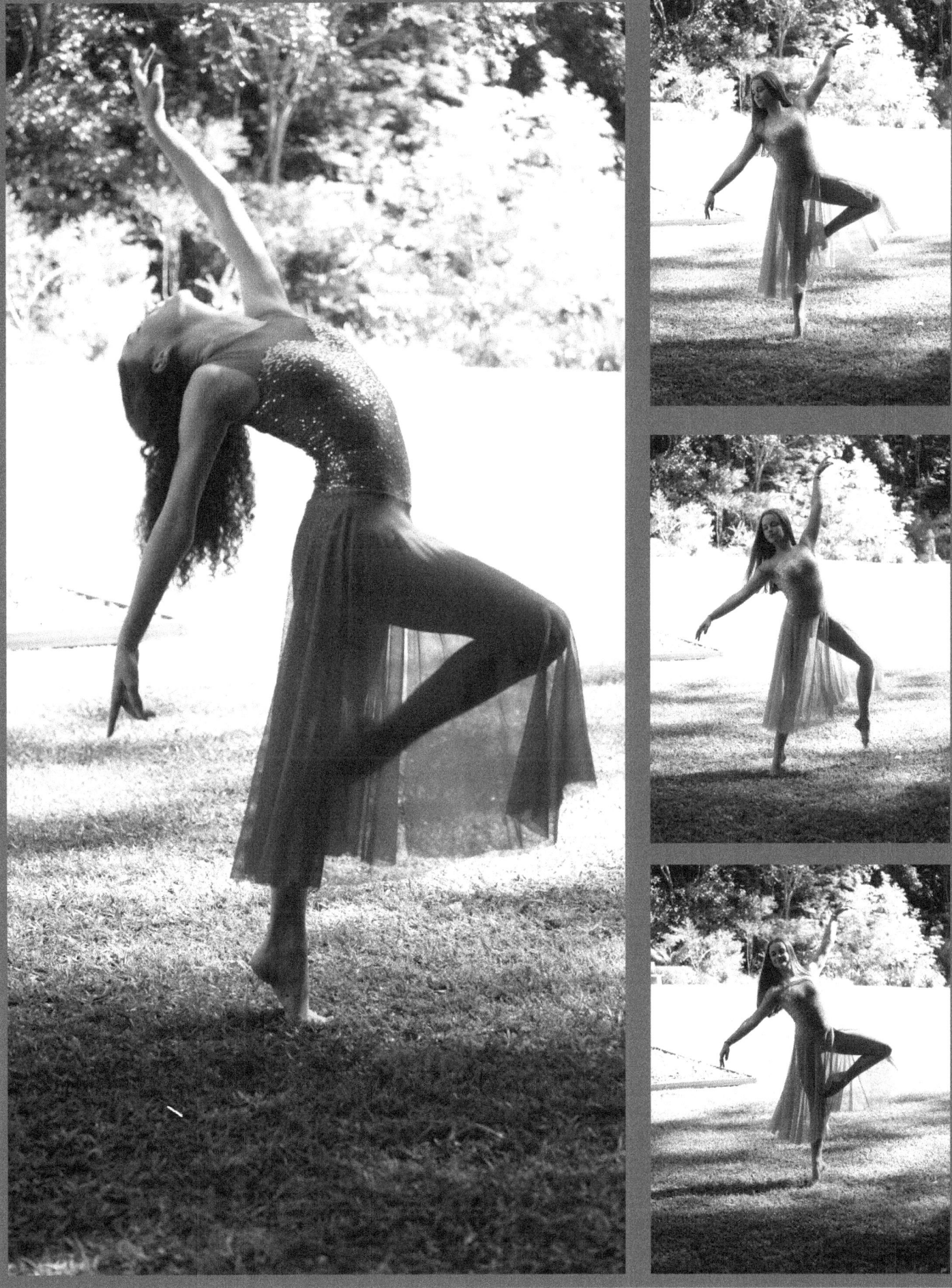

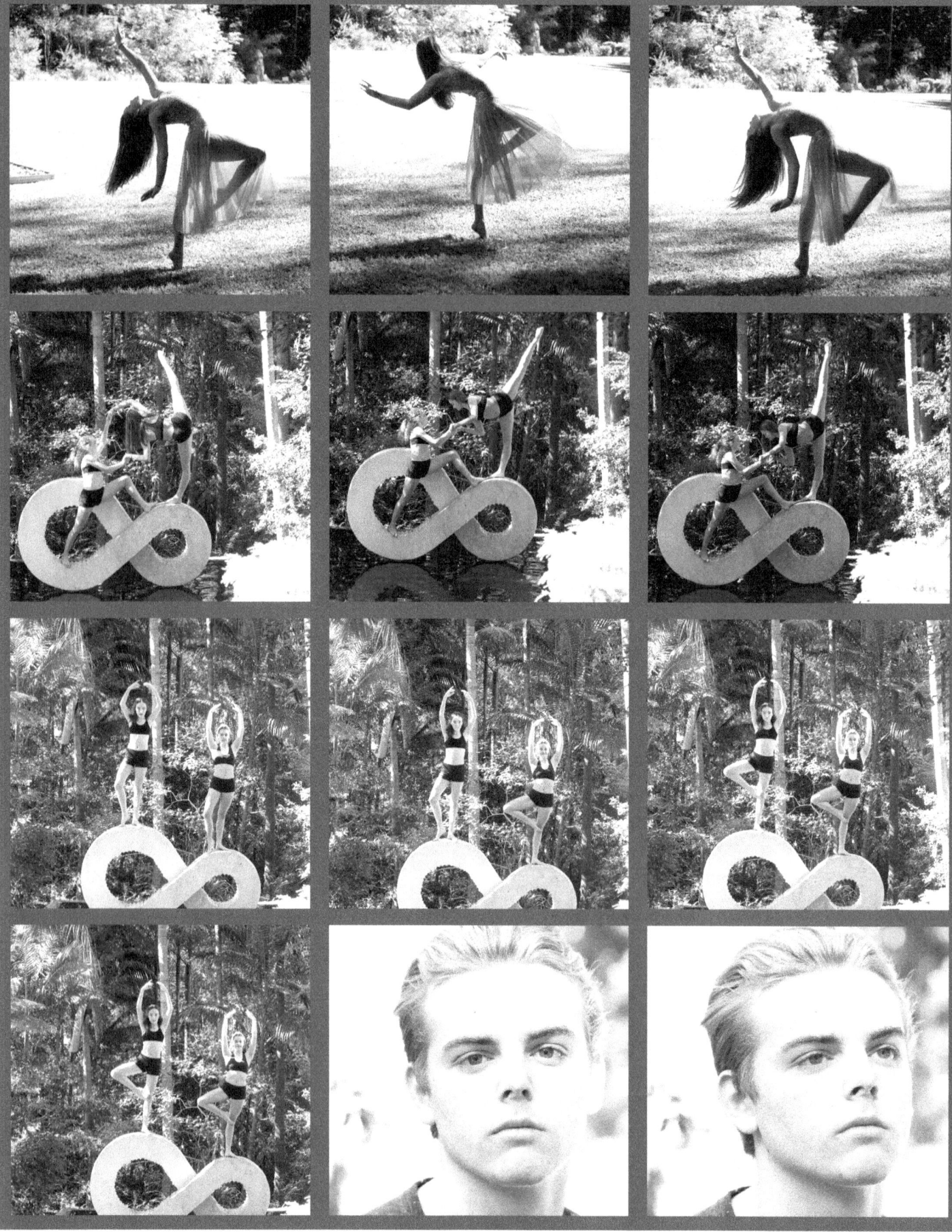

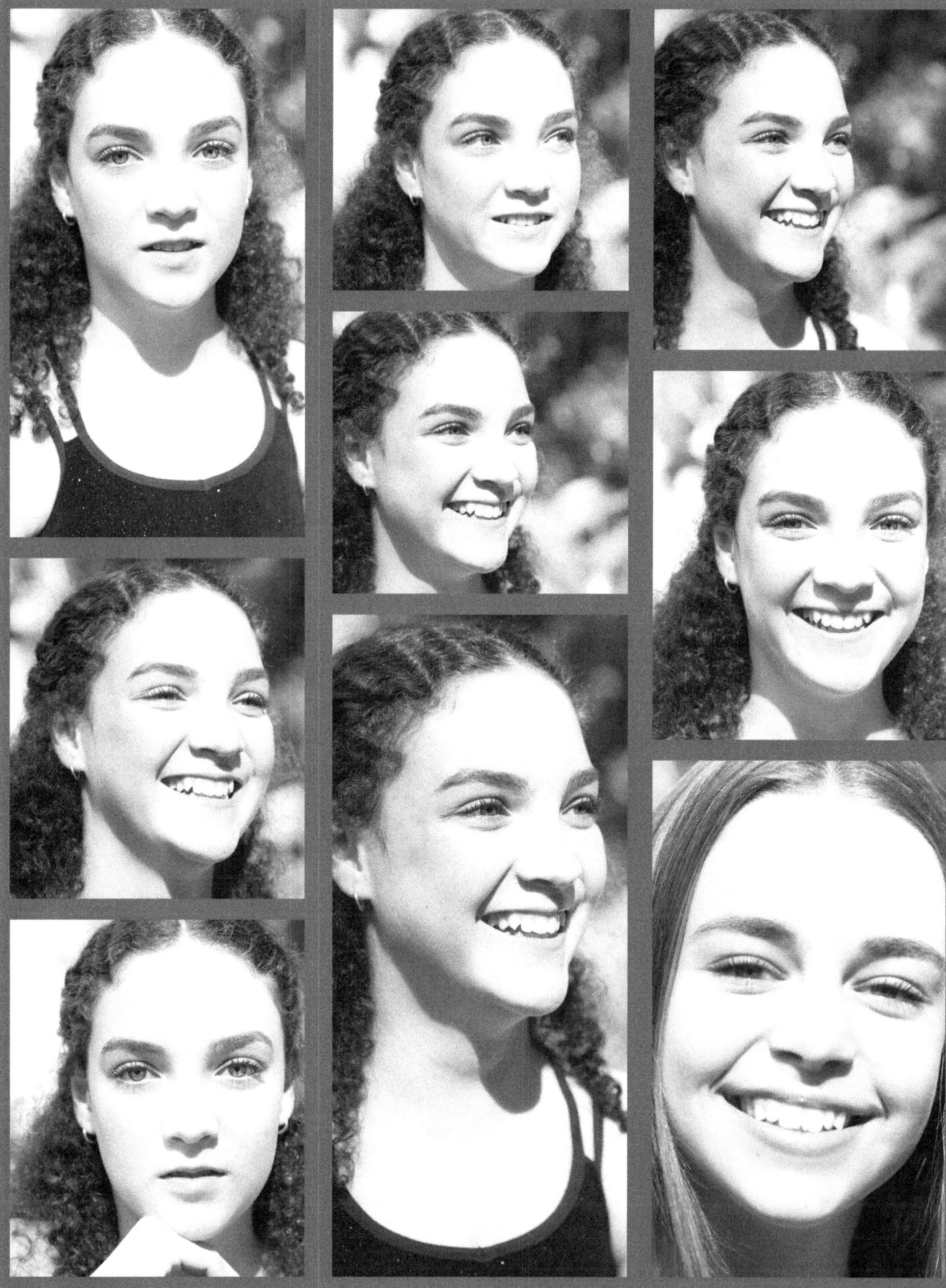

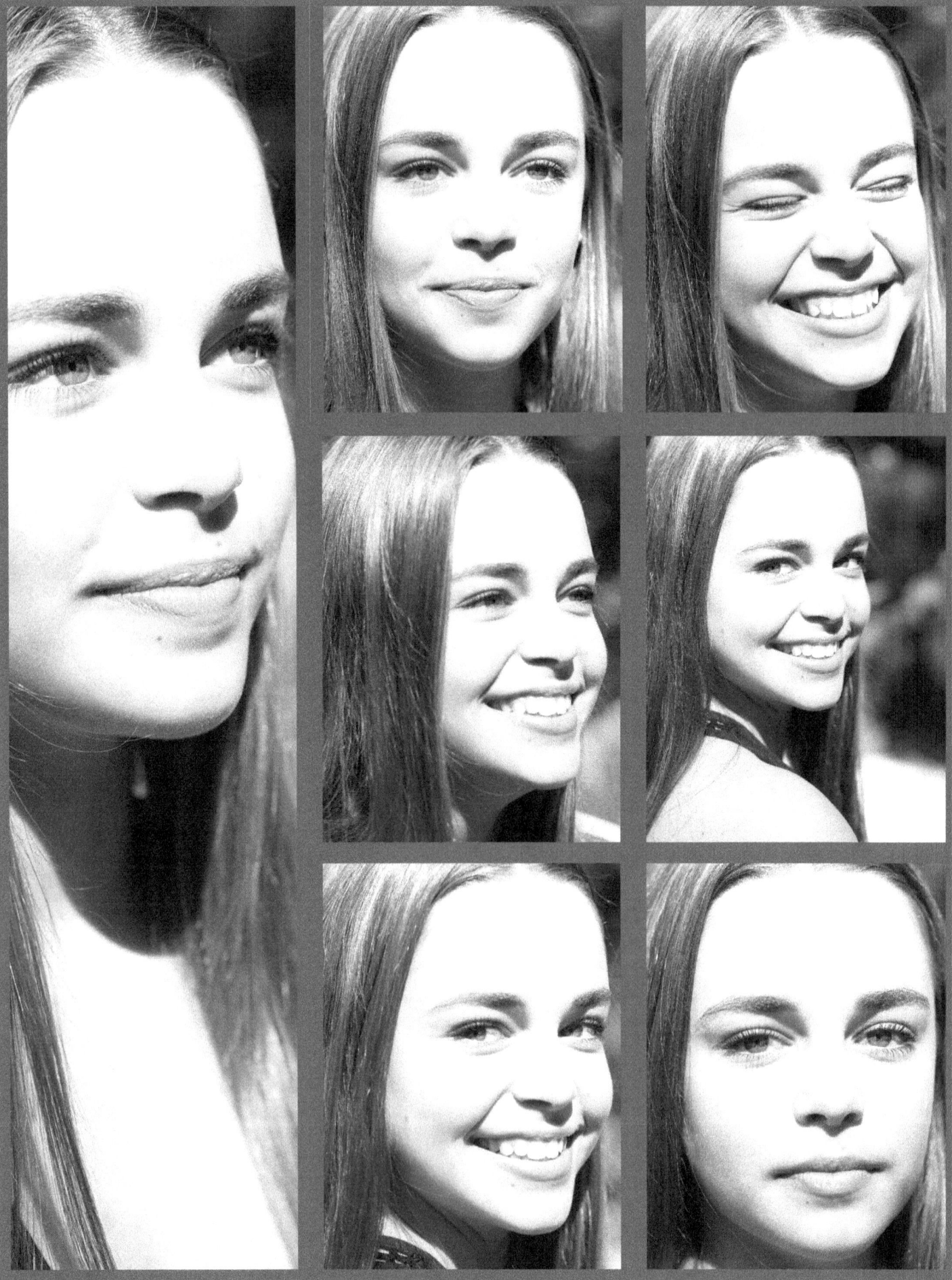

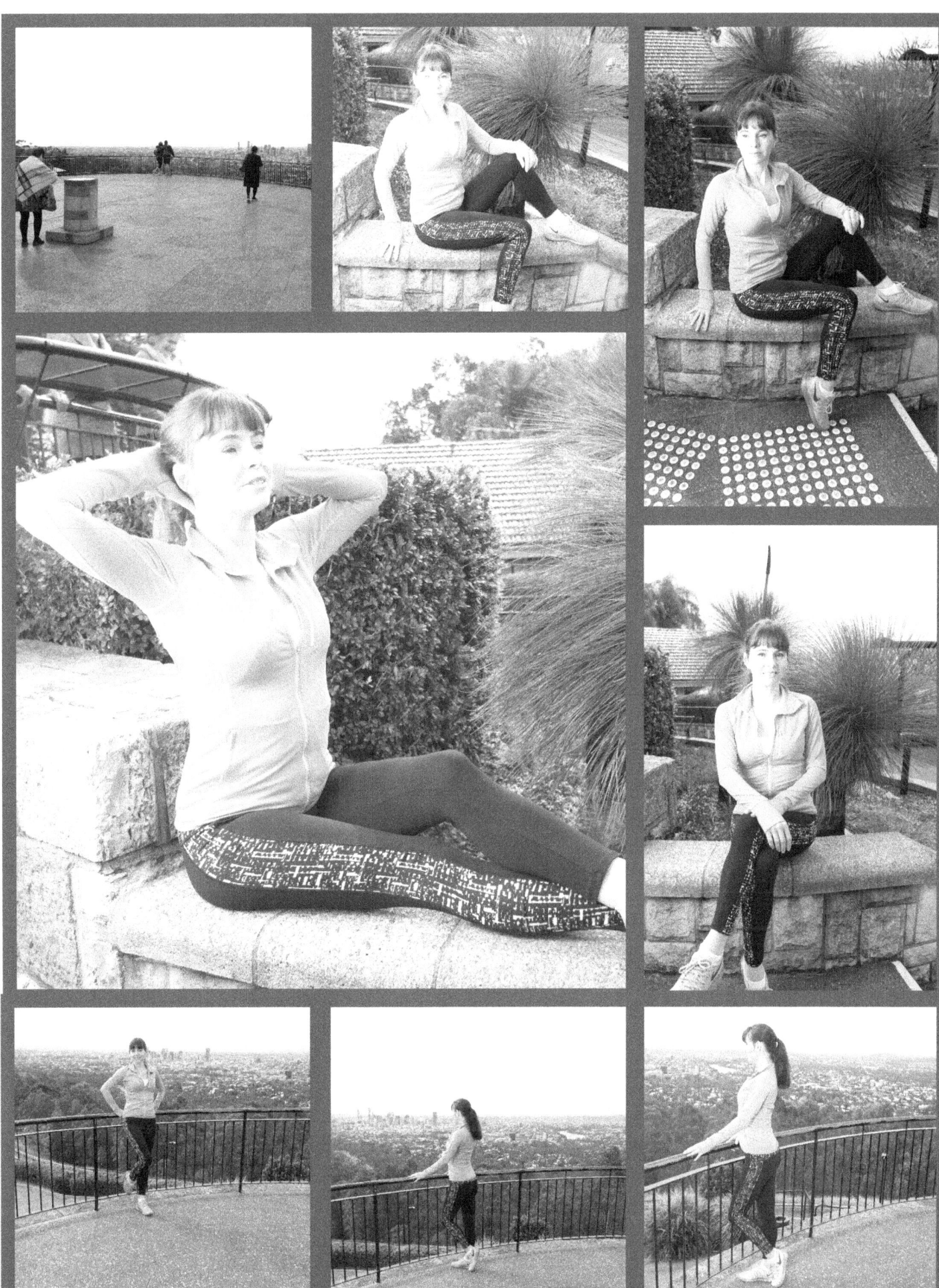

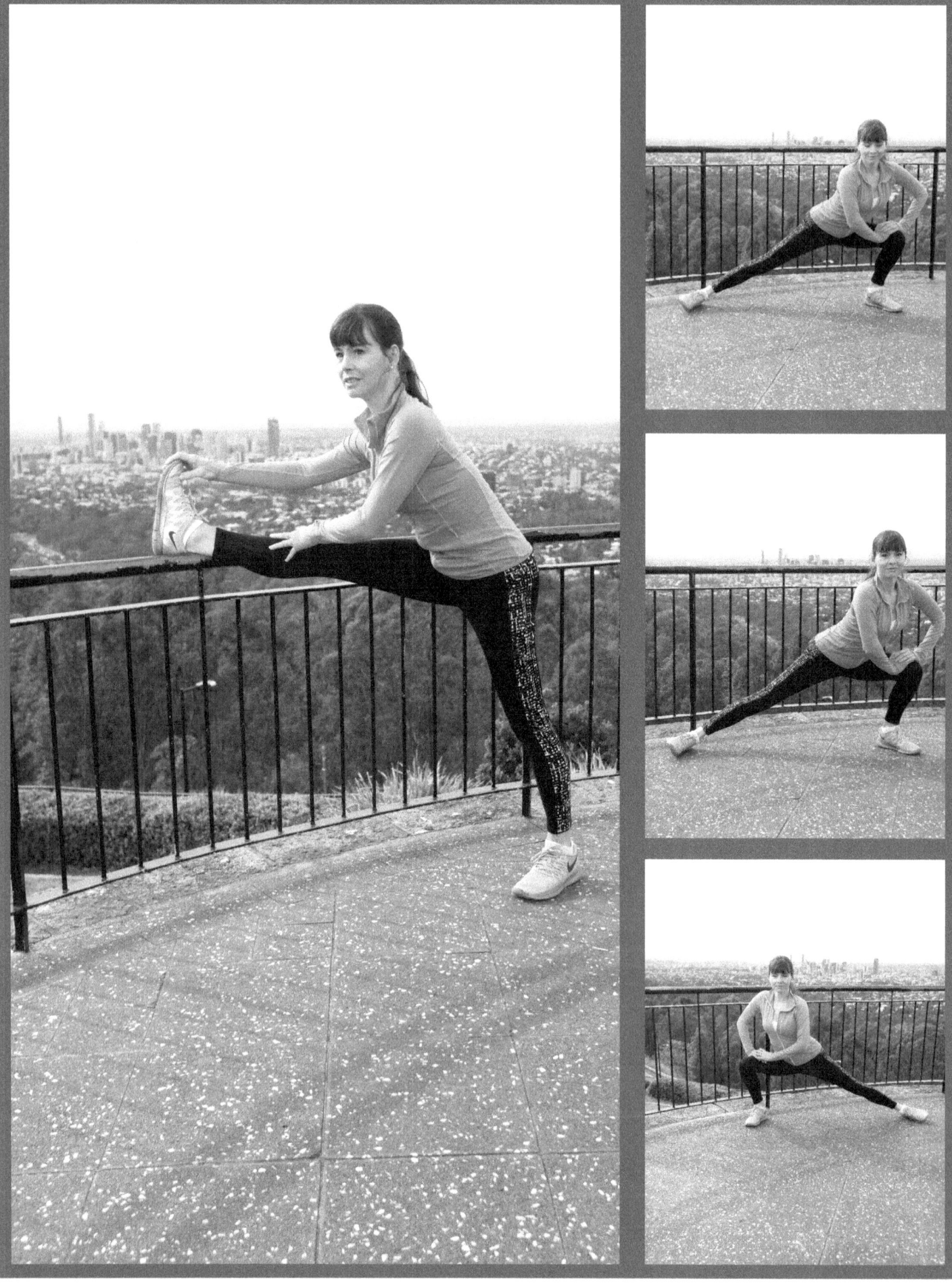

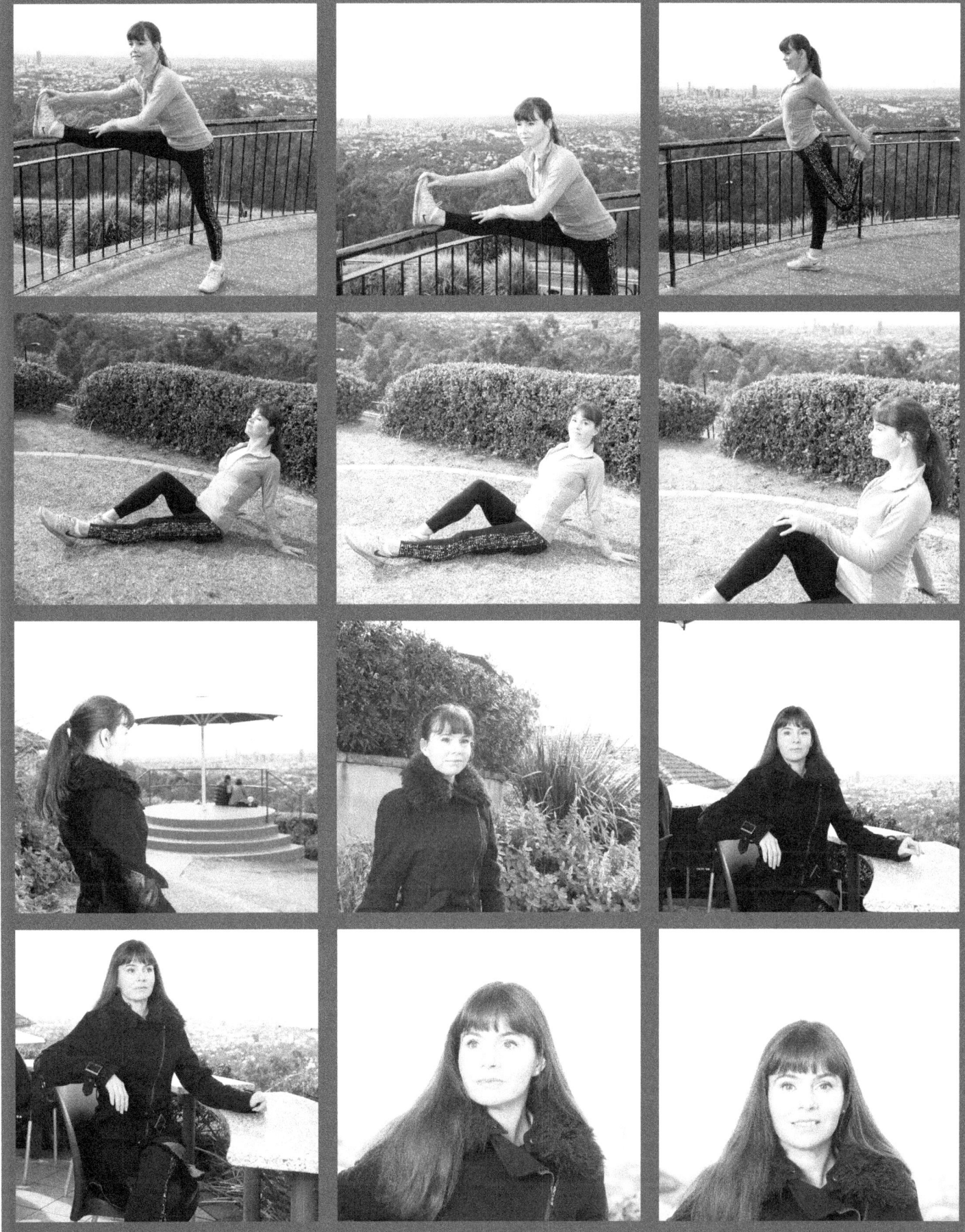

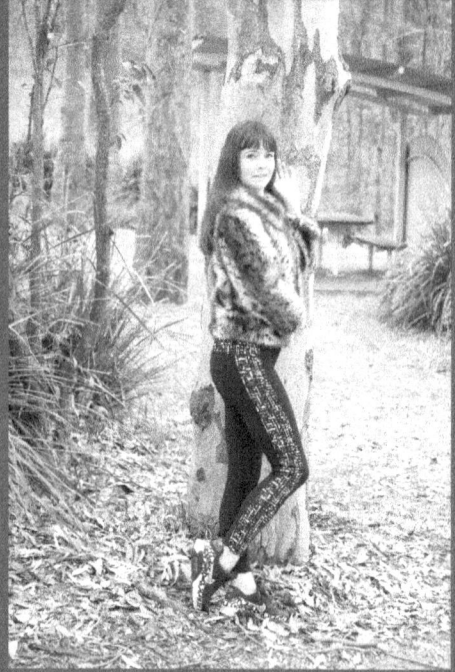

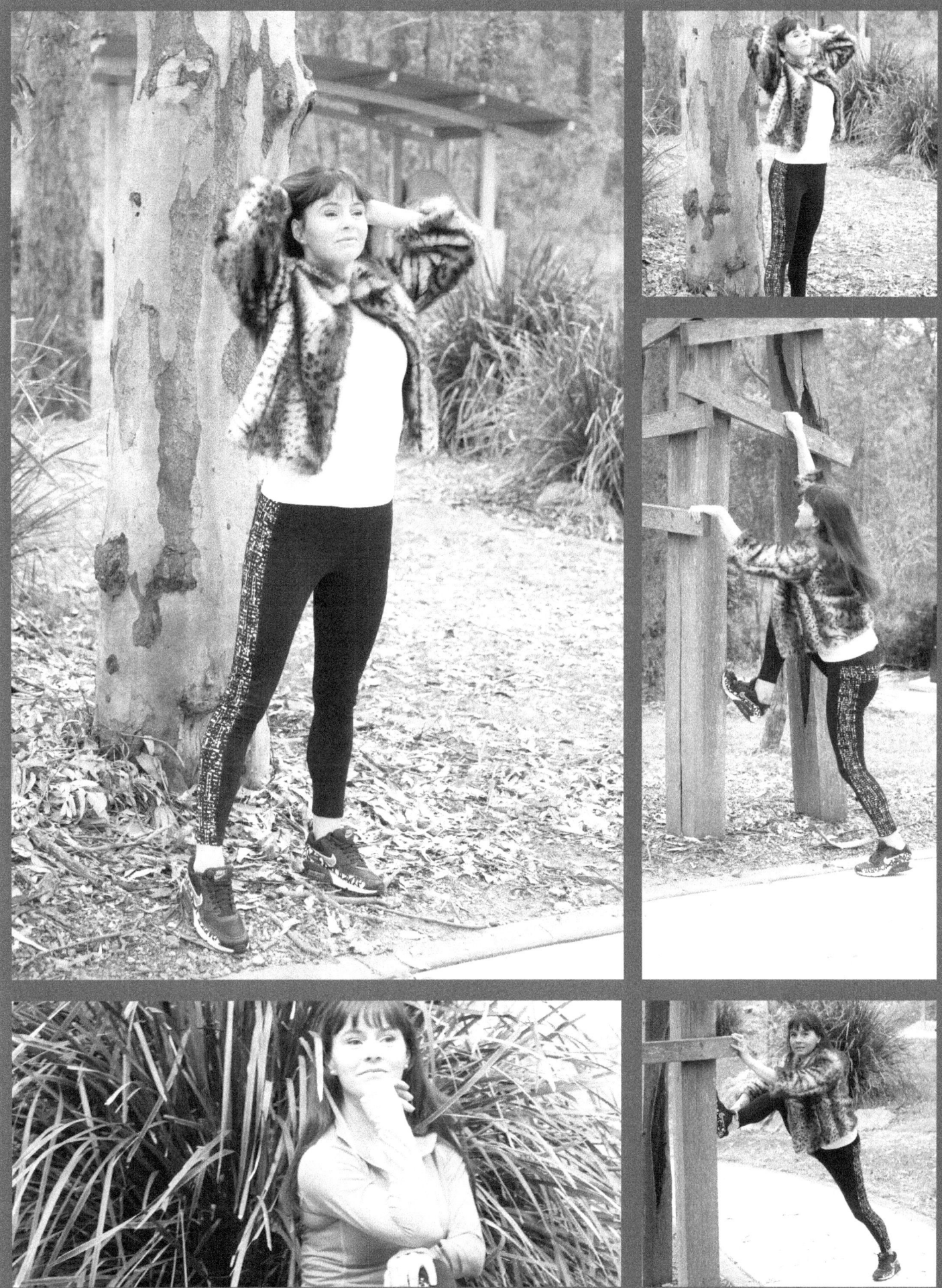

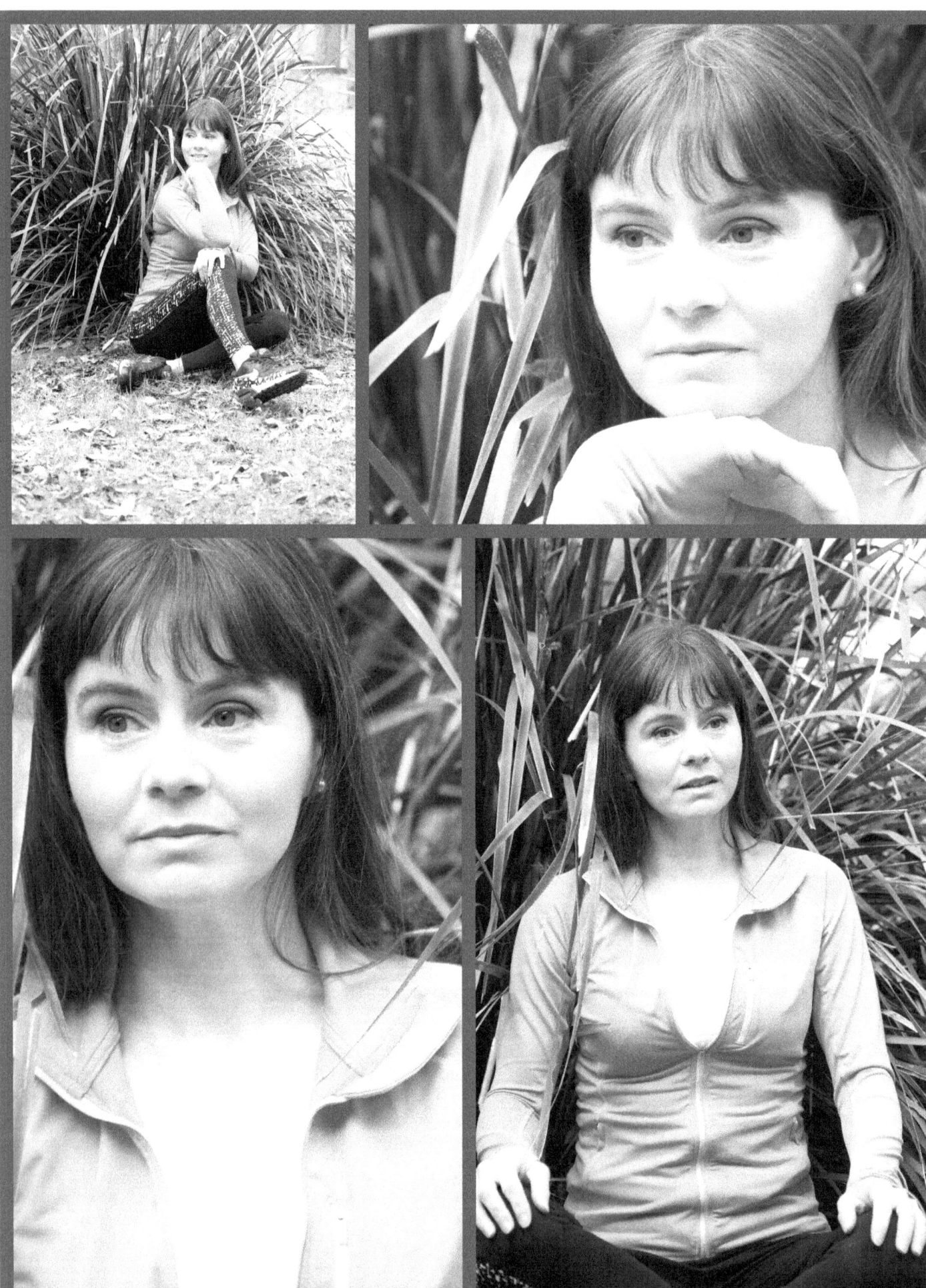

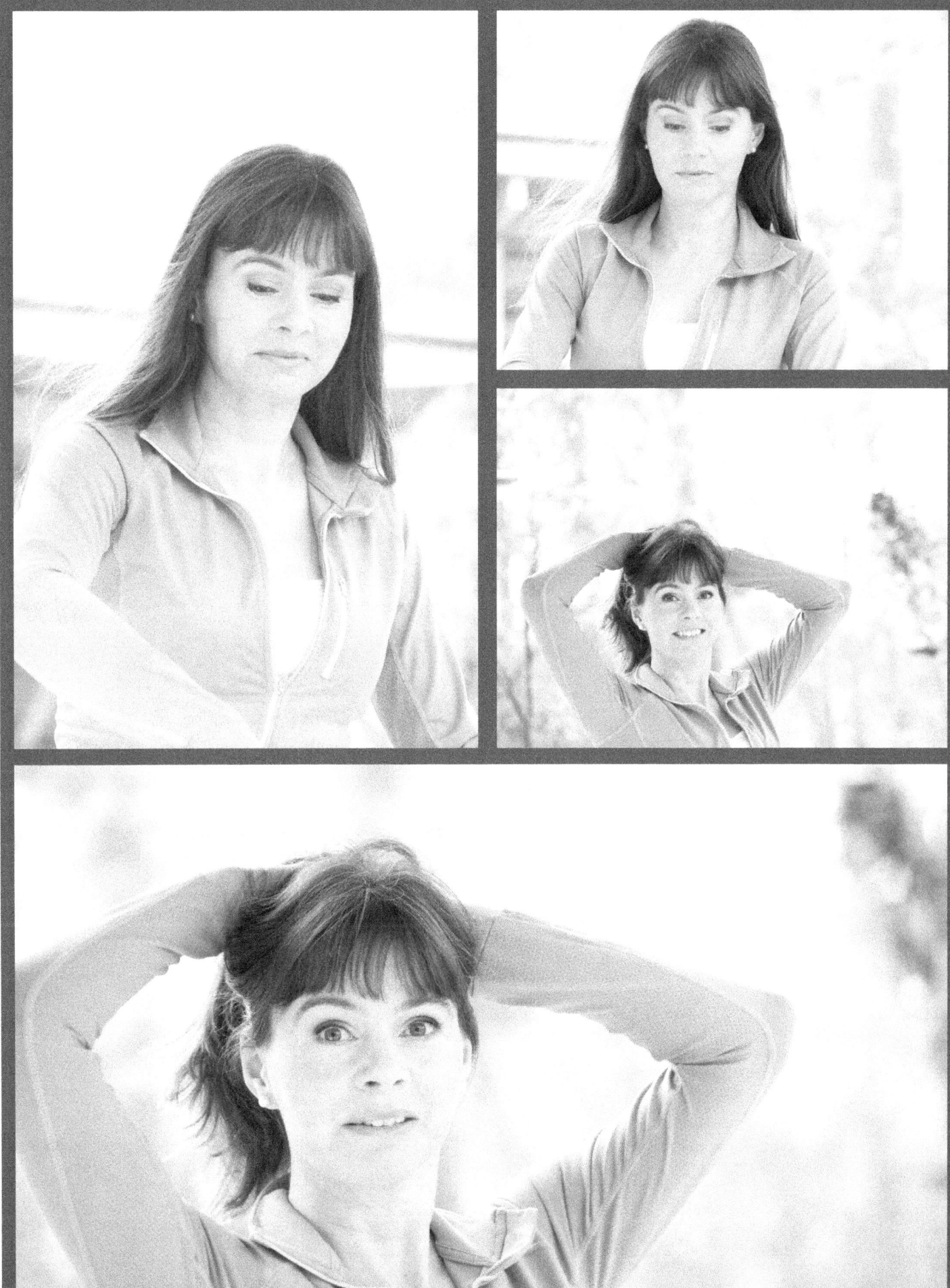

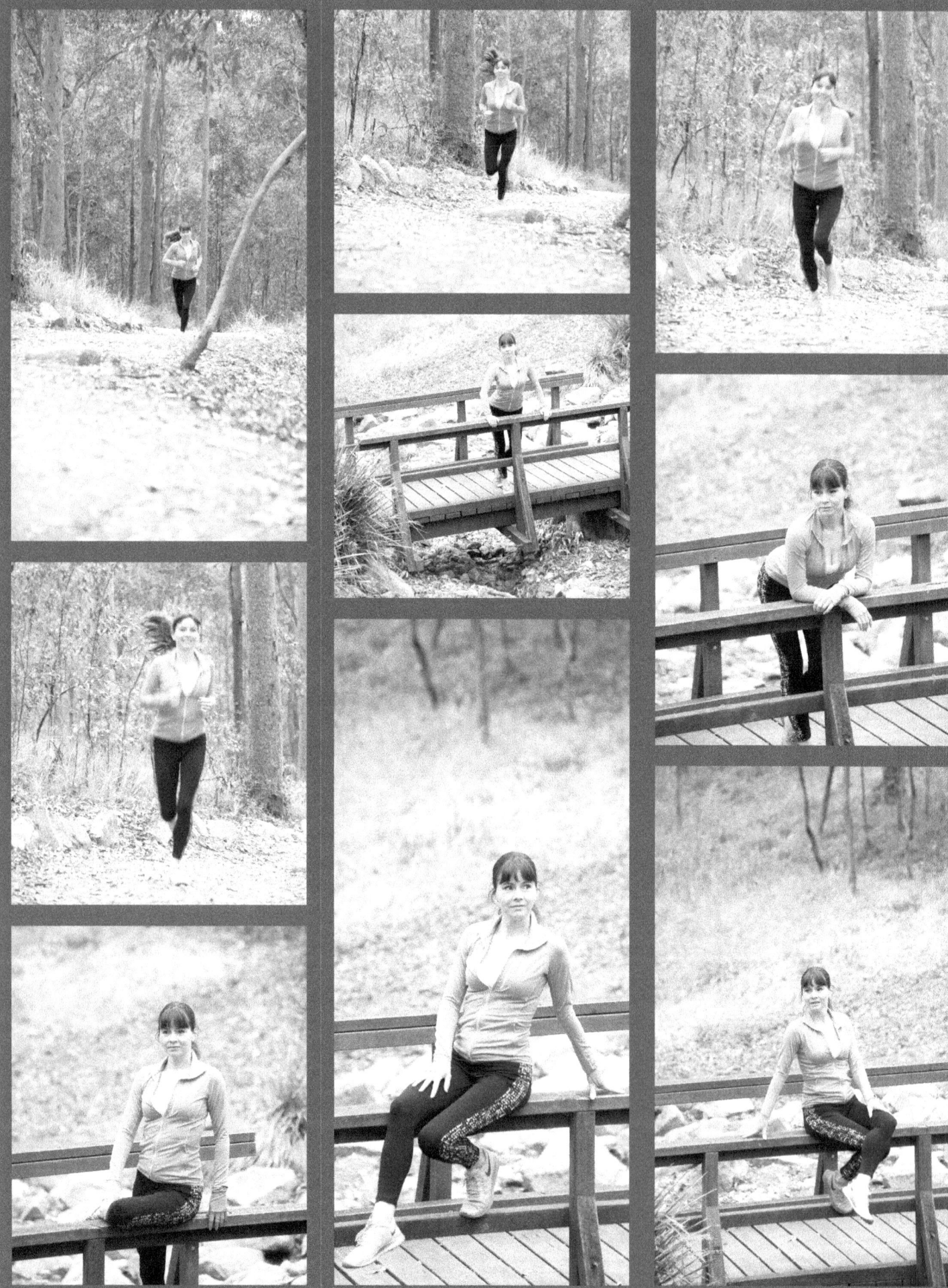

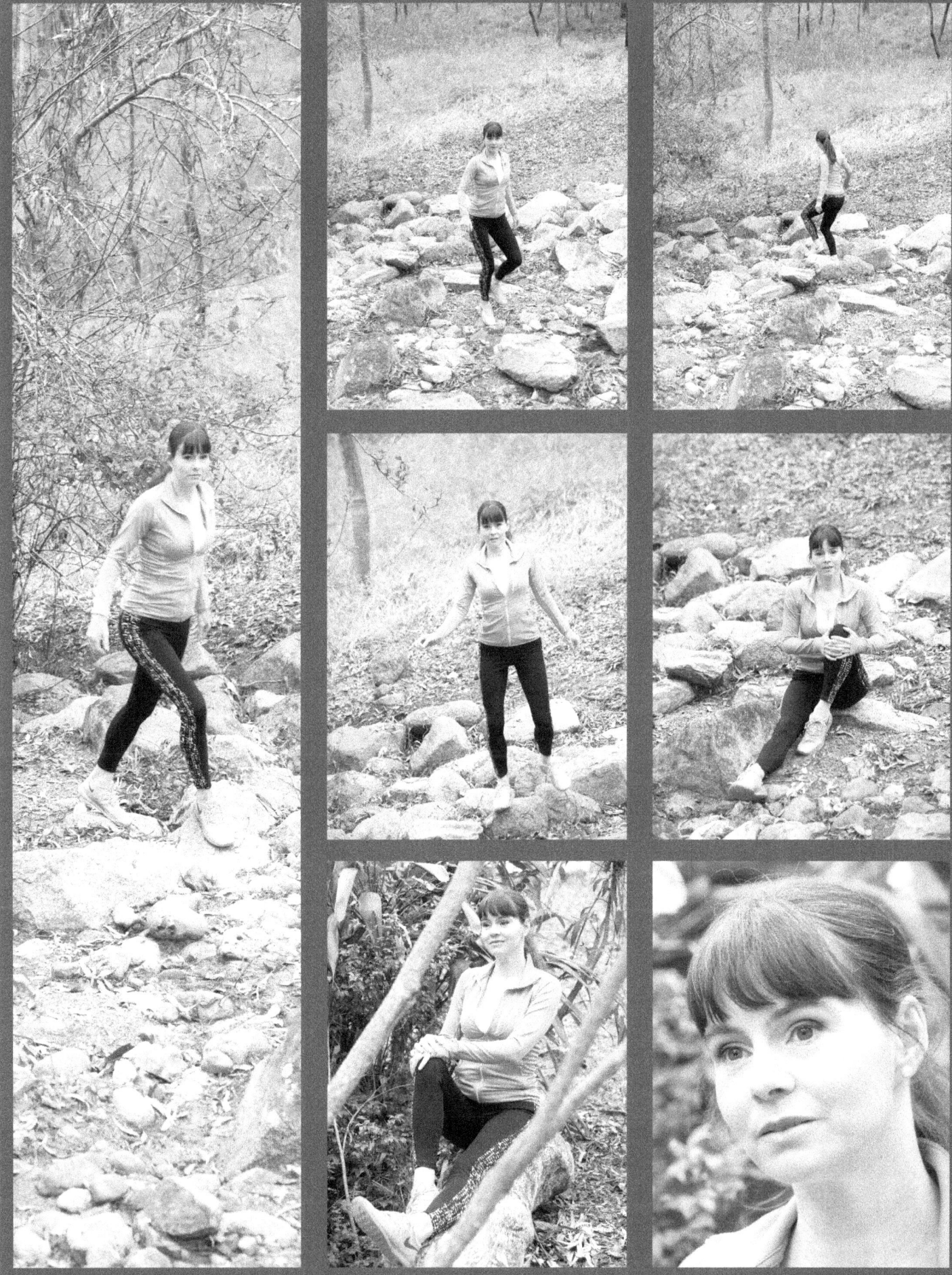

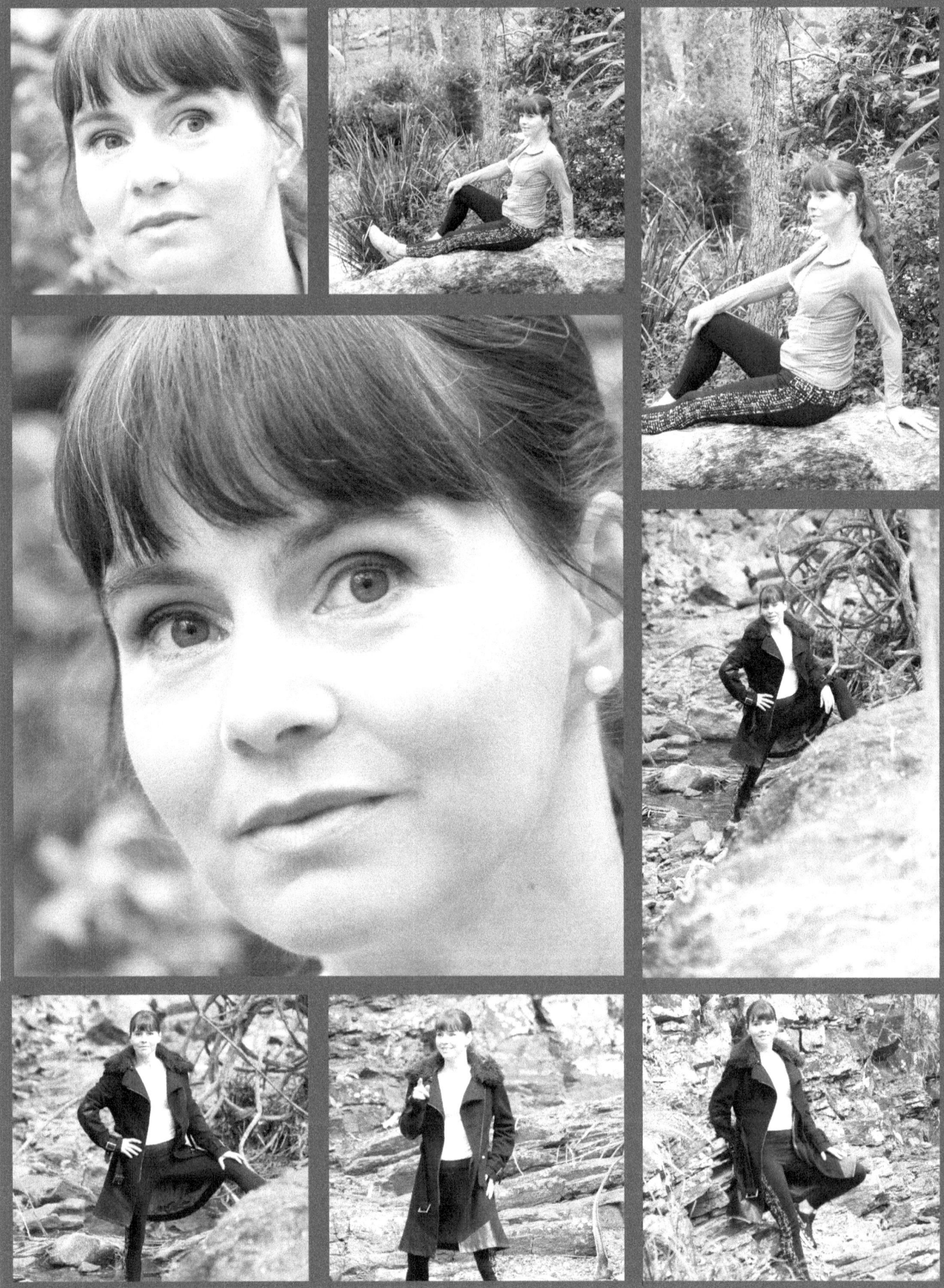

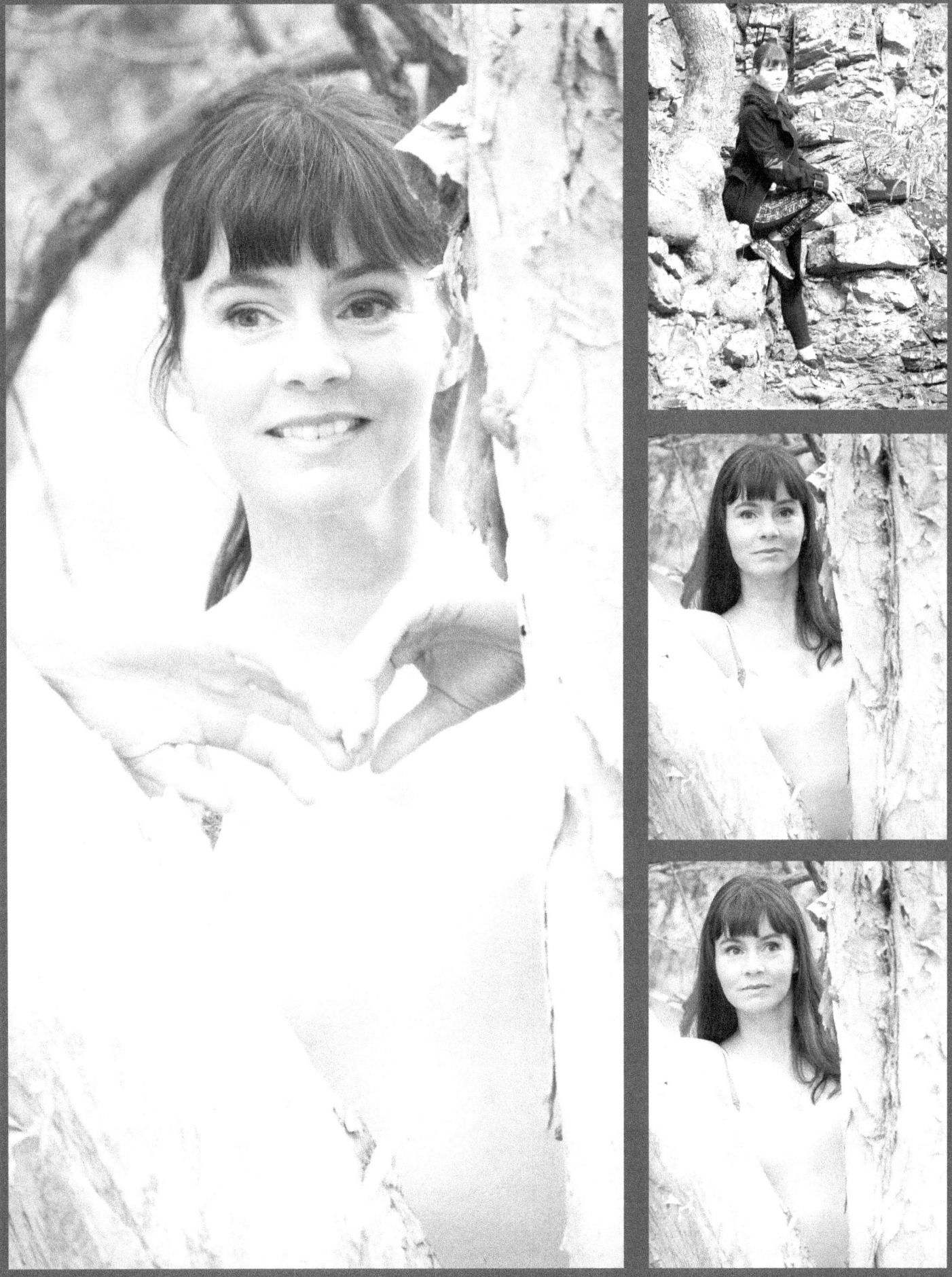

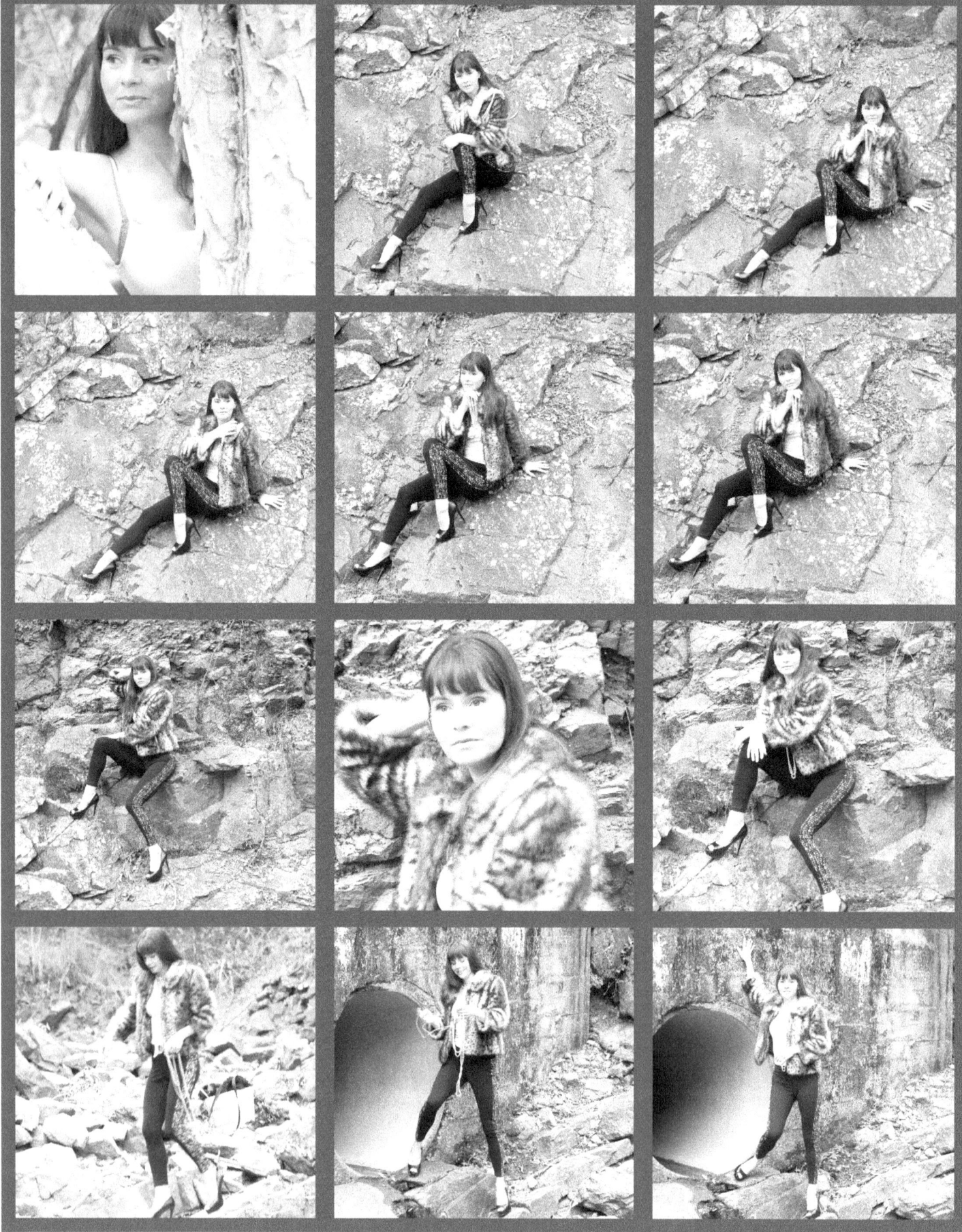

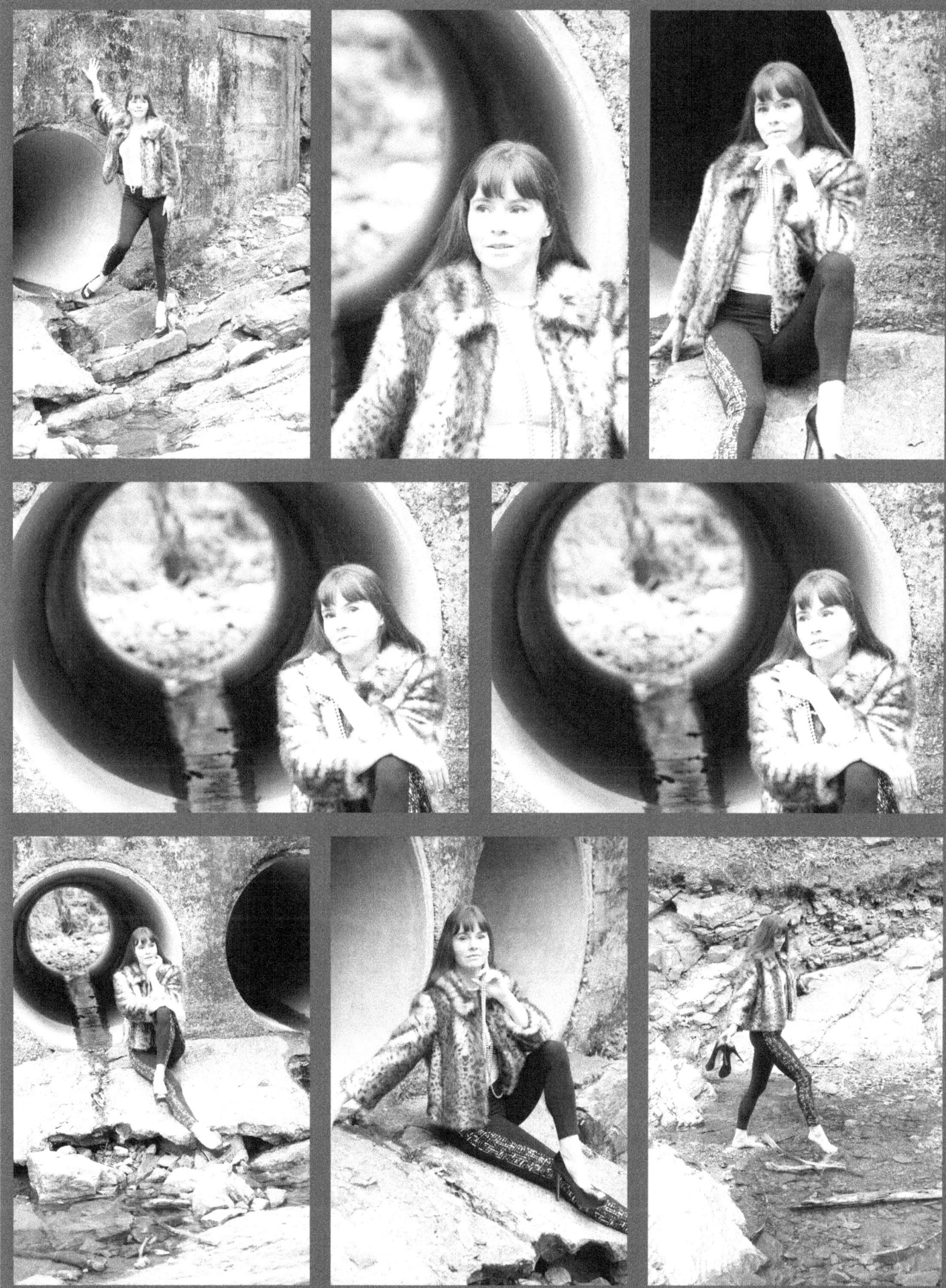

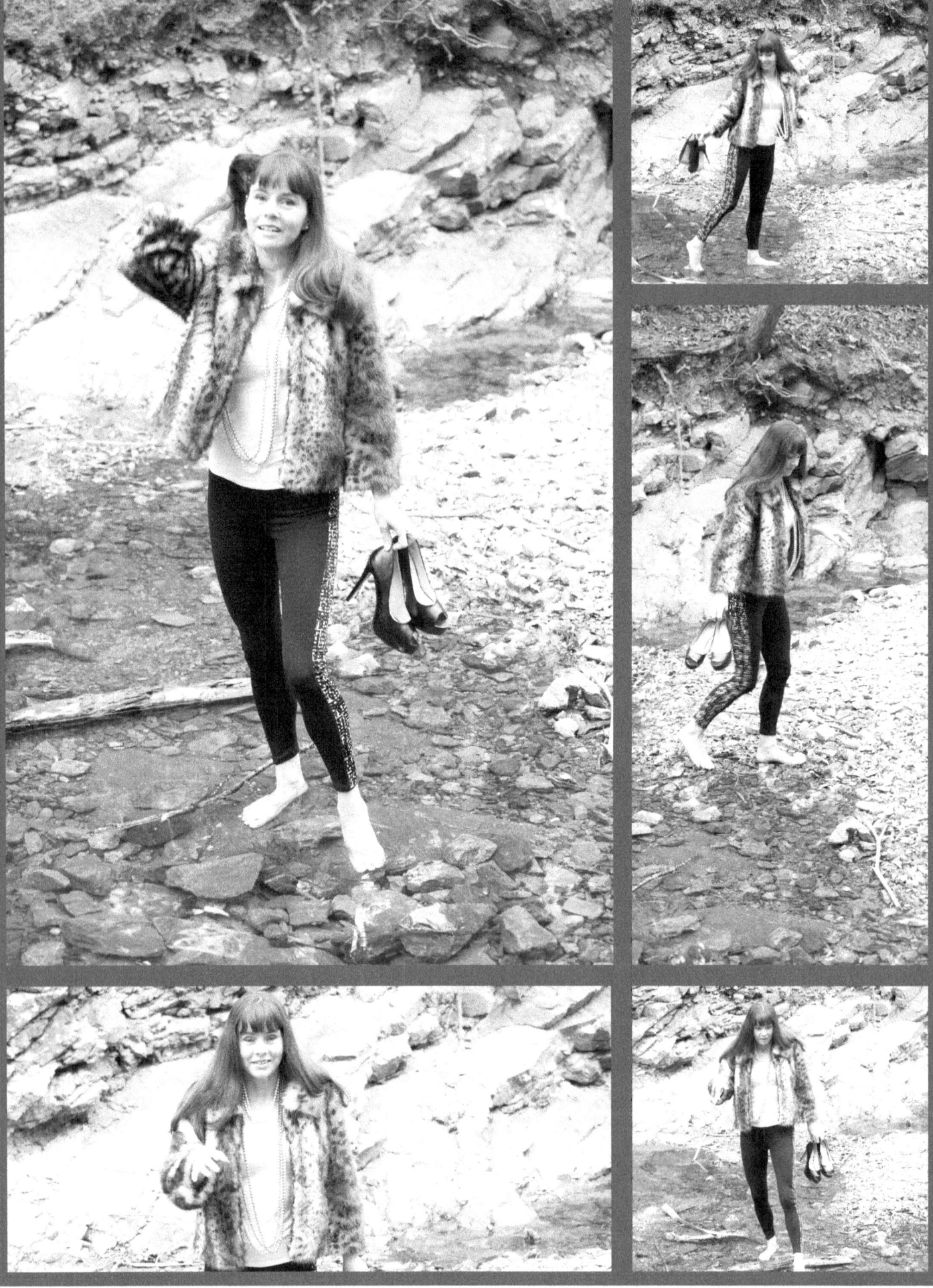

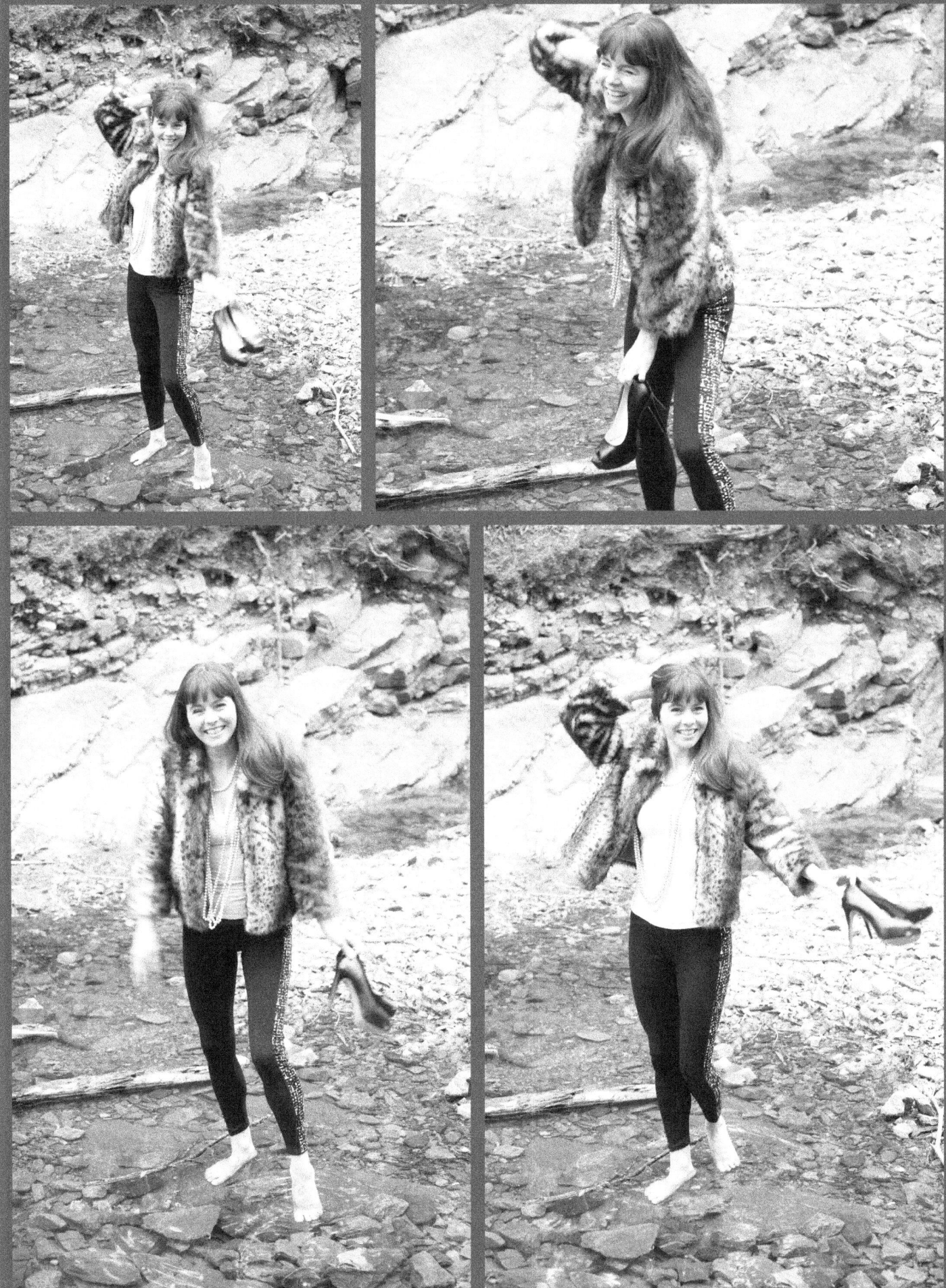

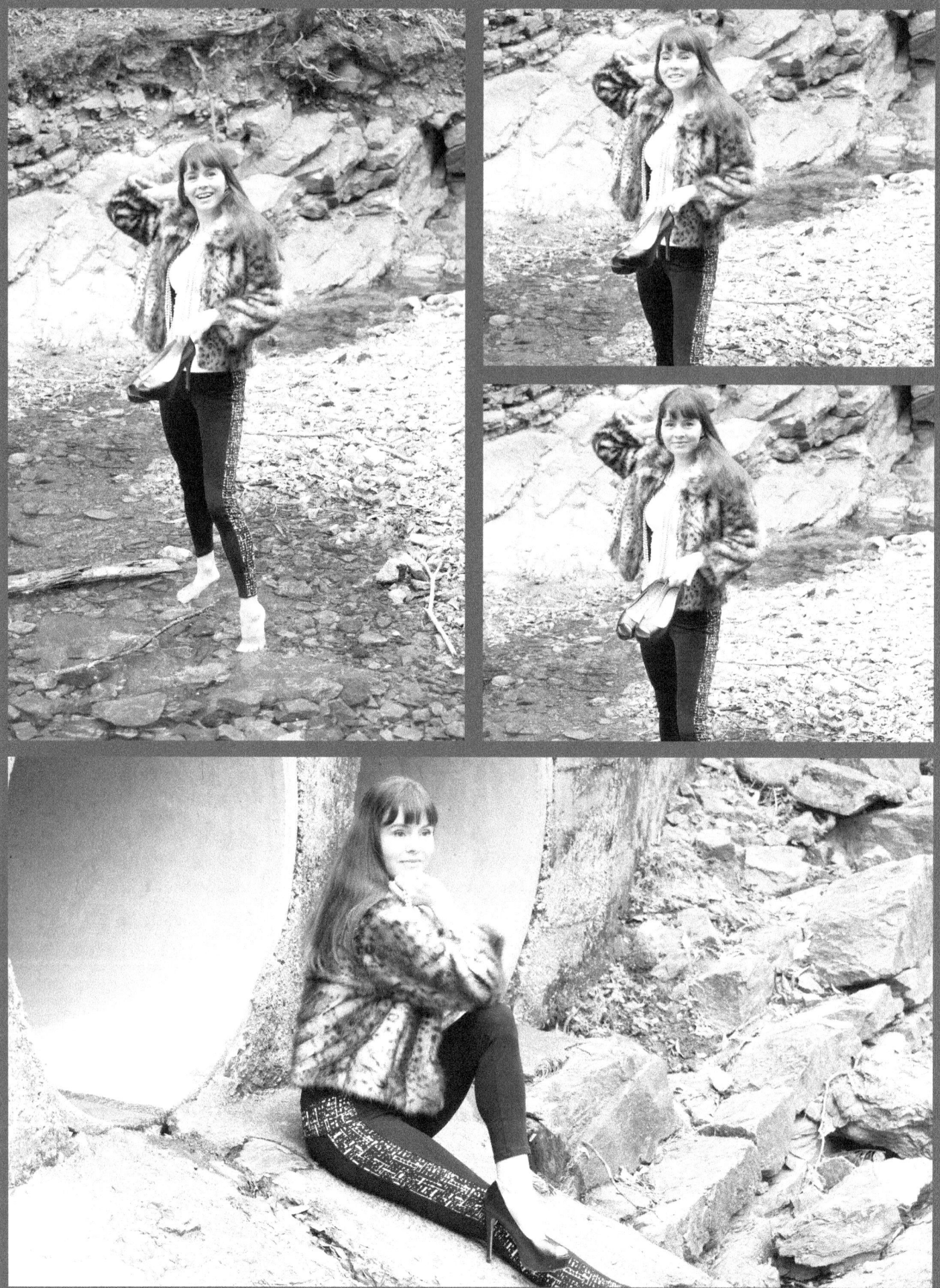

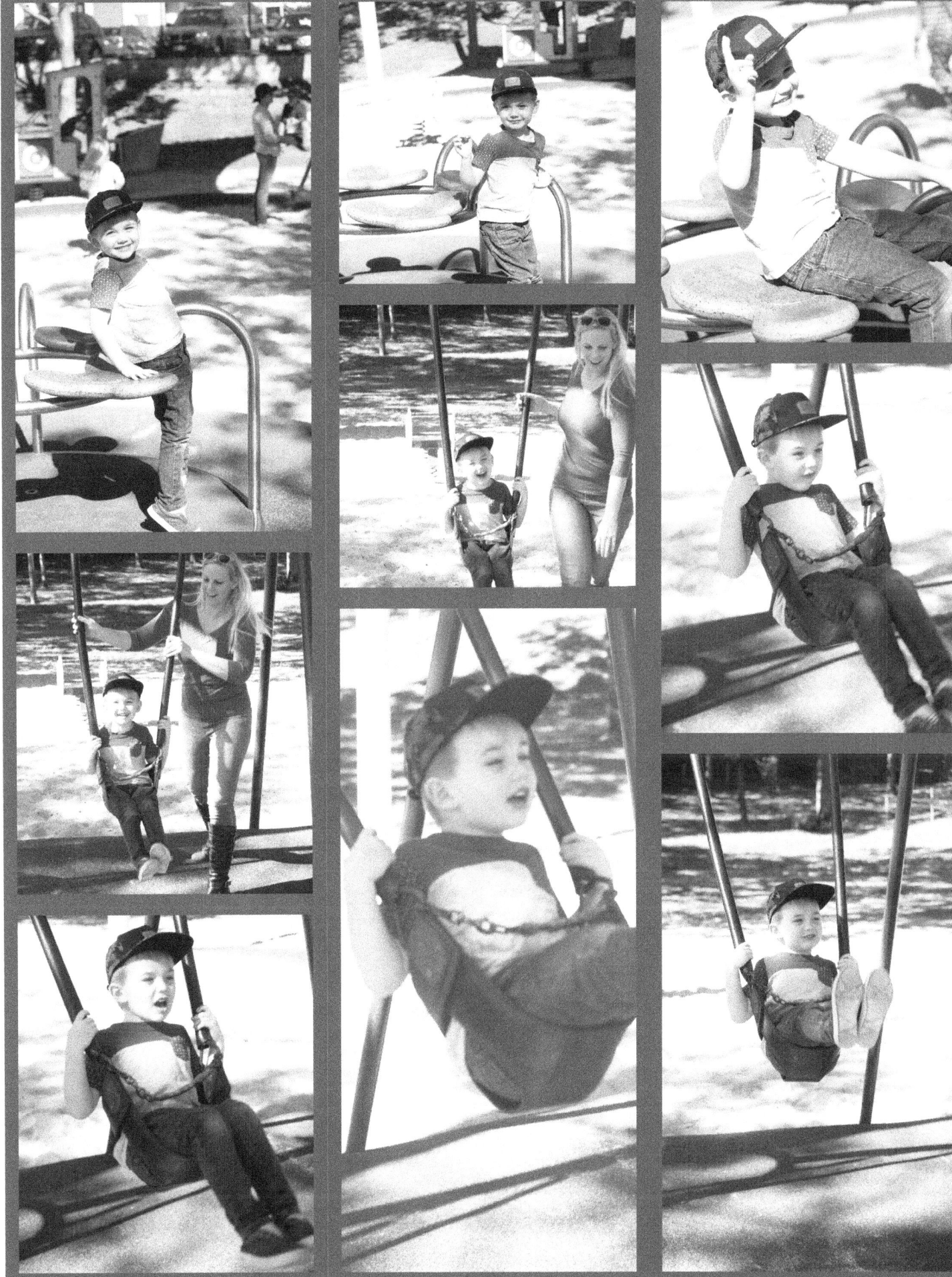

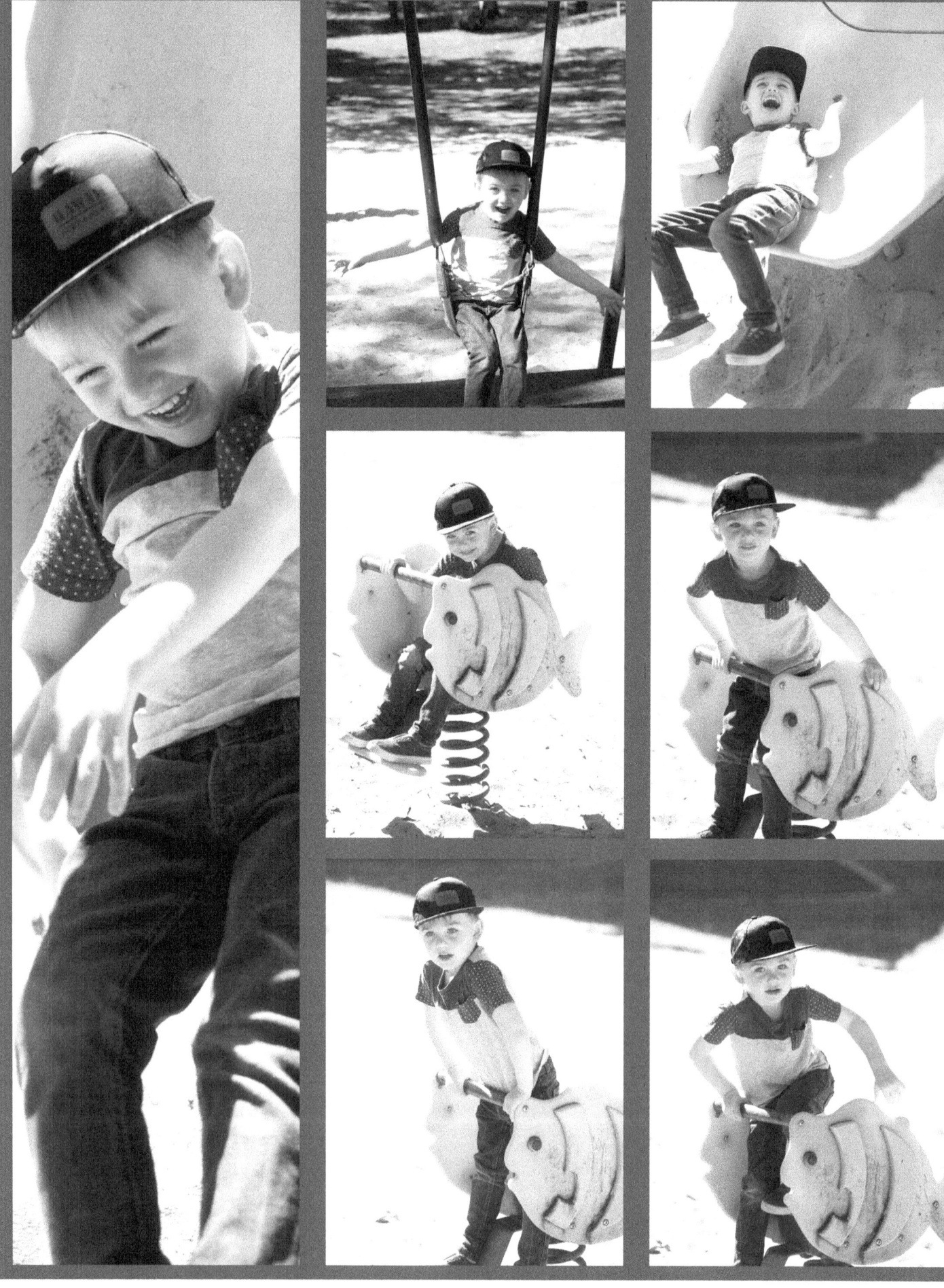

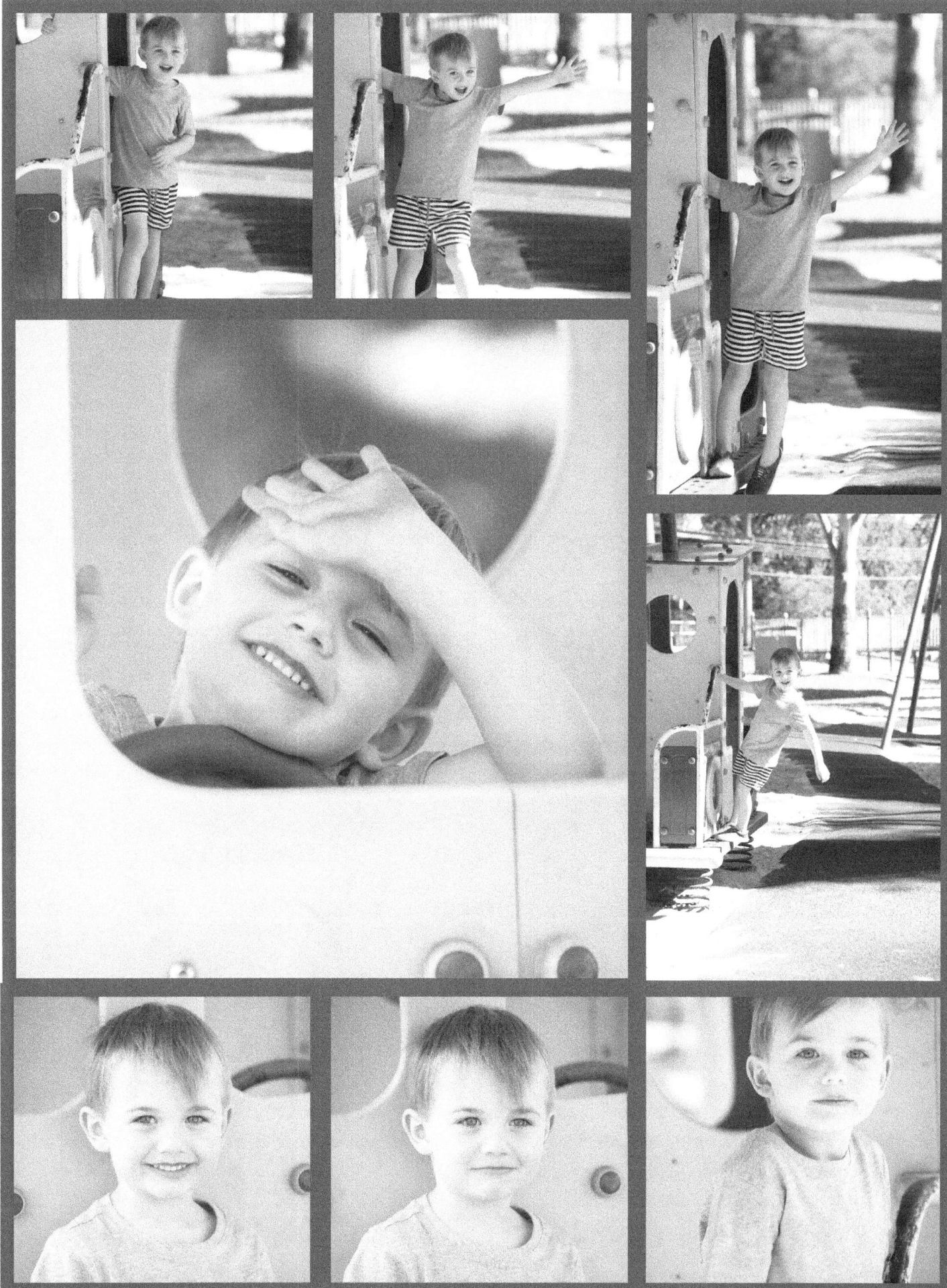

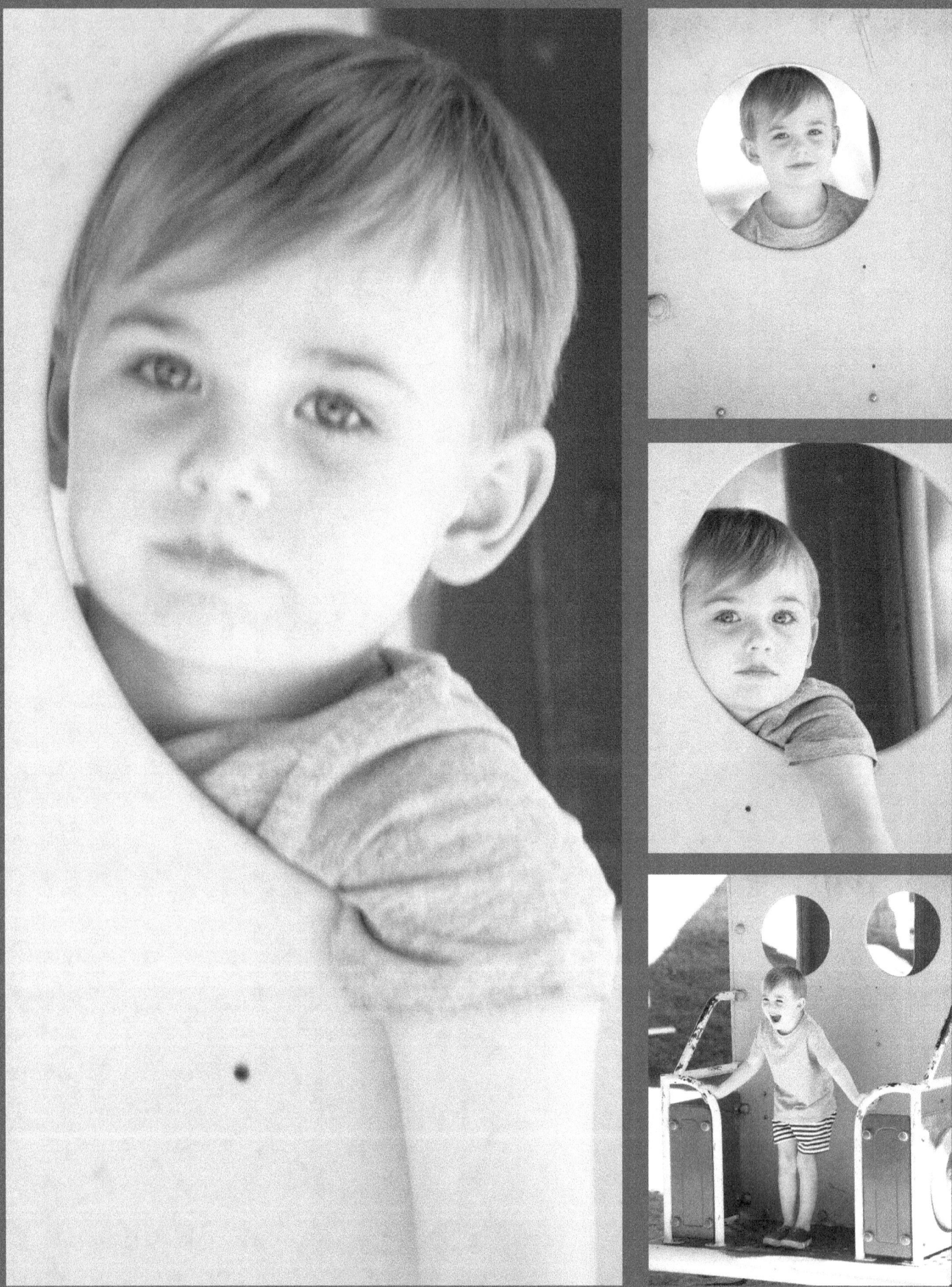

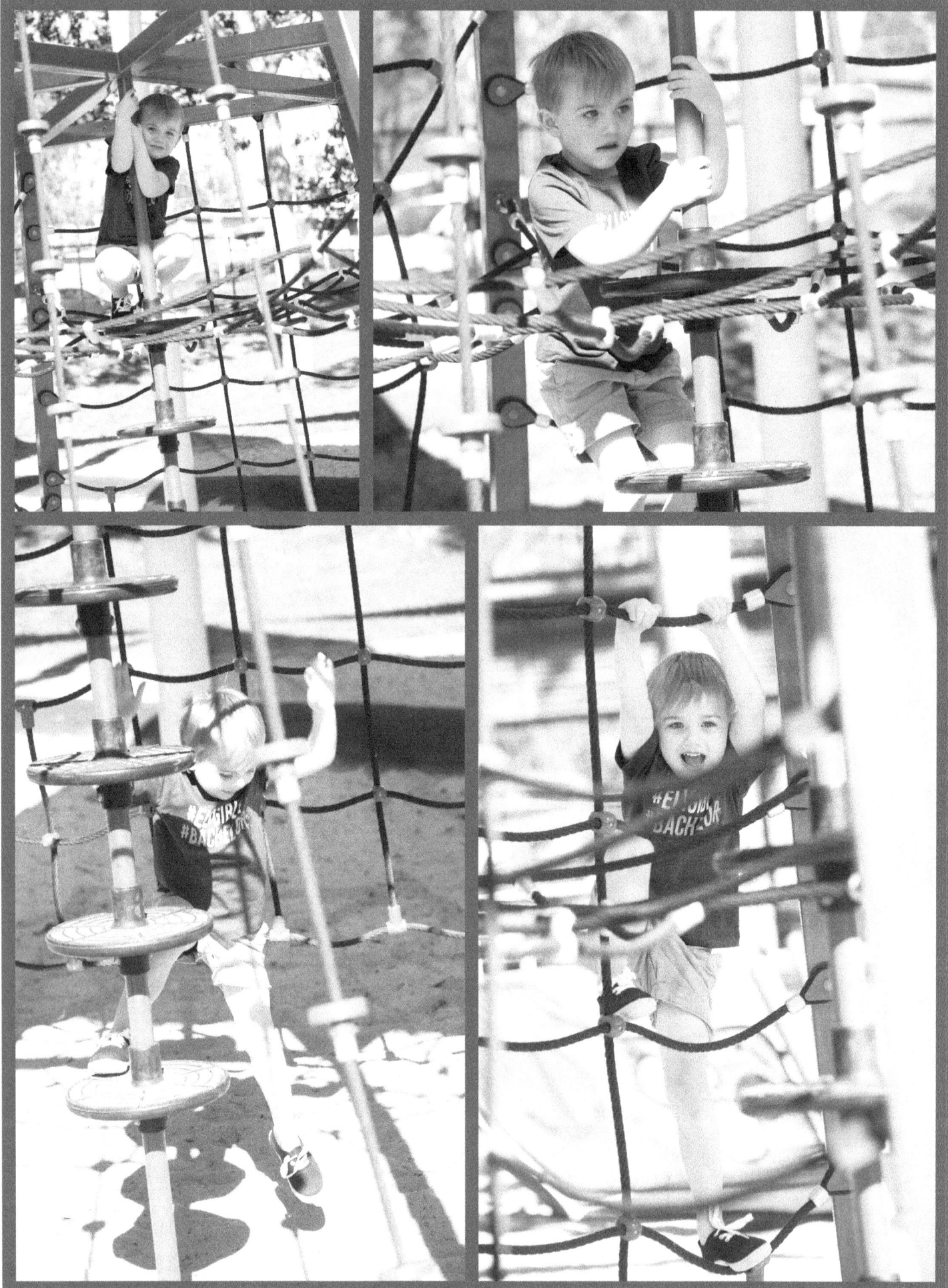

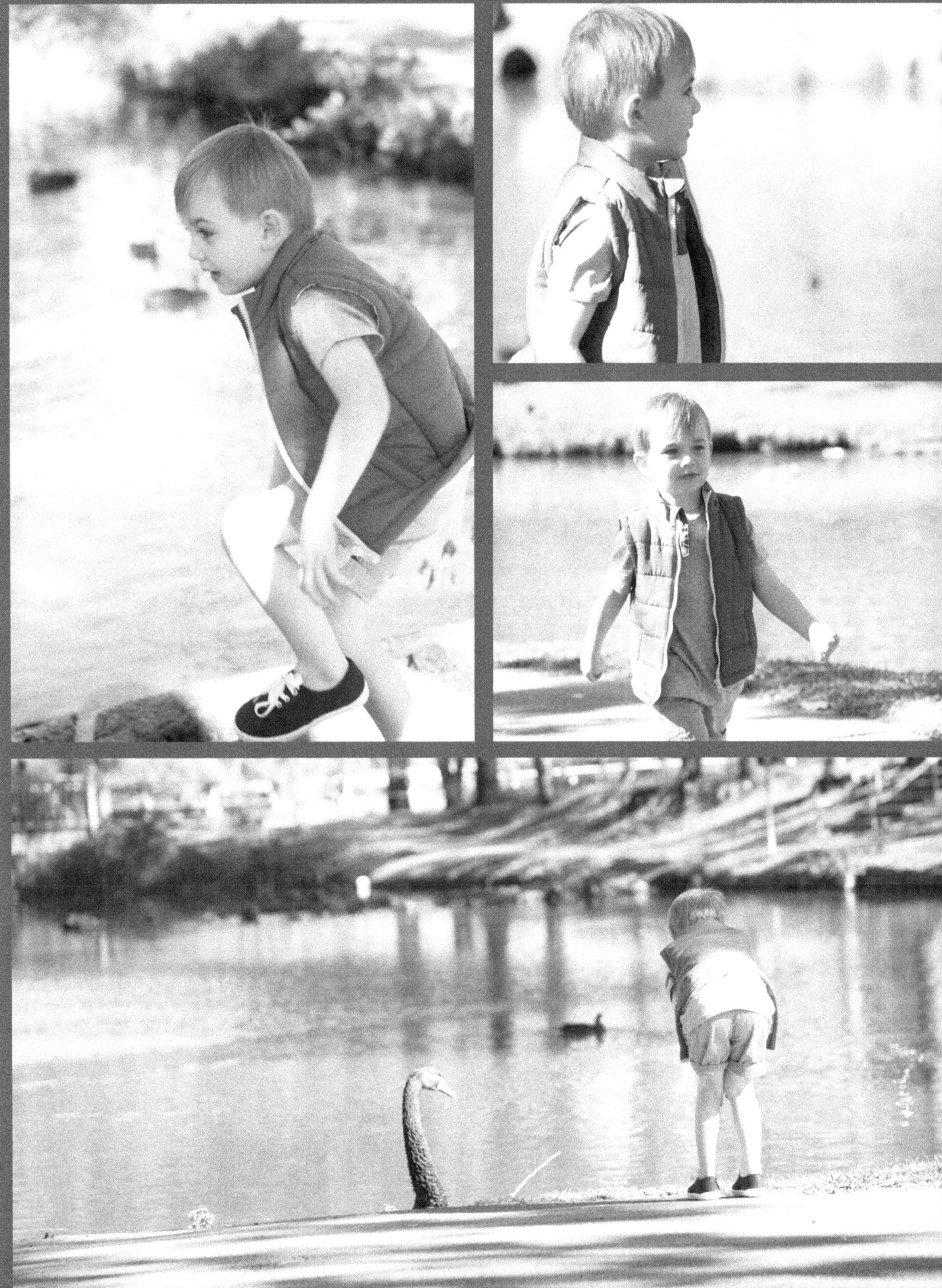

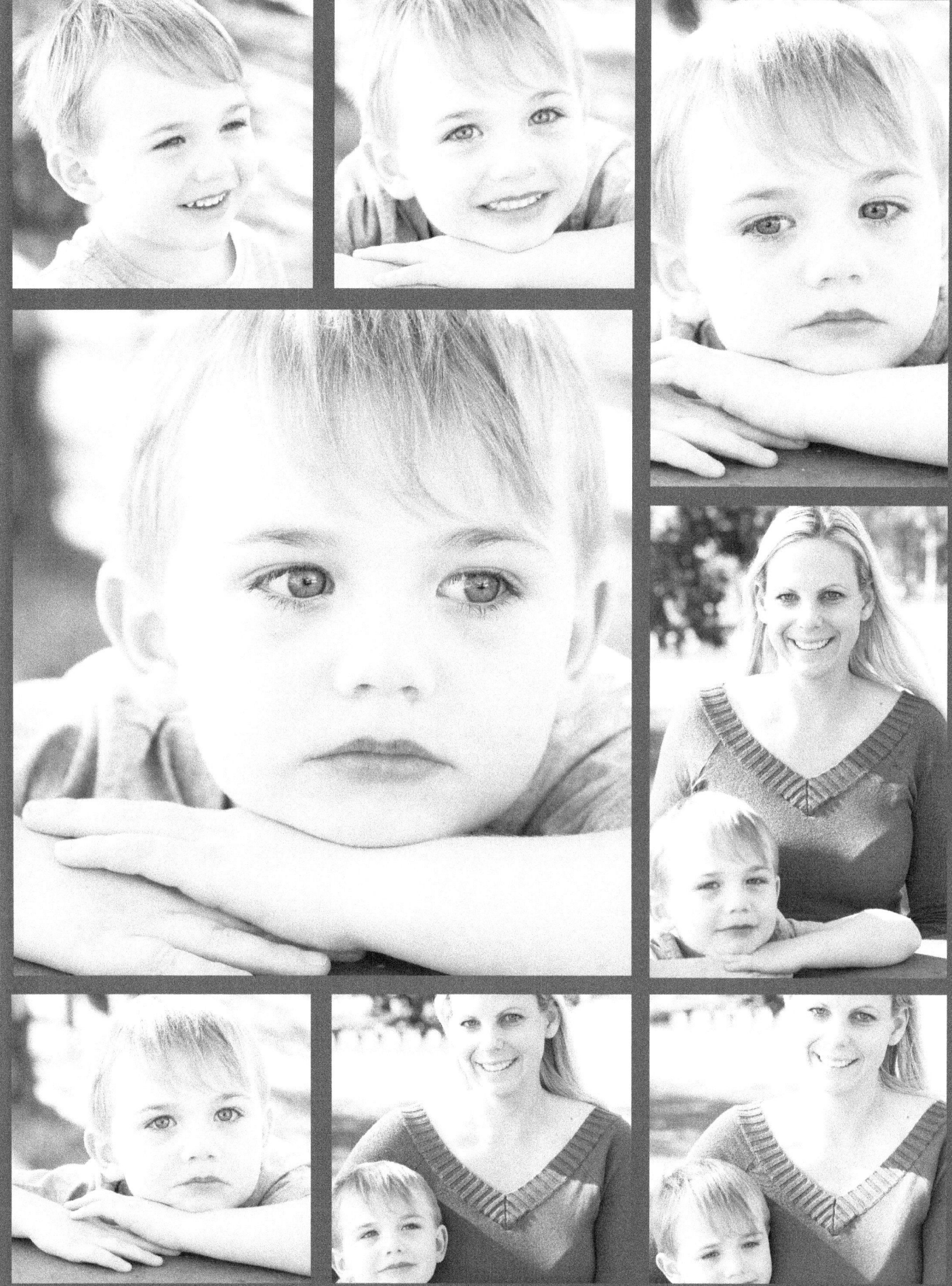

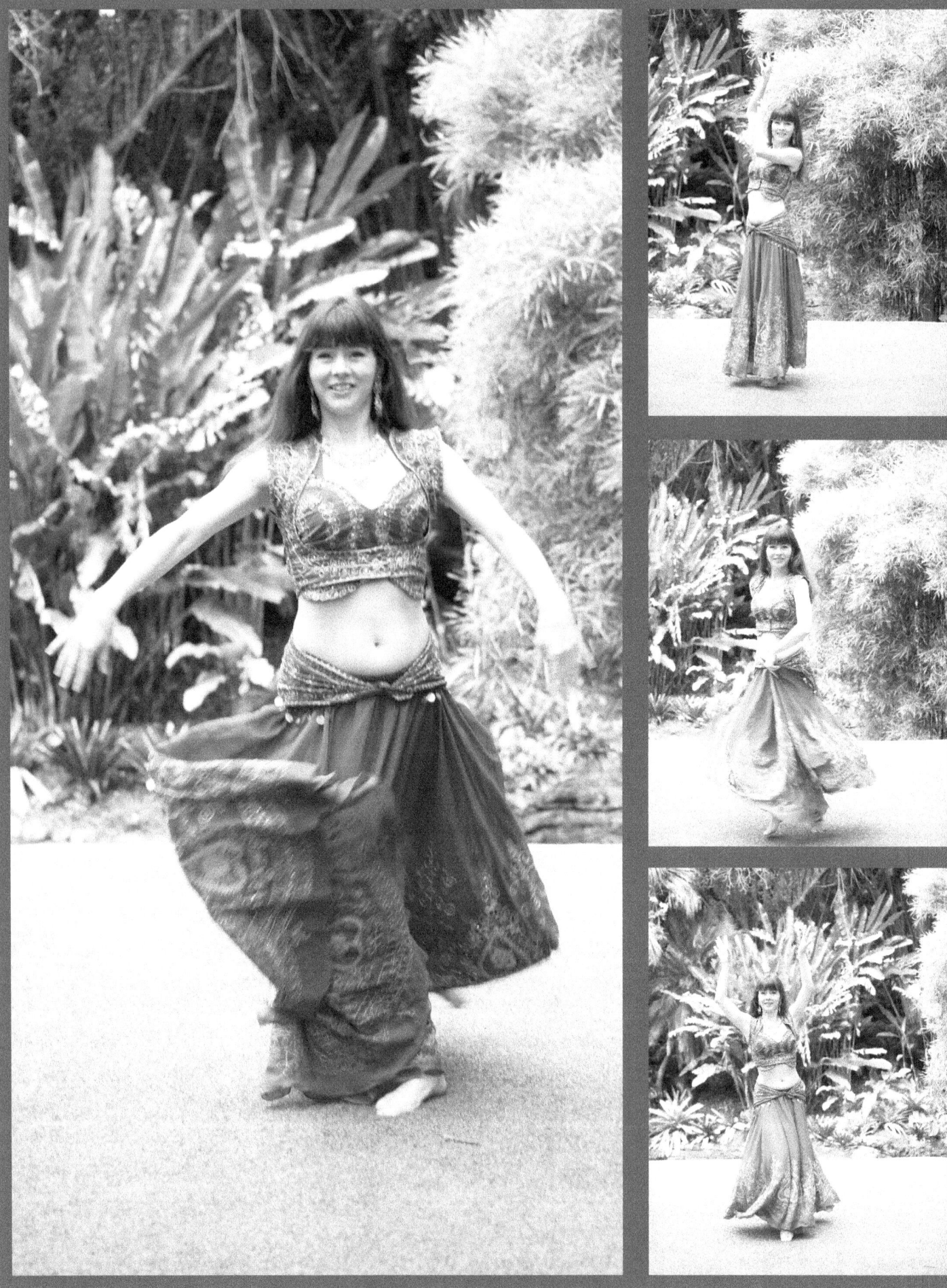

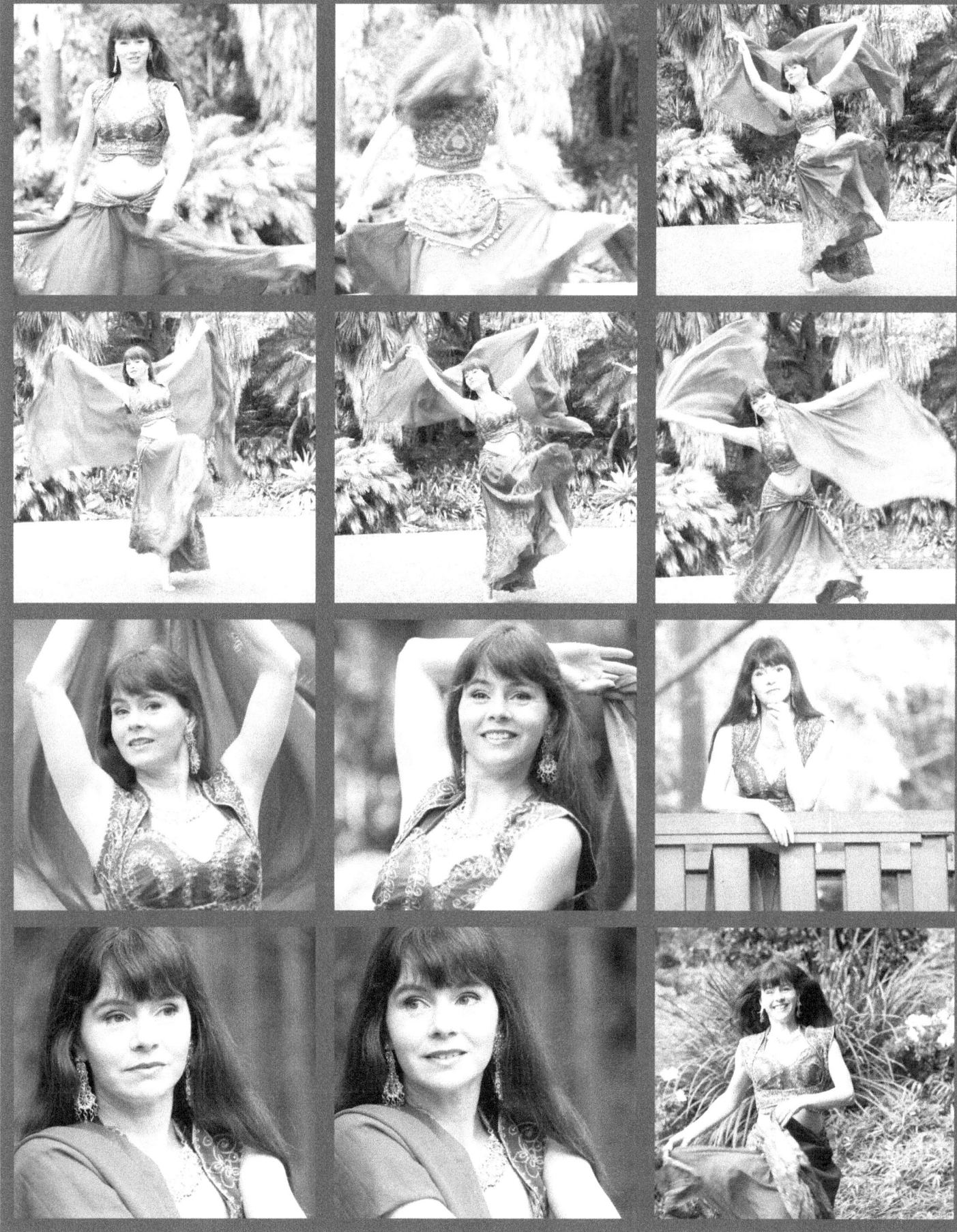

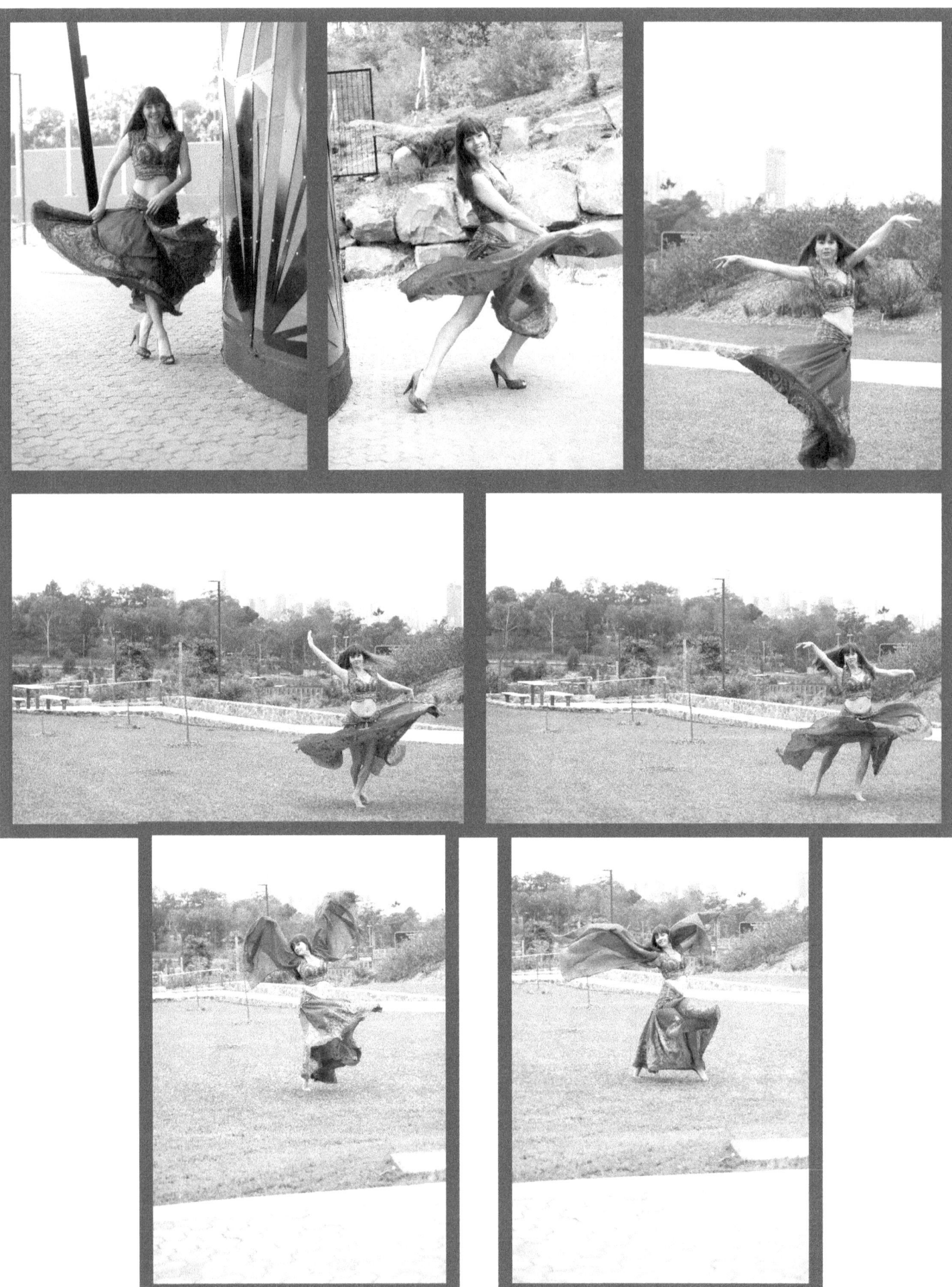

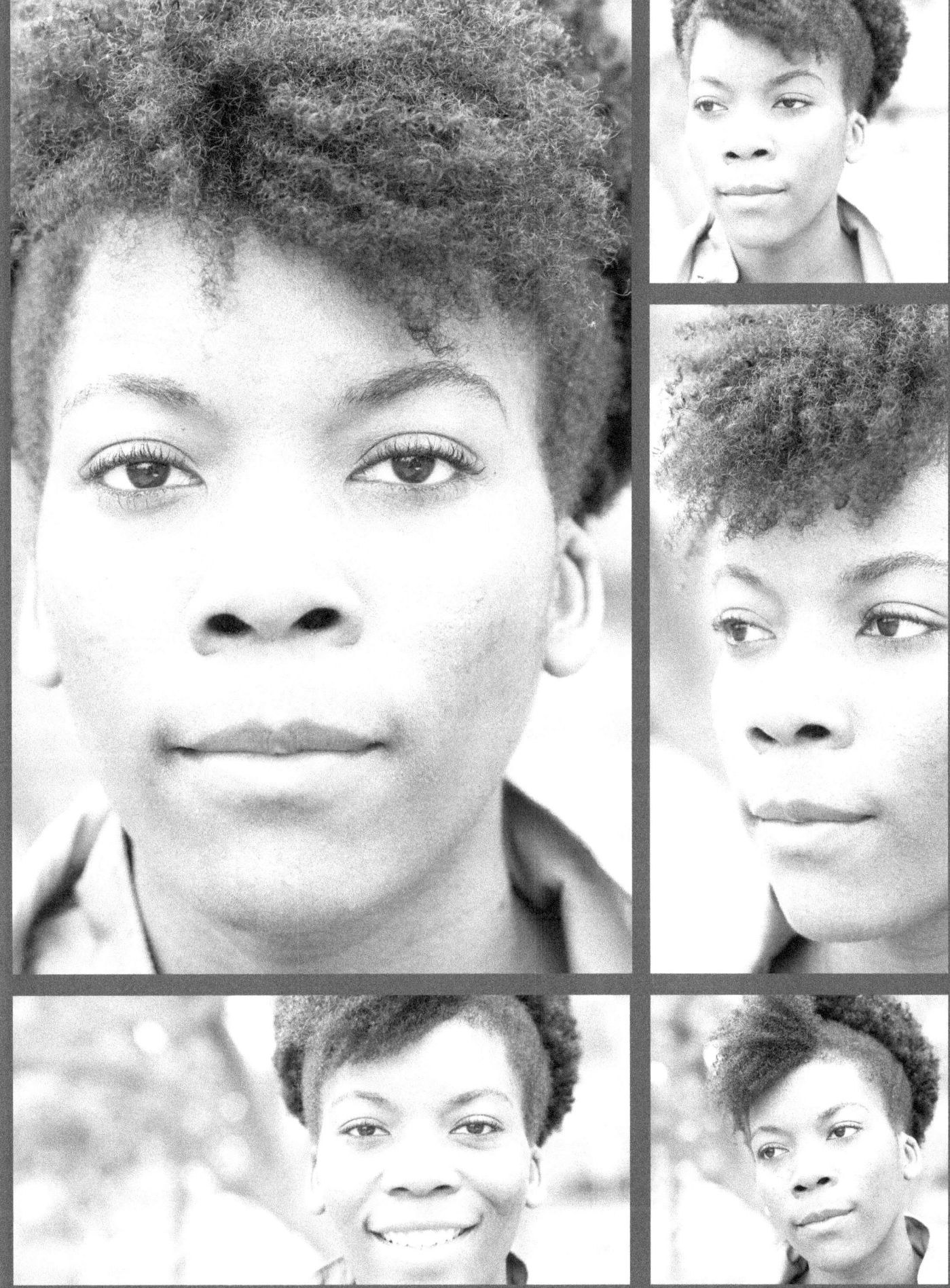

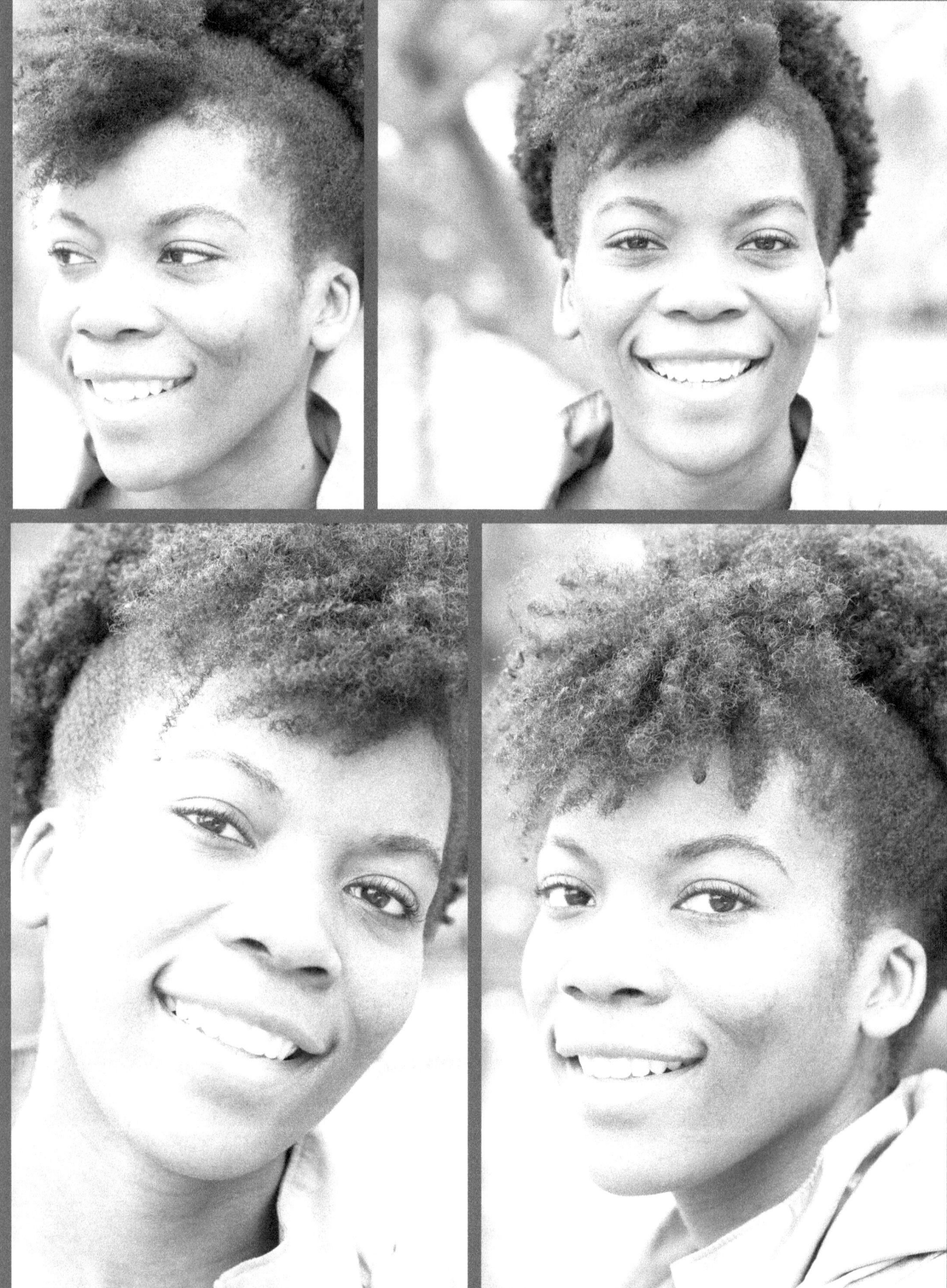

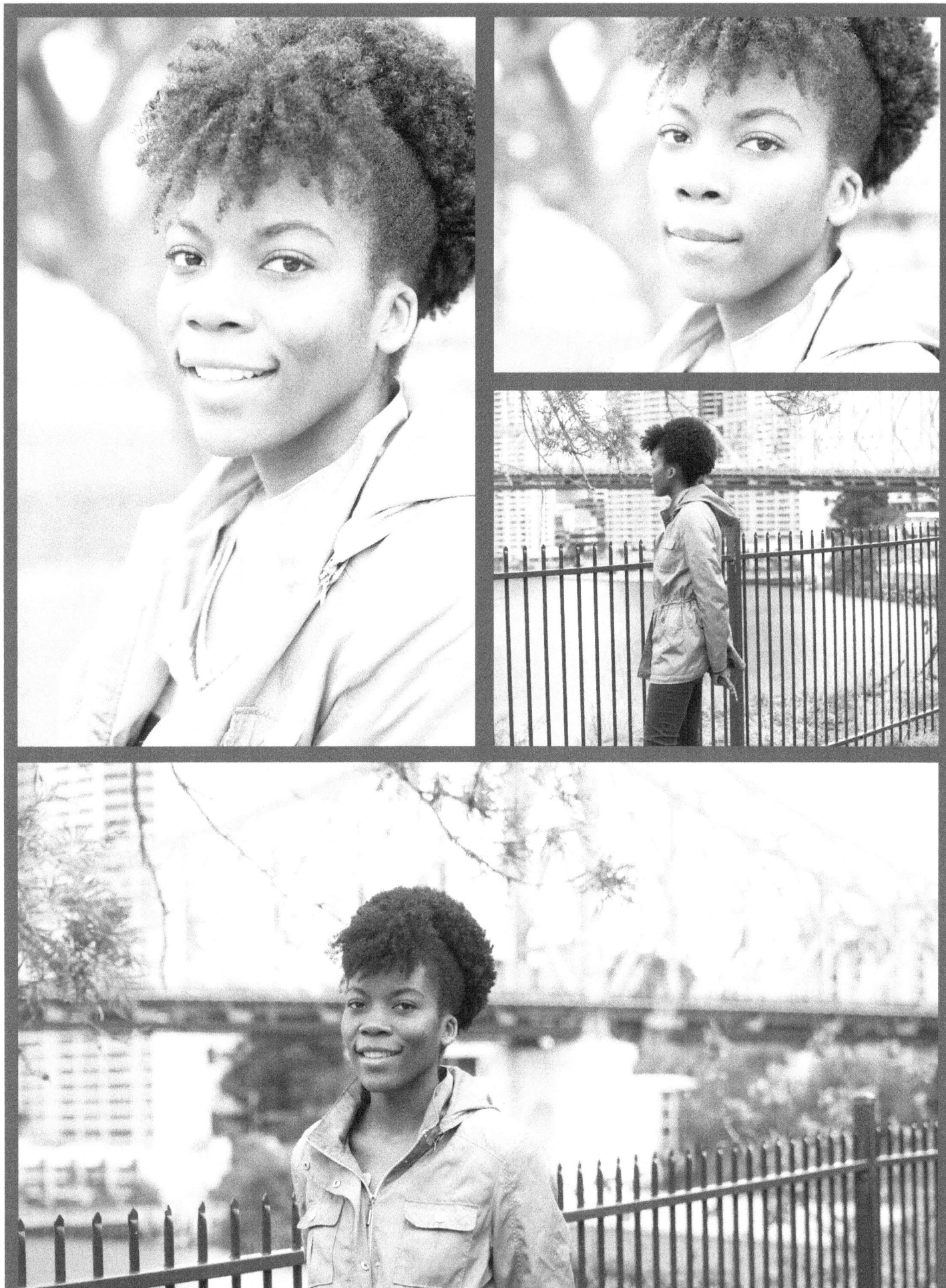

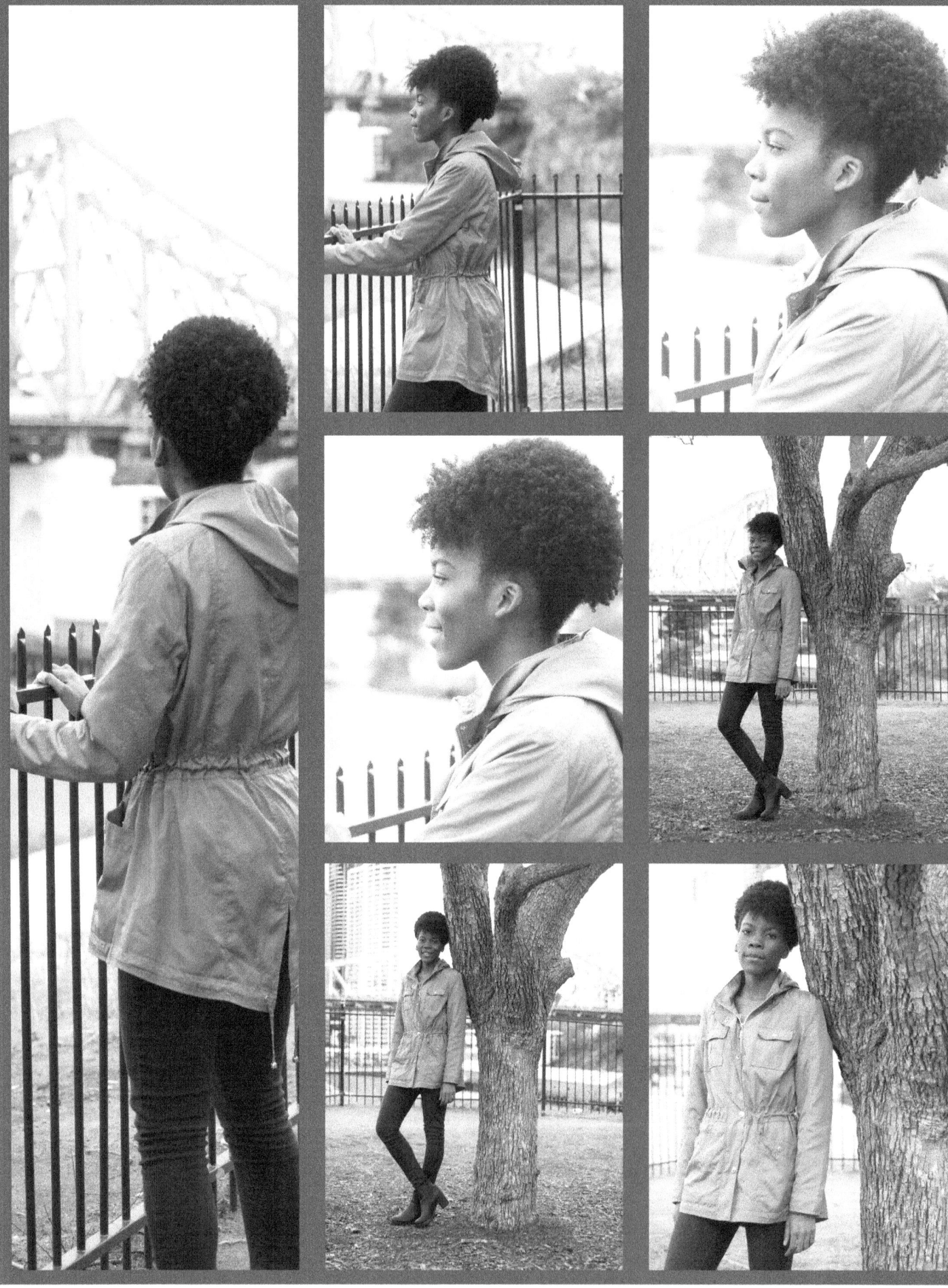

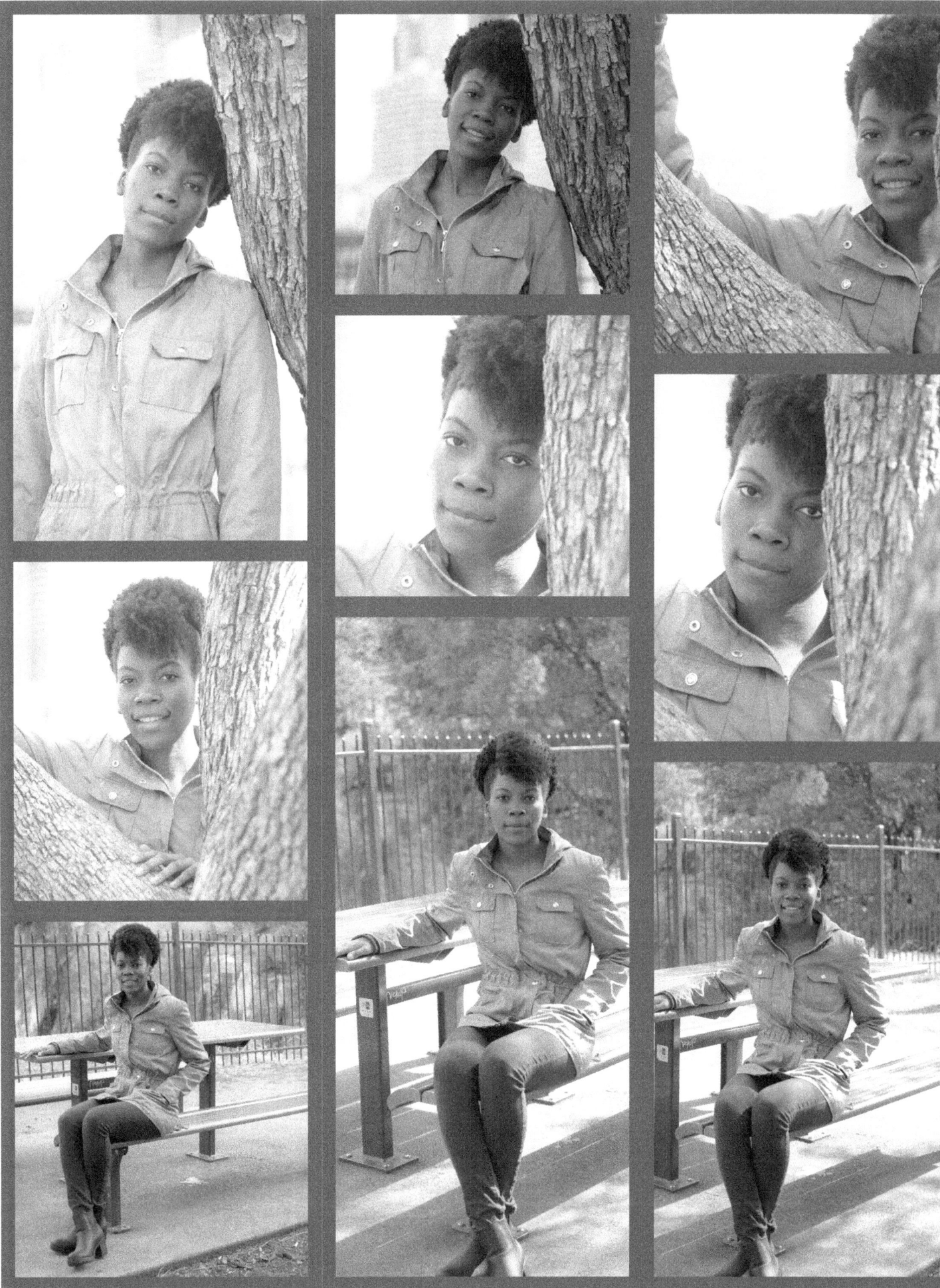

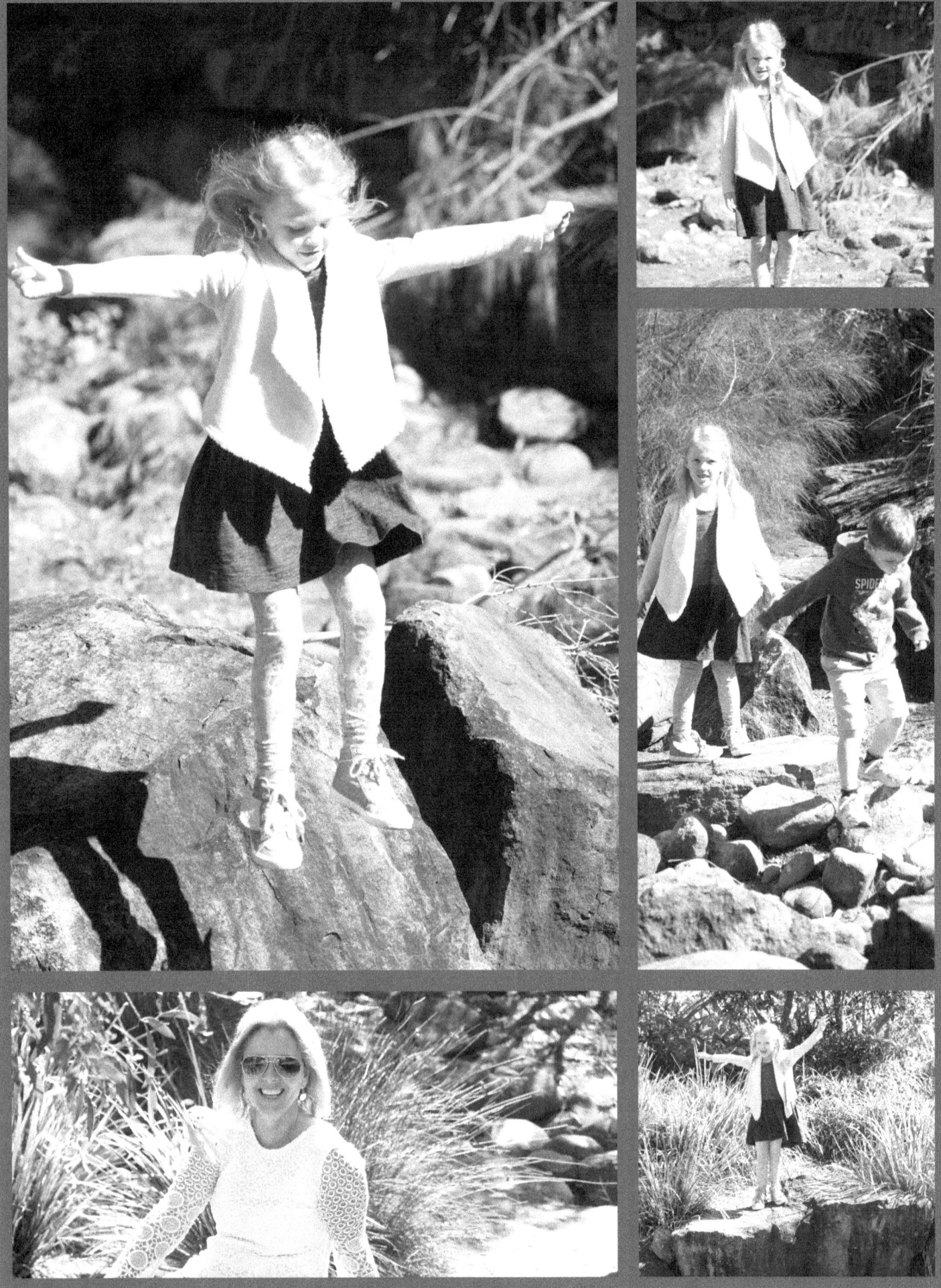

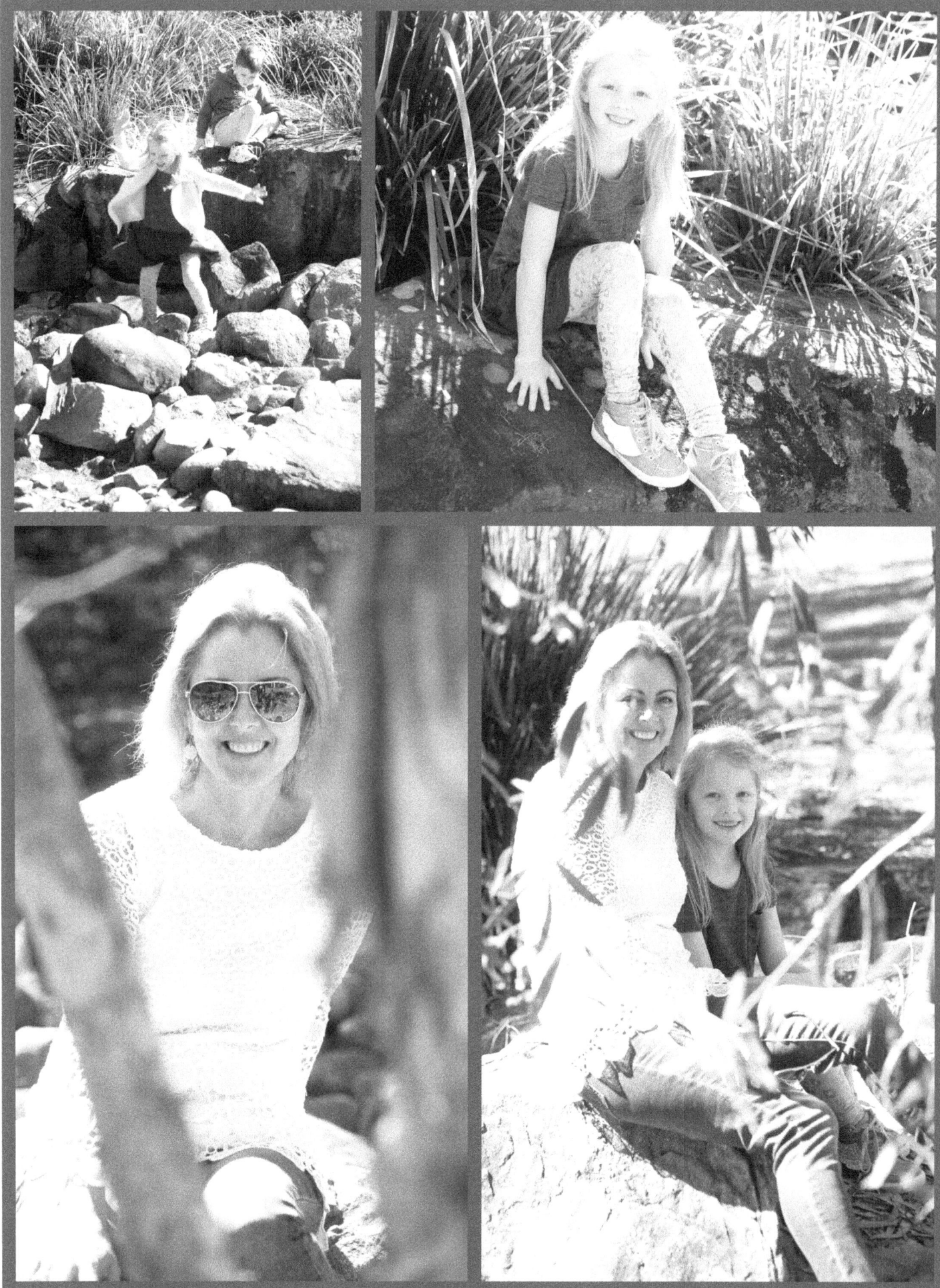

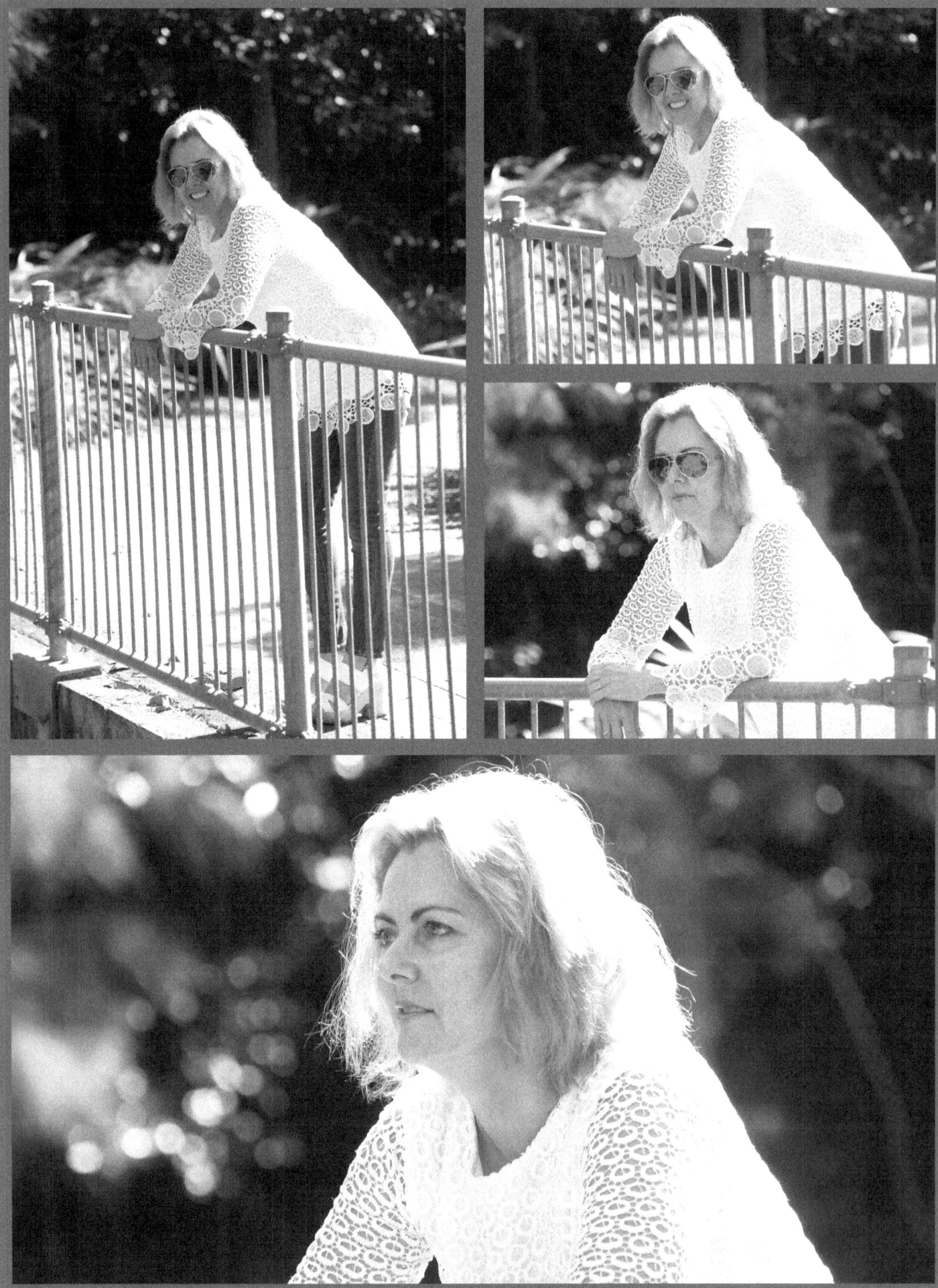

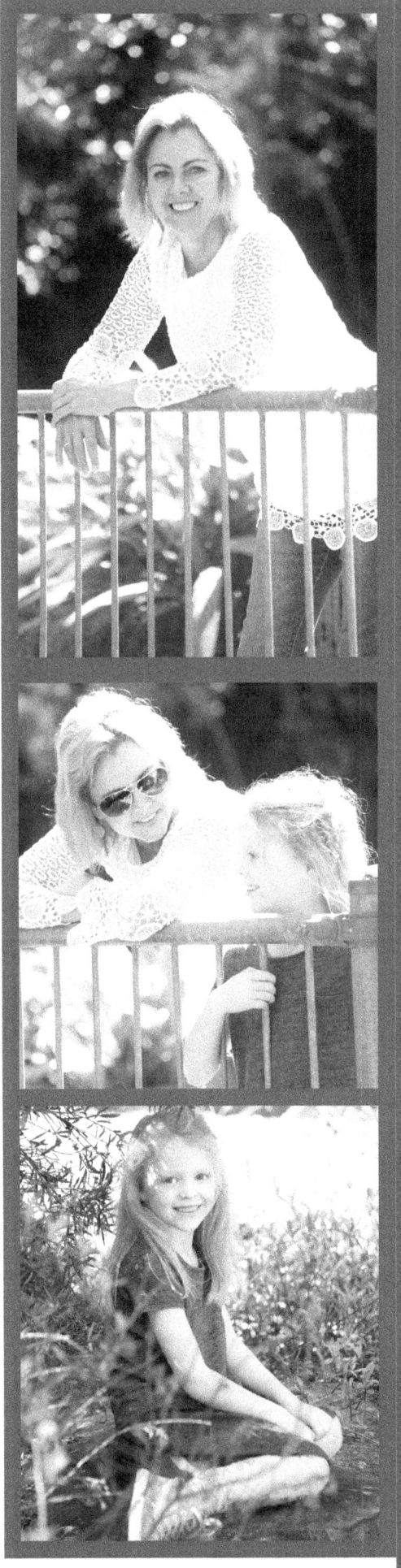
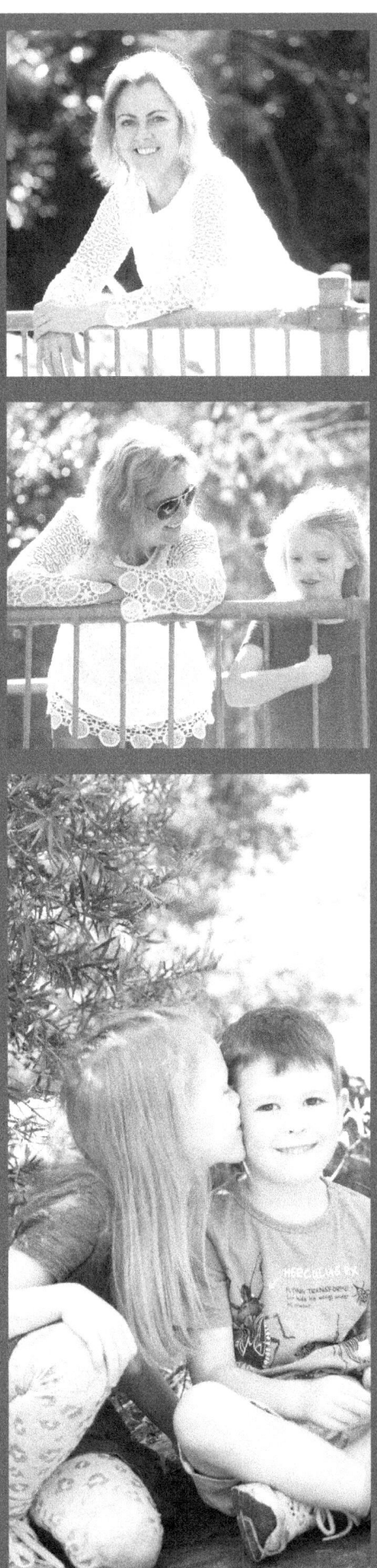
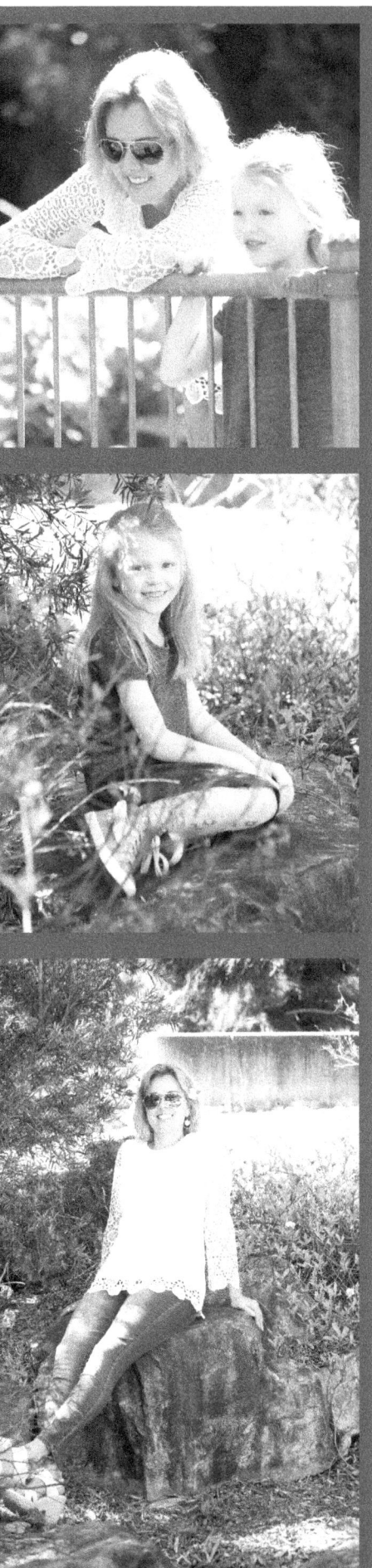

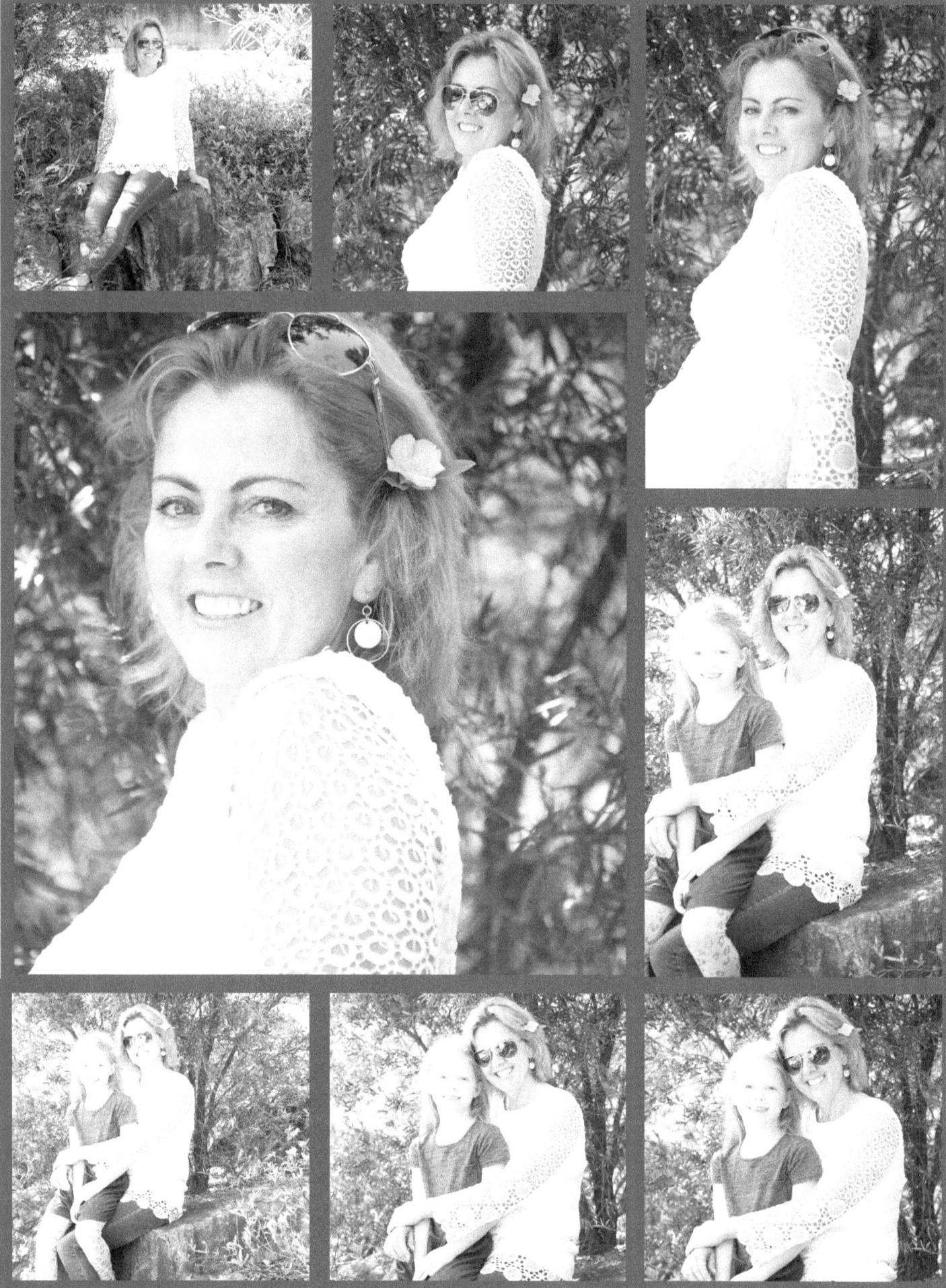

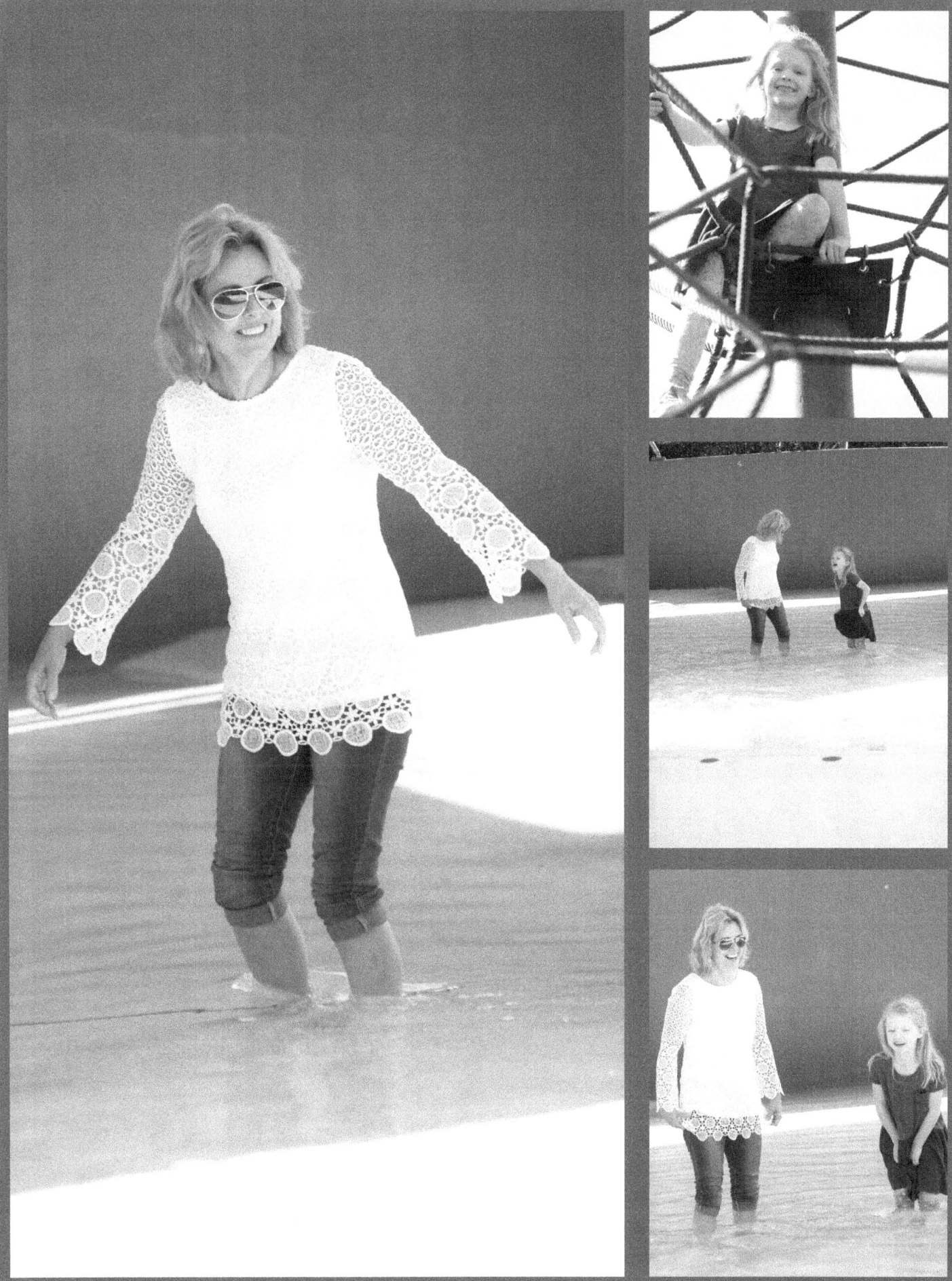

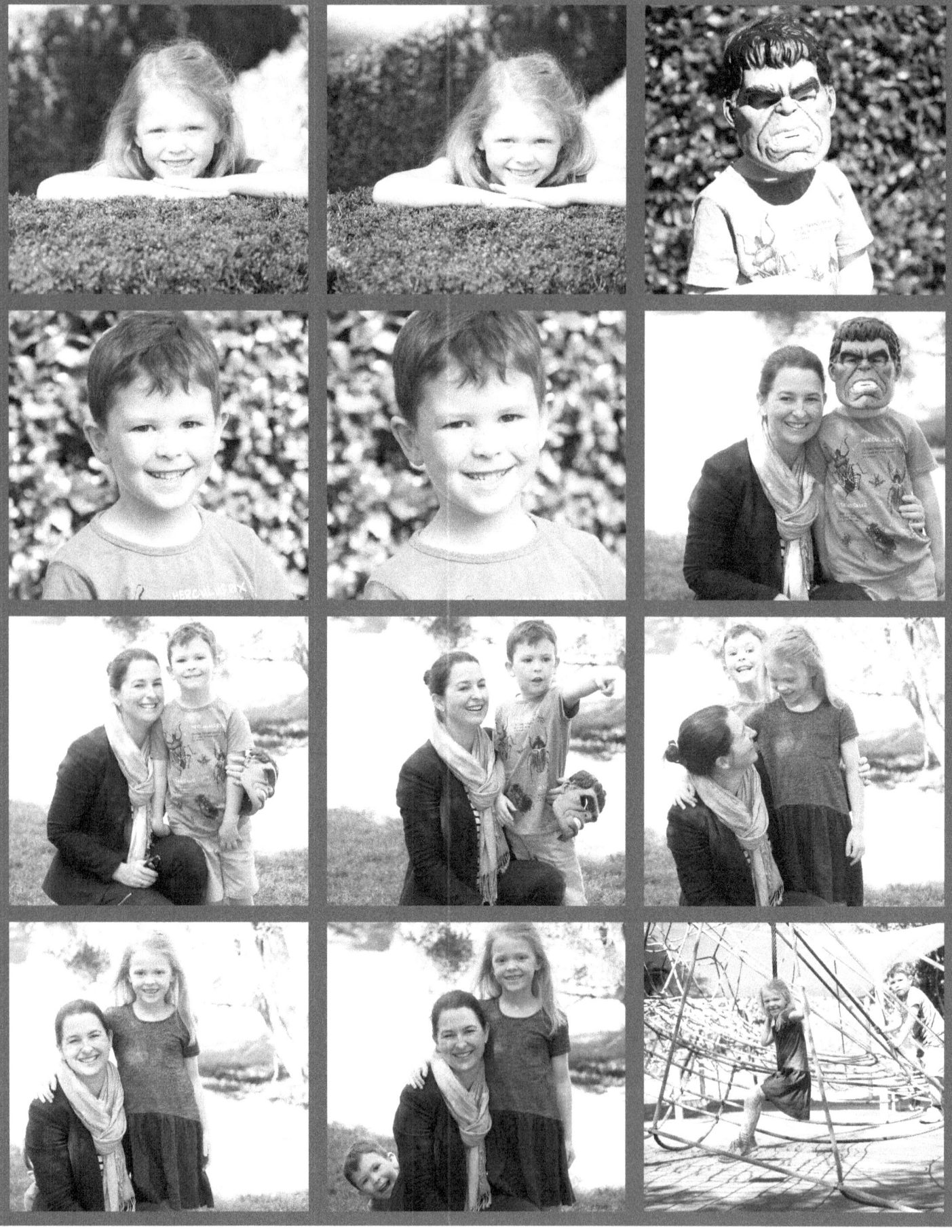

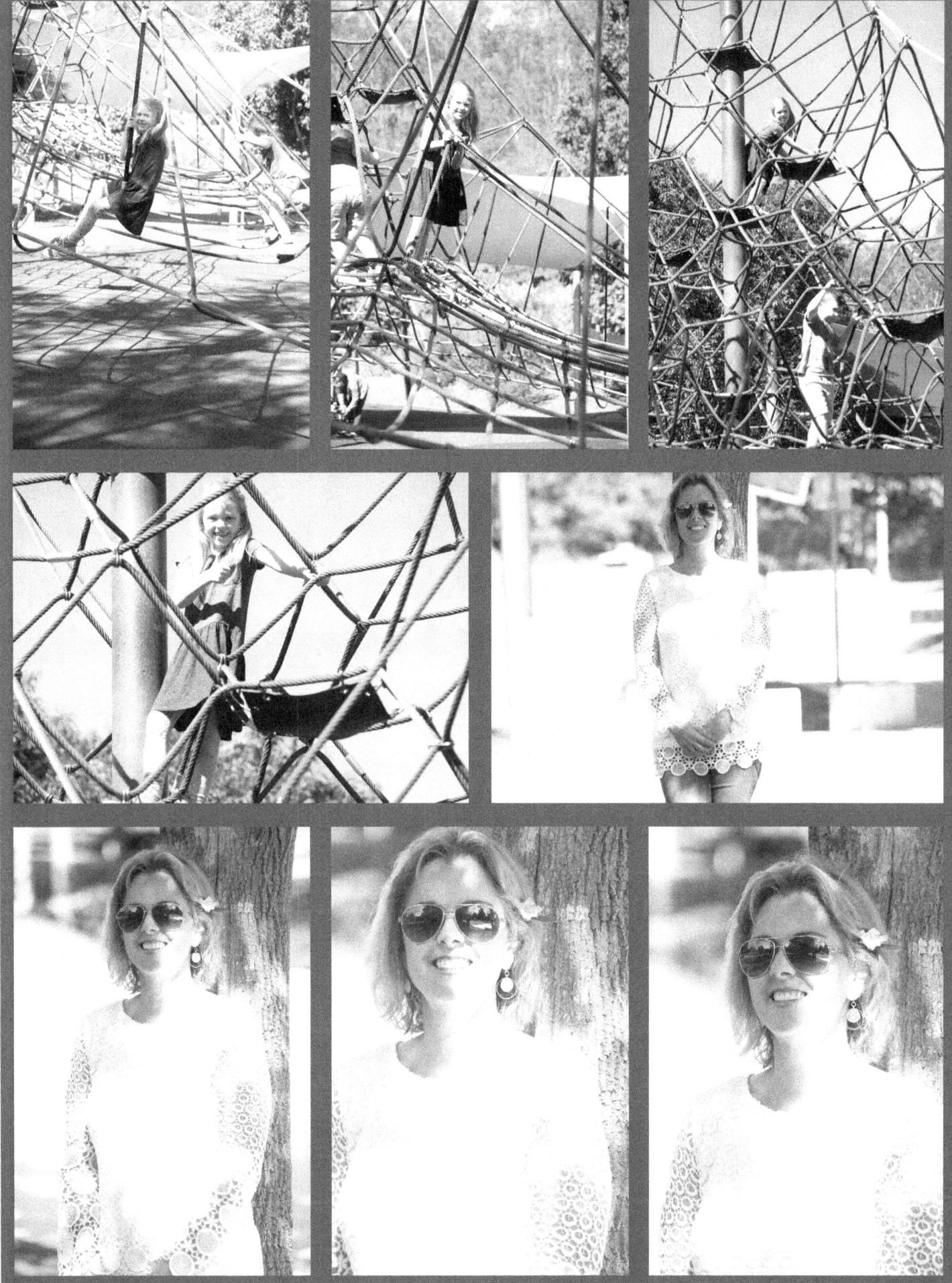

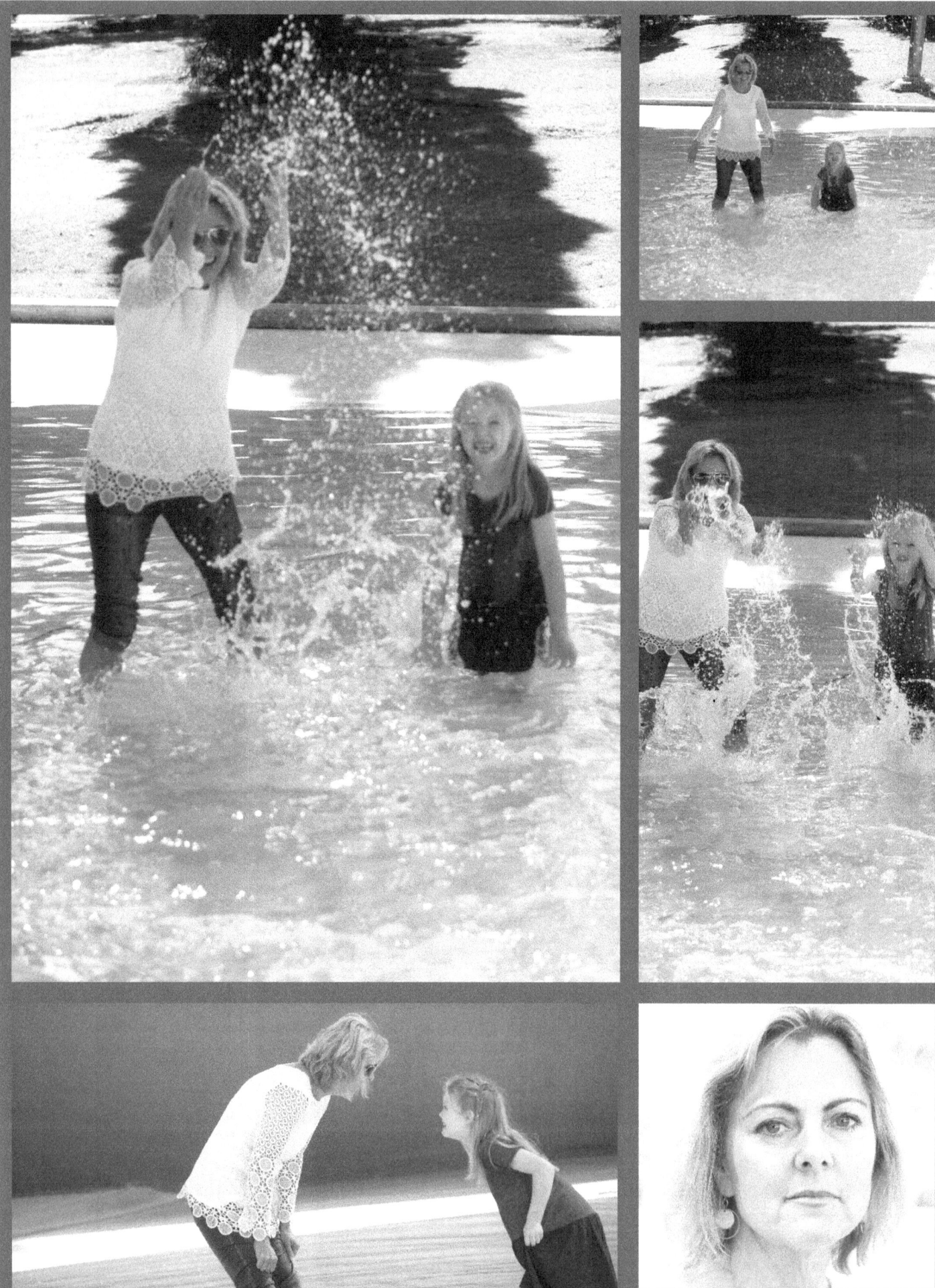

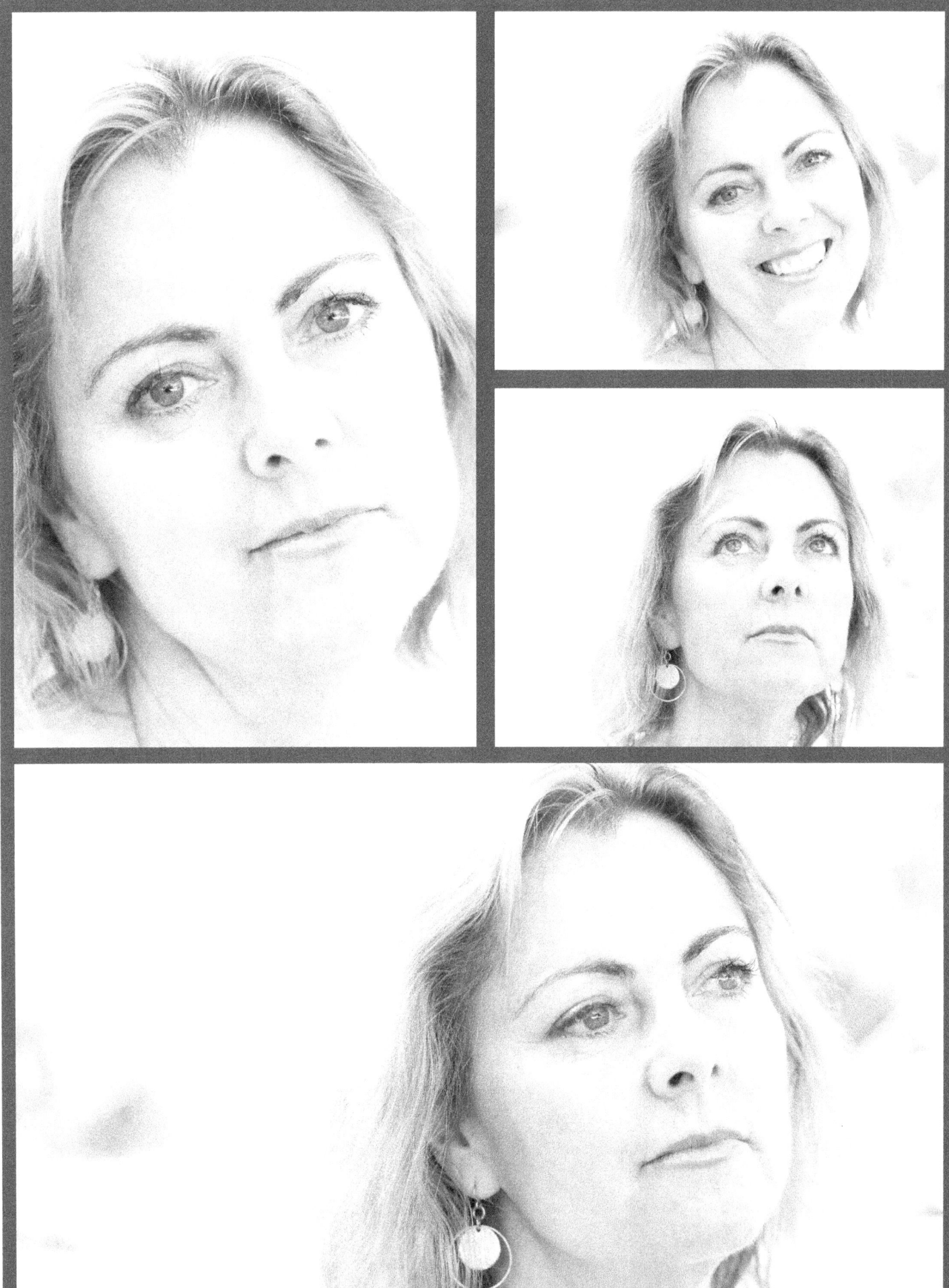

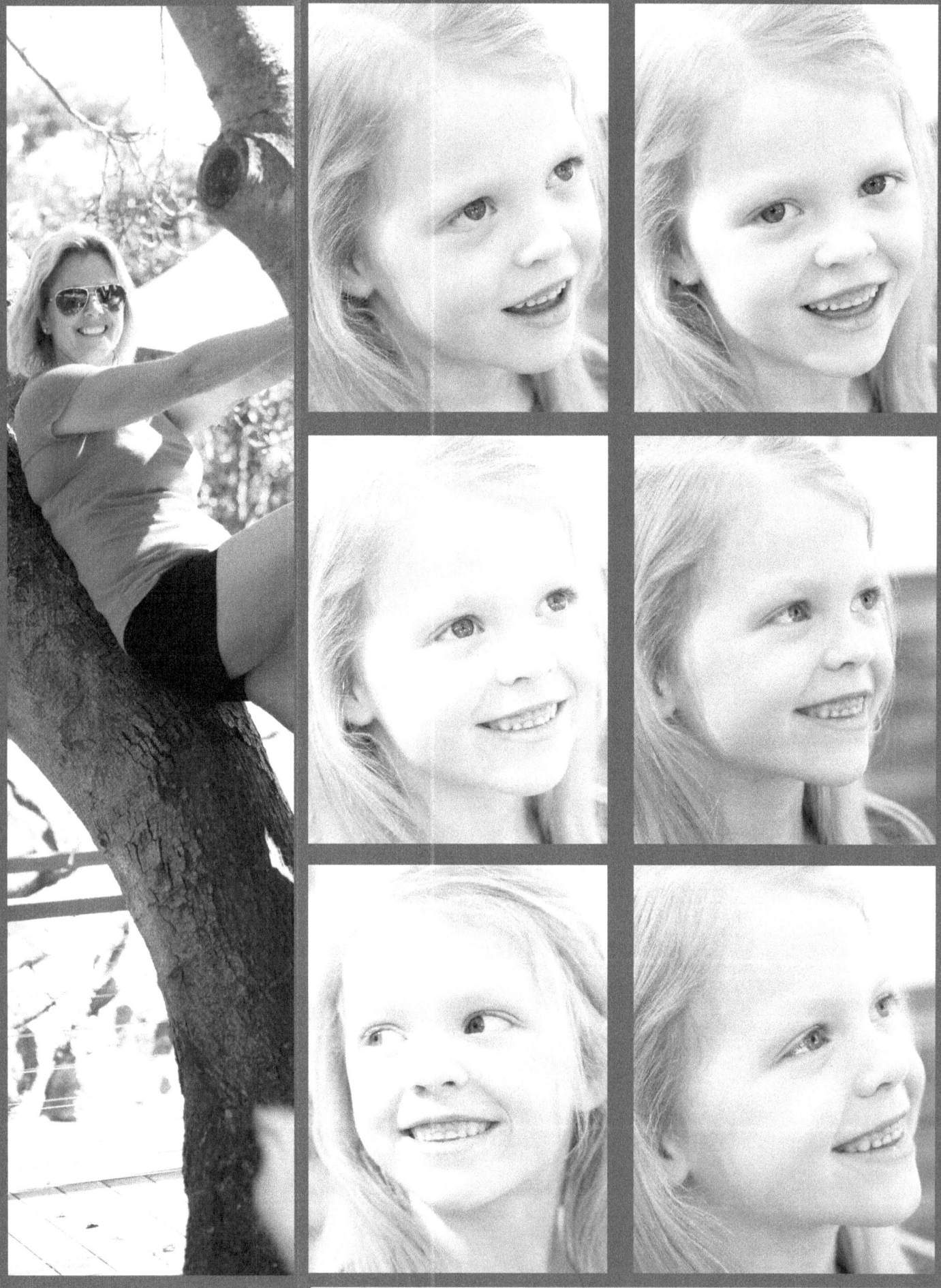

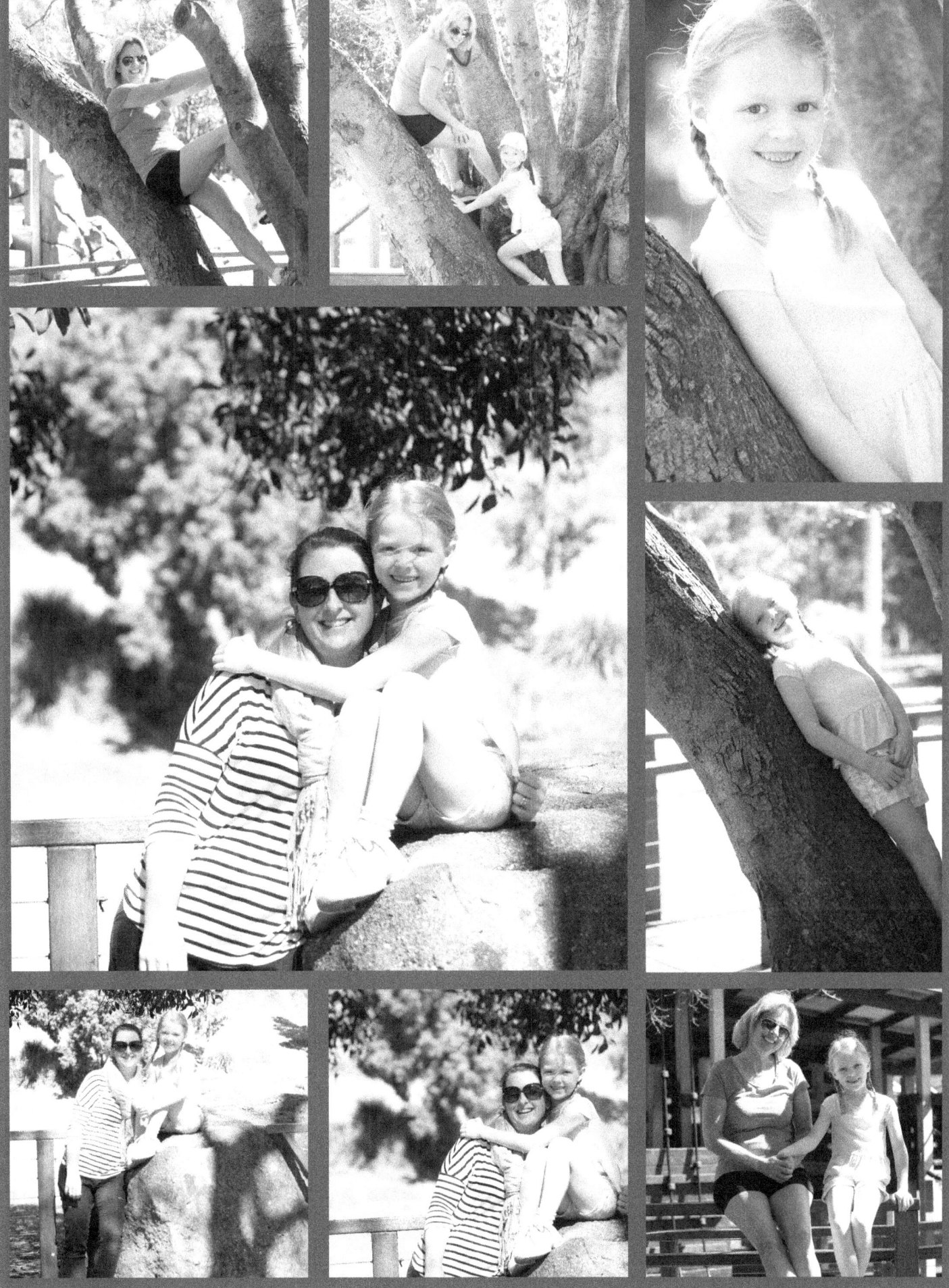

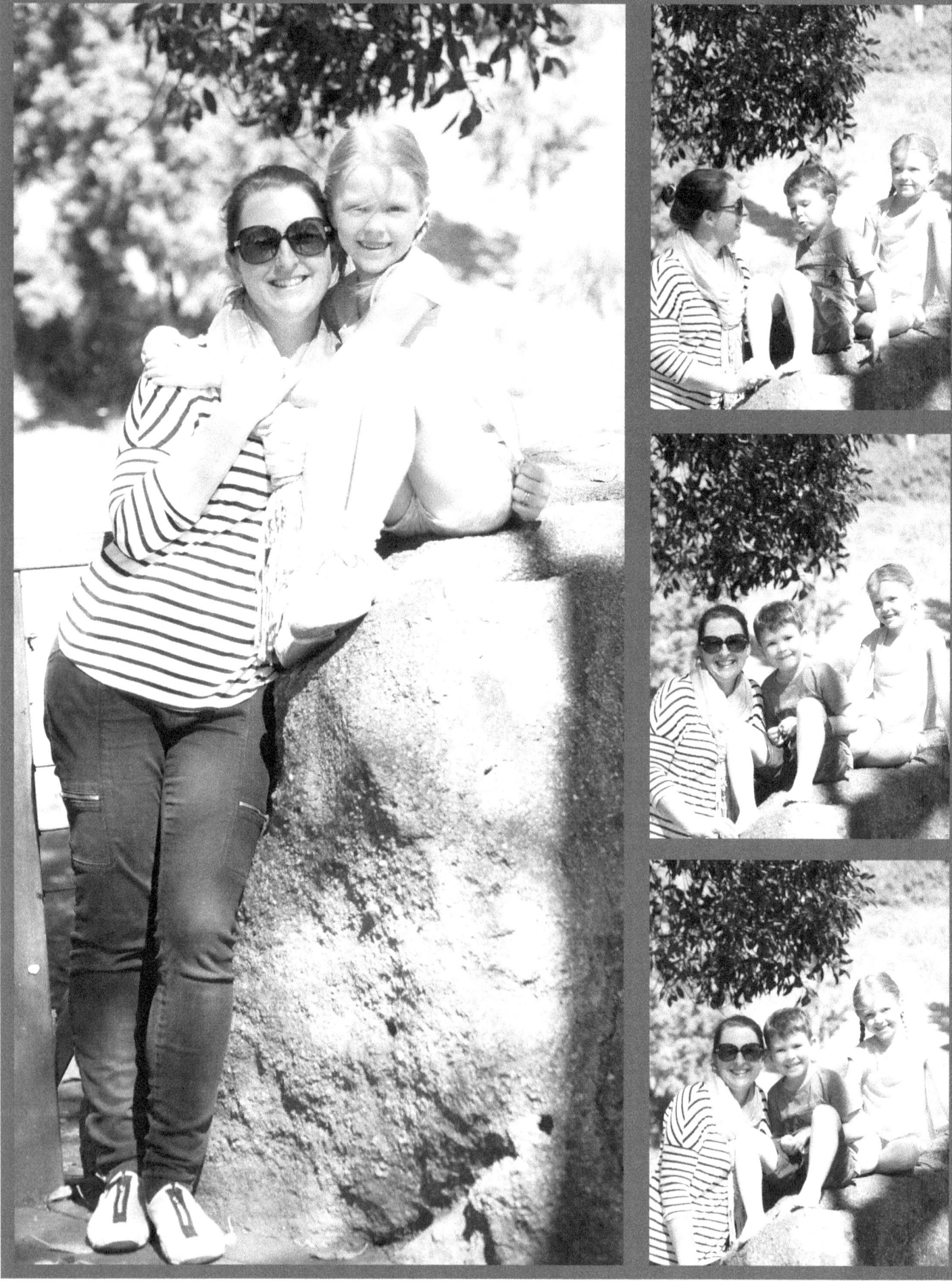

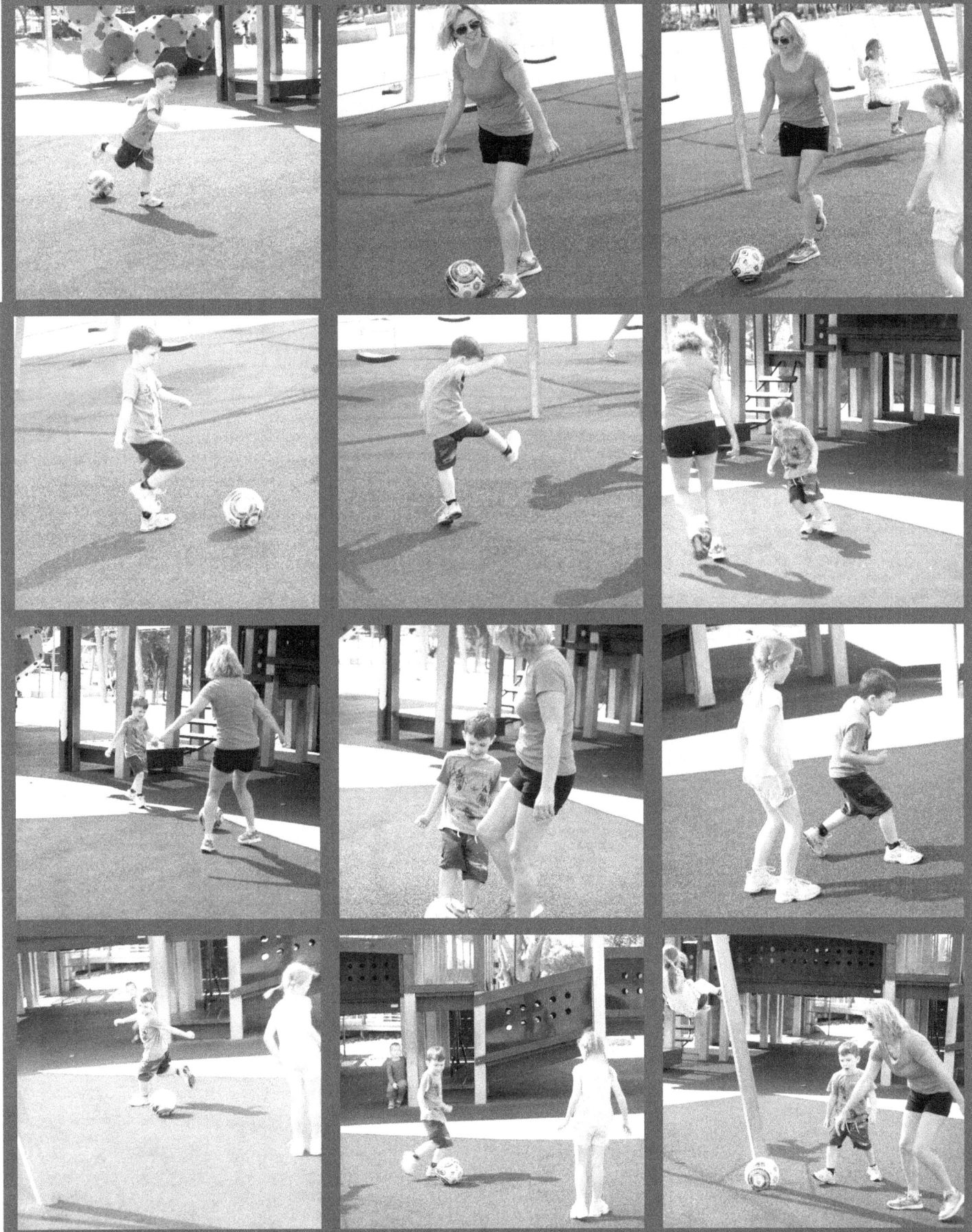

This publication will be available as a full colour printed paperback through all major international book selers.

It will also be available through all international Amazon stores as both a kindle book available for immediate download and as a paperback.

E-book versions will be available both through Google books, iBook store and other e-book sellers.

For a full catalogue of books written and published by Ian McKenzie go to www.IansBooks.com

Ian McKenzie

author
photographer
publisher

www.ingramcontent.com/pod-product-compliance
Lightning Source LLC
Chambersburg PA
CBHW080715190526
45169CB00006B/2389